Edited by Guy Brett

WITH ESSAYS BY
Moacir dos Anjos, Guy Brett, Okwui Enwezor,
Maaretta Jaukkuri, Bartomeu Marí, Lu Menezes,
Suely Rolnik, Sônia Salzstein and Lynn Zelevansky

Tate Publishing

First published 2008 by order of the Tate Trustees
by Tate Publishing, a division of Tate Enterprises Ltd,
Millbank, London SW1P 4RG
www.tate.org.uk/publishing

on the occasion of the exhibition

Cildo Meireles

Tate Modern, London
14 October 2008 – 11 January 2009

Museu d'Art Contemporani de Barcelona
11 February – 3 May 2009

The Museum of Fine Arts, Houston
7 June – 27 September 2009

Los Angeles County Museum of Art, Los Angeles
22 November 2009 – 7 February 2010

Art Gallery of Ontario
27 March – 27 June 2010

British Library Cataloguing in Publication Data
A catalogue record for this book is available
from the British Library

ISBN 978-1-85437-736-4

Designed by Philip Lewis
Colour reproduction by DL Interactive Ltd, London
Printed and bound in China by
C&C Offset Printing Co., Ltd

FRONT COVER *Glovetrotter* 1991 (detail)
FRONTISPIECE The artist with *Eureka/Ghetto*
at Galeria Luiz Buarque de Hollanda & Paulo
Bittencourt, Rio de Janeiro, 1975
PAGE SIX *Babel* 2001 (detail)

Measurements of artworks are given in
centimetres, height before width and depth

Tate is grateful to the Museums Libraries and
Archives Council for arranging indemnity cover
on behalf of HM Government

Contents

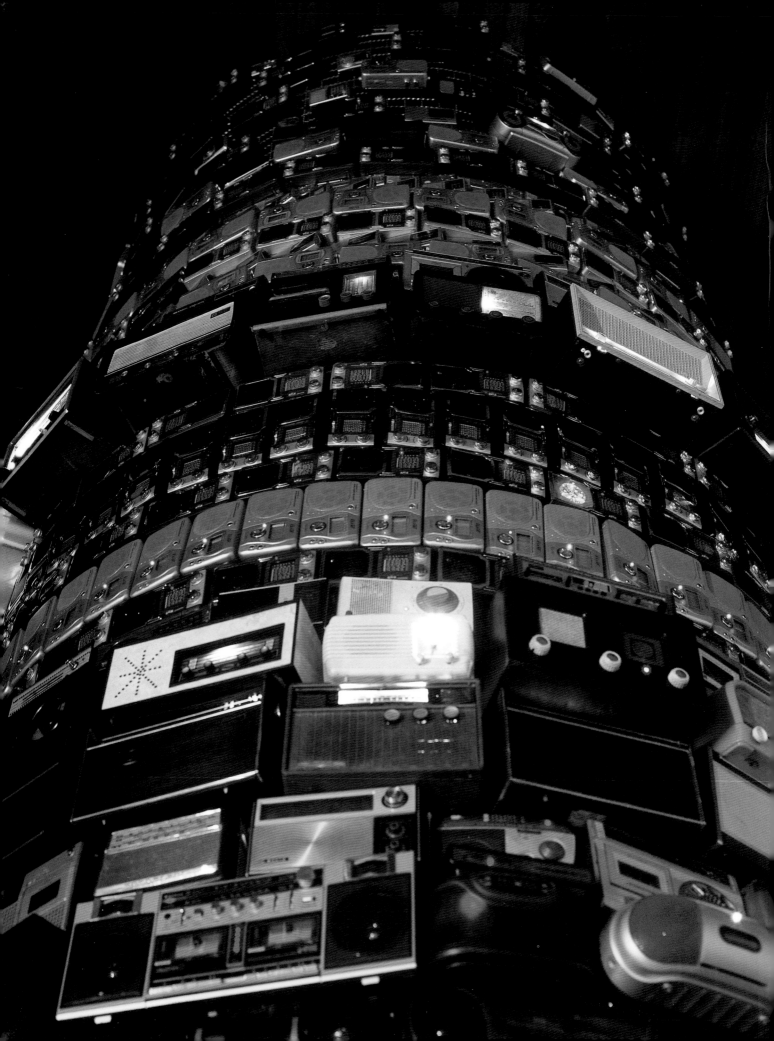

Foreword

Cildo Meireles has made some of the most philosophically brilliant, politically telling and aesthetically seductive works in recent art. We are extremely proud to be given the opportunity to mount this major exhibition of his work, the first in the UK, which brings together a significant number of drawings, objects and installations made between 1967 and 2008. Highlighting key works from a truly exceptional career, this exhibition also brings together for the first time eight of Meireles's major large-scale installations. The esteem in which Cildo Meireles is held cannot be overstated: his work has been highly influential on that of younger generations of artists on an international scale. Powerful and compelling, yet elegant, his work at once possesses clarity and mystery, science and poetry.

First and most importantly my thanks go to Cildo himself, to whom I am deeply indebted for his vision, generosity, advice, humour and good will throughout the gestation of this exhibition. I have thoroughly enjoyed, as has my co-curator Guy Brett, a most rewarding and stimulating dialogue with Cildo over many years of friendship. Together, we would like to thank the artist for his tireless, life-long dedication to the making of artworks which never cease to intrigue, amaze and challenge us. We are also delighted that Cildo has allowed us to publish his own words about the origin of each of the works in the show, which you will find woven throughout this volume.

I have enjoyed an especially fruitful collaboration with my co-curator Guy Brett, who shares our enthusiasm for Cildo's work. His thoughtful and sensitive insights, in our rich dialogue with the artist, have helped shape the exhibition. Furthermore, as editor of this publication, his vision has resulted in a remarkable volume, encompassing intriguing texts from a wide-range of writers from a variety of disciplines.

The enthusiasm, dedication and sheer hard work which Amy Dickson, as assistant curator, has brought to this project deserves special recognition and gratitude. She has literally kept the many strands involved in such an undertaking together, liaising between them, keeping up the momentum, and solving problems. We are very much in her debt.

Warmest thanks go to Trudo Engels, whose intelligence, technical skill, precision, good humour and intimate knowledge of Cildo's installations, have

enabled us to tackle such an ambitious project. I would also particularly like to thank Max Meireles, Rubens Teixeira dos Santos, Miriam Vasquez Tavares, Christophe Laudamiel, Jochen Volz and Janaína de Mello Castro at Inhotim Centro de Arte Contemporânea, Minas Gerais, Brazil and Käthe Walser at Daros-Latinamerica for their knowledge, generosity and able technical assistance both in the lead up to and the installation of the exhibition. Sincere thanks also go to Robert Blackson at Reg Vardy Gallery and John Hatfield at The New Museum of Contemporary Art for their helpful advice.

An exhibition of this scale, followed by a European and American tour makes great demands on the lenders without whose generous support such an exhibition would not be possible. This is particularly true of the artist himself, Inhotim Centro de Arte Contemporânea, Minas Gerais, Brazil, Daros-Latinamerica and Fundación 'La Caixa' who have lent large-scale installations to the show. Other lenders include Collection Luiz Buarque de Hollanda, Museu de Arte Moderna, Rio de Janeiro; Instituto Carlos Scliar – Collection Francisco Medeiros Scliar; Collection Fundação de Serralves – Museu de Arte Contemporânea, Porto; Ricardo and Susana Steinbruch Collection and Collection Marcantônio Vilaça. Luisa Strina in São Paulo and Mary Sabbatino of Gallery Lelong in New York have lent their invaluable support and expertise to this project and have been unstinting with their advice and generosity throughout. Oscar Cruz has also assisted with loan administration.

An exhibition of this size and technical complexity could not have been staged without the expertise of many individuals here at Tate. The installation arrangements have been masterminded by Phil Monk and the exhibition has been ably installed by his team. Expert advice has been given by the exhibition registrar, Stephanie Bush, while Stephen Mellor has advised on further logistical and contractual matters. In meeting the unusual institutional challenges posed by this ambitious project we are most grateful to Dennis Ahern for his continuous guidance and support. I would like to thank the project interns for their important contributions: chief among them Ana Luiza Teixeira de Freitas for her energetic support, and also Lois Olmstead and Cleuci de Oliveira for their able assistance in the early stages of the project.

Guy Brett has brought his extensive knowledge of Cildo's work, as well as sensitivity, precision, and clarity to the editing of this publication, to which Moacir dos Anjos, Okwui Enwezor, Maaretta Jaukkuri, Bartomeu Marí, Lu Menezes, Suely Rolnik, Sônia Salzstein and Lynn Zelevansky have contributed insightful essays on different aspects of Cildo's work. Felipe Scovino conducted the interviews with the artist which form the heart of this publication. Stephen Berg's subtle translations retain the poetry of the artist's own words. I would also like to thank Stephen, Michael Asbury and Alayne Pullen, for their skilful translations of the catalogue essays. Philip Lewis has produced a beautiful design with his customary sensitivity. At Tate Publishing, Mary Richards has guided the book to completion with great skill, efficiency and good humour, and Celeste Stroll has brought enormous expertise to print and production issues.

To coincide with the Tate Modern exhibition and to inaugurate their new open-air gallery space, Chelsea College of Arts has staged Cildo's recent work, Occasion. I would very much like to thank the Research Centre for Transnational Art Identity and Nation (TrAIN) for collaborating with us on this, in particular Michael Asbury for his curatorial vision and Paulo Pimenta for his support.

We are delighted that the exhibition will travel on to Museu d'Art Contemporani de Barcelona; The Museum of Fine Arts, Houston; Los Angeles County Museum of Art; and Art Gallery of Ontario. In Barcelona I would like to thank Bartomeu Marí and Soledad Gutiérrez; in Houston, Peter Marzio and Mari Carmen Ramírez; in Los Angeles, Michael Govan and Lynn Zelevansky; and in Ontario, Catherine de Zegher, Jill Cuthbertson and Iain Hoadley.

Finally, this exhibition has greatly benefited from the generosity of the following donors: Bruce T. Halle Family Foundation; Inhotim Centro de Arte Contemporânea; The Henry Moore Foundation; Beatriz Quintella and Luiz Augusto Teixeira de Freitas; Paulo A.W. Vieira; and those donors who wish to remain anonymous. I extend my heartfelt thanks to these supporters for their involvement and commitment to the exhibition.

Vicente Todolí
DIRECTOR, TATE MODERN

Cildo Meireles: On the nature of things

GUY BRETT AND VICENTE TODOLÍ

Dark Light 1982 (p.103) is a box mounted on the wall with a panel forming a screen at one end. On this screen an apparition: the dark shape of a light bulb in the middle of a blaze of light. The image denotes light and darkness simultaneously, but in a kind of reverse relationship: what we expect to be light is dark and vice versa. Different circuits of the mind, different understandings of 'energy' and 'image' are pleasurably confused. We can leave the workings of this box a mystery, or read the artist's own description: 'There are two light bulbs, one of which . . . is the source of light. The other bulb forms a screen through which the light will be projected [casting a shadow] onto a further screen upon which the spectator will see the image.'[1]

Dark Light is an object completely sufficient for what it demonstrates. It bears no superficial resemblance to the other objects that Cildo Meireles has produced, of whatever physical size, underlining the artist's belief that 'every idea demands as singular a solution as possible'.[2] Where *Dark Light* does resemble Meireles's other works – and it is a very strong resemblance, which runs through his entire oeuvre – is in its fascination with paradox. 'I am interested in this kind of inversion', he has stated, 'the paradoxical relationship between objects. I believe that even when I try to avoid it, things sometimes make themselves quite explicit to me through paradox, through the relationship between thesis and antithesis. I am forever trying to look for this hypothetical synthesis.'[3] Therefore, 'dark light' may be taken as a synthesising metaphor for the spirit in which Meireles investigates things in general.

He is seen as one of the key instigators of Conceptual art, now that Conceptualism has been acknowledged to have had points of origin all over the globe. But the label is inadequate to describe the combination of abstract thought and direct physical experience in his extraordinarily diverse body of works. A deep interest in the relationship between the sensorial and the cerebral, the body and the mind, is now seen as one of the defining characteristics of the post-war Brazilian avant-garde, out of which Meireles emerged with his early works at the end of the 1960s. 'In Brazilian conceptual art, so linked to sensuality, the limits of the body and pleasure', he puts it, 'it is impossible not to think of seduction; there are also, however, political aspects which are rare in art from other parts of the world'.[4] He has remained loyal to these origins, and to a political/ethical viewpoint formed outside the 'cultures of plenty'. At the same time, he has become a global artist, responding in his work to different contexts and dealing with issues that affect us all.

Visitors to the exhibition will immediately realise that the works on show range immensely in size and diversity of materials – at its greatest extreme, from an object in the form of a finger-ring to an installation covering 225 square metres. And it may happen that a tiny object provokes the sensation of a vast space, while a big environment feels obsessively delimited. Such contradictory sensations often incorporate or lead on to one another. We also realise that some exhibits, for example *Insertions into Ideological Circuits* 1970 (p.62–7), do not constitute the work itself but are relics or samples of an

1 Cildo Meireles, interviewed by Felipe Scovino (2007). The interview, specially commissioned for this catalogue, forms the basis for Meireles's recollections of the origins of his individual works, quoted in each catalogue section.

2 Cildo Meireles, interview with Gerardo Mosquera, in Paulo Herkenhoff, Gerardo Mosquera, Dan Cameron, *Cildo Meireles*, London, Phaidon Press, 1999, p.27.

3 Quoted in Scovino (see note 1).

4 Herkenhoff 1999, p.28.

event that took place outside the art milieu, in society in general, works whose limits are unknown.

This exhibition brings together more of Meireles's large installations than any previous one. If architecture permits, the museum space can be opened out to accommodate these works without divisions, following the artist's belief that each installation 'defines its own space'. Some are completely open to the neutral circulation space, some partially veiled, and others concealed and secret. The way of entering and leaving each work is different. All make a startling first impression, a complete and unique scenario, which gradually reveals the workings of a perceptual/philosophical/ethical proposition, a modern allegory rooted in the material world.

Certain themes run through this varied body of works, appearing in very different physical guises, and criss-crossing with other themes. A striking feature of Meireles's works is the way in which they are dated, often with a span of several years. This may represent the birth of an idea followed by the date of its realisation, a gap sometimes denoting a wait for sufficient resources to construct the piece, or sometimes it may refer to the maturing of an idea. A project like *Red Shift* 1967–84 (pp.120–31), might mature for as long as seventeen years. There are some preoccupations that remain constant and universal. His entire oeuvre could be described, for example, as a 'poetic of physics'. The cosmos, how it may be known or imagined, is a persistent reference, though not necessarily an explicit one. And then there are contingent demands, such as the necessity

that Brazilian artists felt in the 1970s to resist or counter the abuse of democratic and human rights, and individual freedom, perpetrated by the military dictatorship (1964–85). In Meireles's case, this was part of a wider concern with Brazilian history and predicament: 'Political and social events steamrollered us.'[5] These two responses to the world are completely intertwined in Meireles's art. For this reason, it was decided to structure the exhibition catalogue differently from the norm. Instead of one or two long interpretive essays, there are short texts by nine writers, each taking an individual approach to the work. These are accompanied by Meireles's own commentaries on the origins of each project in the exhibition, usually grounded in some ife-experience or memory, often a childhood memory, whose story he tells.

Frederico Morais has described Meireles background:

He was born in Rio de Janeiro in 1948. His father was an Indianist who worked for the Indian Protection Service, having served on Marechal Rondon's original team. His uncle was a backwoodsman. The uncle's son, Apoena (named in honour of a Xevante chieftain) followed the same path. As a boy Cildo accompanied his family on their constant moves throughout the vast Brazilian territory, vicariously participating in the pioneering expeditions aimed at making contact with unknown tribes. He resided or spent seasons at Curitiba, Belém do Pará, Goiânia, Brasilia (1958–67) and Maranhão. In this unsettled, rough and active life, he learned things more by

5 Cildo Meireles, 'Places for Digressions' interview with Nuria Enguita, in Nuria Enguita and Bartomeu Marí, *Cildo Meireles*, exh. cat., IVAM Centre del Carme, Valencia 1995, p.163.

actually seeing and hearing them than by studying them in a schoolroom. He speaks of his father, whose name he inherited, with boundless affection and admiration. Many of his art works have been born as memories of his experiences at the side of his father, who loved books like a bibliomaniac. From him he received his first book on art – on Goya.[6]

Space physical and mental

Meireles has often cited 'spatial questions' as a fundamental concern of his work.[7] He not only sees space as a complex, having connotations that are 'physical, geometric, historical, psychological, topological and anthropological', but also treats and works with space as a reality inseparable from scale, an endlessly elastic phenomenon and source for the characteristic wit, intelligence and poetry of his art. Scale is space relative to ourselves as humans, suspended somewhere between the unimaginably vast and the unimaginably tiny.

Meireles began with two fields of operation: geometricised, Euclidean space, taking the form of full-size mock-ups of the corners of domestic rooms, as in *Virtual Spaces: Corners* 1967–8 (pp.20–3), and the outdoors – Brazil's immense territory. Actions undertaken in the outside world were brought to the exhibition space in the form of a box, or case, something portable. In *Geographical Mutations: Border Rio-São Paulo* 1969 (pp.46–7), an exchange of earth was made between two spots that were physically very close but separated by a mental construct.

Collages such as the *Physical Art* series of 1969 (pp.40–5) proposed fantastic, imagination-stretching interventions in Brazil's geography: for example, instructions for taking 1 cm of material from Brazil's highest mountain, Pico da Neblina in the north, and exchanging it with materials from the subterranean depths of Brazil: rubies, emeralds or diamonds. A further example of a paradoxical inversion. And in turn, a piquant borderline emerges between imagining and actually doing: 'Once I thought', the artist relates, 'about a project of a country so reduced that it could only be operated from abroad. It would be a minimum of terrain, a border only, where only one person, or not even that, could fit'.[8]

The fluctuating relationship between mental construct and sensory experience was put to the test, with the public's participation, in the environment *Eureka/Blindhotland* 1970–5 (pp.111–15). Many balls, visually identical, were discovered by the viewer, in the process of playing with them, picking them up, rolling them, etc., to vary greatly in weight (between 500 and 1,500 grams). A large variety of bodily responses and exertions were created within a visual constant. Meireles saw the work partly as an investigation of density ('what it is and what it seems to be'),[9] which he was concurrently exploring in a direct relationship to scale. If a political landscape had been condensed into a carrying case in *Geographical Mutations*, it was further condensed into a finger-ring, *Condensation II – Geographical Mutations: Border Rio/São Paulo* 1970 (pp.50–1), where tiny traces of soil are encased in white gold,

6 Frederico Morais, interview with Cildo Meireles, in *Cildo Meireles: Algum Desenho / Cildo Meireles: Some Drawings (1963–2005)*, exh. cat., Centro Cultural Banco do Brasil, Rio de Janeiro 2005, p.57.
7 Enguita and Marí 1995, p.164.
8 Cildo Meireles, in Paulo Herkenhoff (ed.), *Geografia do Brasil*, exh. cat., MAMAM (Recife), MAM-BA (Salvador) and ECCO (Brasília), Rio de Janeiro 2001, p.86.
9 Enguita and Marí 1995, p.165.

onyx, amethyst and sapphire. Or in *Condensation I – Desert* 1970 (p.50), one could wear the desert on one's finger in a pyramidical ring containing a viewing window and a single grain of sand. A further ring (*Condensation III – Ringbomb* 1970 [p.53]) introduced the notion of space as potentially explosive, an extraordinary concept that was to flourish in works like *Southern Cross* 1969–70 (pp.58–9), *The Sermon on the Mount: Fiat Lux* 1973–9 (pp.82–5) and *Volatile* 1980–94 (p.181). *Ringbomb* contained a capsule of gunpowder and a lens through which the sun's rays could potentially ignite it.

Meireles often mentions Marcel Duchamp as a primary inspiration, and with this talk of boxes and condensations it is natural to think of Duchamp's *Boîte-en-Valise* 1938. But whereas Duchamp understood miniaturisation as replica, a portable version of works already made, Meireles saw it as the possibility of creating new versions, invoking the poetics of the small but highly charged or precious artefact: a facet of energy, or density.

The tiny cube of oak and pinewood that constitutes *Southern Cross* is ideally exhibited without a plinth in a space of 200 square metres. 'I wanted it to be much smaller … but when I sanded it down to my nails, I lost patience and stopped at 9mm.'[10] If the cube was photographed with its surrounding space, it would be nearly invisible, so it has usually been pictured for catalogues resting on a finger tip (an image bearing an interesting resemblance to a simile recently used by a scientist to describe the huge pressures achieved by the experimental laser fusion generator, HiPER: 'equivalent to ten aircraft-carriers resting on your thumb'.[11] At the same time, *Southern Cross* is wittily conceived within the Minimalist scenario of abstract 'objecthood', and it is only when you learn that the rubbing together of oak and pine has been traditionally used by Brazilian indigenous tribes to kindle fire, that your whole experience of the installation changes. The material turns to the mental, a historical, mythological and cultural dimension opens up, and the metaphor of fire takes on implications, vis-à-vis the predicament of indigenous Brazil, of both destruction and of creative potential. This ambiguous state of something being 'simultaneously raw material and symbol' is fascinating for Meireles.[12]

Space as circulation

Around the turn of the 1970s, Meireles's thinking branched away from the specialised art space, and the cosmic space of nature, towards an idea of space as a circulatory network, and the object as travelling. It was a time of authoritarian oppression, with an atmosphere of censorship and fear increasingly pervading the public space and the media. A form of clandestinity was necessary, both to preserve individuality and the freedom to speak out on social matters, and to continue experimentation with the nature of the art object. Hence the *Insertions into Ideological Circuits*, which, although a response to the immediate situation and materially ephemeral, have since become possibly the best known and most discussed of Meireles's works. The Coca-Cola bottles imprinted with political messages (Coke

10 Scovino.
11 *Guardian*, London, 6 December 2007.
12 Scovino.

bottles in Brazil circulated on a deposit system in those days), or the banknotes stamped with an awkward question concerning the murder of a prominent opponent of the regime, made use of existing, self-propelling spatial systems in the economic sphere that were effectively uncensorable.

Value

'I like dealing with paradigmatic things', Meireles has said, 'material things that are recognised by the public in their everyday lives, things that are at the same time matter and symbol. Money, for example.'[13] From the blatant exhibition, on a pedestal, of a wad of banknotes secured with rubber bands, *Money Tree* 1969 (p.77), to the gold thread and gold nails inserted, respectively, into a great mass of straw in *Fio* (*Thread*) 1990–5 and plain wooden crates in *Ouro e Paus* (*Gold and Wood*) 1982–95, the conundrums of value have continued to fascinate Meireles. *Money Tree* 'points towards the problem of the value of the art object and the discrepancy between use-value and exchange-value'.[14] It consists of 100 one-Cruzeiro notes and was offered for sale for twenty times that amount. One wonders what it would fetch today; in inflationary Brazil at the time it was made, Meireles joked, money was the cheapest material.[15] Much later, for *Occasion* 2004 (p.176–9), the artist contrived a scenario in which the public would be faced by money in the most direct way. This ensured that our attention would be drawn away from speculative thoughts about the art object, and back to ourselves. We encountered a small, elegant, open receptacle containing new banknotes in the centre of a brightly lit room lined with three big mirrors on three of the walls, producing endless recession images. One of the mirrors was two-way. Viewers reacted in various different ways to the presence of the naked cash, and then, leaving the room and looking back through the two-way mirror, saw other people where they themselves had been a moment before, becoming voyeurs.

As a last clandestine fling, Meireles became an ironic counterfeiter, printing a large number of bills – *Zero Cruzeiro* 1974–8[16] and *Zero Dollar* 1978–84 (pp.79–81) – the latter with the help of the designer/engraver João Bosco Renaud. Reducing official value to zero, the subversive Cruzeiro notes are embellished with the portraits, not of some illustrious figure of the Brazilian pantheon, but of two individuals effectively excluded from Brazilian society, whose civil rights are minimal: a Kraô Indian on one face and the inmate of a mental asylum on the other (Meireles knew both these men).

En masse

One unmistakable characteristic of Meireles's art is the very large number of a particular element that he loves to deploy. In fact, it is a feature of almost all his major installations: 2,000 bones, 600,000 coins and 800 communion wafers in *Mission/Missions (How to Build Cathedrals)* 1987 (pp.99–101);

13 *Cildo Meireles: Algum Desenho/Cildo Meireles: Some Drawings* 2005, p.61.
14 Enguita and Marí 1995, p.165.
15 Ibid.
16 The cruzeiro was the then currency in Brazil.

126,000 matchboxes in *Fiat Lux*; 6,000 carpenters' rulers, 1,000 electric clocks and 500,000 numerals in *Fontes* 1992/2008 (pp.165–7); an indeterminate number of red objects in *Red Shift*; the anthology of different kinds of barrier that make up *Through* 1983–9 (pp.138–46); the many radios in *Babel* 2001; the open pages of innumerable blue books that recreate the sea in *Marulho* (*Murmur of the Sea*) 1992–7; the more than 200 balls pushing up the heavy mesh in *Glovetrotter* 1991 (pp.161–3). In general terms, such accumulations denote a teeming universe (the massed rulers of *Fontes*, for example, are structured as a double spiral, or, looked at from the side, as a projection of the Milky Way). They denote, too, the human masses and the density of history. But for Meireles, the phenomenon of number is riddled with paradox. You can go into a shop and buy a box of matches with no problem, but pack thousands of boxes together, as in *Fiat Lux*, and you have a potential bomb. You have broken the law. Yet this relationship between the one and the many is reversible. The poster announcing *Fiat Lux* depicted 400 razor blades compressed in a clamp: a single blade is dangerous but the conglomerate will not cut and is harmless. In a similar spirit of inversion, Meireles has pointed out how a big installation can be made for a single person (for example *Murmur of the Sea*), while a small object can be made for a huge audience (*Insertions*).

Such statements reveal the complex relationships that Meireles establishes with the public, involving bodies and minds in intricate, and occasionally disturbing, combinations. Sometimes an experience is overwhelmingly sensorial, and difficult to verbalise, as in the room full of red objects in *Red Shift*. We note that it is a collection of already red objects, not a coat of red paint over everything. The subtleties and wit in this work are compelling, yet the overall feeling is of monomania, which makes us realise how essential variety and diversity are to our lives. But things open up: in *Red Shift* we are taken from a domestic to a cosmic space.

Sometimes the warring sensations of illusion and reality are so acute – as when we see the candle-flame and smell the gas in the powder-strewn room of *Volatile* – that we are left to contemplate stark fear and its aftermath. In *3 Estudos* (*3 Studies*) 1969, the abstractions of space and time are given an intense corporality in our minds through a piece of paper stuck to the wall typed with a few simple words. One of these 'instructions', for example, reads: 'Go without drinking water for 12 hours and then drink half a litre from a small silver tumbler, very slowly.'[17]

Sound is an important element in many of Meireles's works. In *Eureka/Blindhotland* the tactile sensation of different densities is translated into sound, through a track that records the impact of the balls of different weights falling from different heights at different distances from the microphone, in a complex set of permutations. The magisterial tower of radios, *Babel*, is heard before it is seen. Or the public may produce the work's sound inadvertently – by walking over broken glass in the labyrinth of *Through*, or by the rasping of their shoes on the sandpaper floor around the stacks of

17 Enguita and Marí 1995, p.161.

matches of *Fiat Lux*, greatly augmenting the sense of potential catastrophe.

Eye and body

As Moacir dos Anjos writes, invoking one of Brazil's leading aesthetic thinkers, Ferreira Gullar, Meireles exercises a method of investigating the world that, 'instead of focussing only on the retinal field of perception, concentrates on a "synthesis between sensorial and mental relations", so that the senses and the reason stimulate each other to produce, together, the cognition of inhabited or merely conceived spaces'.[18] Nowhere in the exhibition is this summed up more elegantly, economically and paradoxically than in *Through*, one of Meireles greatest works, rarely seen because of its huge size.

Through is a penetrable maze of short, discrete sections of barriers, obstructions, fences, blinds, demarcations, limits. It is a work concerned with visuality, although it is neither a painting nor a sculpture. Can we see through? Can we go through? Can we reconcile the pleasure of visual interference – semi-transparency, veiling, variations of density – with prohibitions on our bodily movement? Is the eye's experience divisible from the body's? How do we move from the experience of the different screens and barriers as abstract, visual and plastic, to their social meaning? (They range from the neutral – netting – to the aggressive – barbed wire – and include barriers that indicate the complexity of social experience.) We see the sort of ropes used to fence off artworks in museums, or the lattice screens that in certain contexts can evoke gardens, in others the decor of cheap cafés (token barriers whose constraints we accept although we could very easily demolish them). The work is a tangle of such questions; questions that in a way are set by the overall form of the installation. *Through* poses the right-angled and perspectival 'order' of the arrangement of screens against the nucleic energy and chaotic form of a great ball of crumpled cellophane that lies at its centre.

The cellophane may be taken as one of Meireles's cosmic metaphors. The great ball is an indication of infinity, which is found at the heart of all these devices of limitation. Are we relieved of the social minutiae of each different barrier by the transparent abstraction we discover at the centre? Or are we reminded of the human need constantly to frame and contain experience in order to be able to live in the ferocious universe?

If earlier artists pursued energy, contemplated space-time, in a spirit of clearing away, starting from zero, from a *tabula rasa*, Meireles presents such a search as enmeshed in culture, as inescapably mediated. Hence the components of his labyrinth, made from mass-produced utilitarian items designed to satisfy a multitude of consumer needs, foibles, fears and preferences. Yet *Through* goes beyond these givens (a process already implicit in its title) towards those unlimited spaces and yearnings latent in the abstract.

These two forces or conditions – the contingent and the infinite – are continuously in contention in the work of Meireles, always re-appearing in new

18 See Moacir dos Anjos's essay in this catalogue, 'Where all places are' (p.170). His reference is to Ferreira Gullar's influential essay 'Teoria do Não-Objeto' (Theory of the Non-Object), *Jornal do Brasil*, 21 November/20 December 1960.

guises quite different from what we have seen before. He continues to be 'forever looking' for the 'hypothetical synthesis' mentioned at the start of this introduction. It is not a doom-laden scenario, but a fascinating process of investigation leavened by modesty and humour. While not wanting to be chauvinistic, in the wider context Cildo Meireles has spoken of a 'model of social harmony [that] runs throughout Brazilian culture, despite its historical social and political upheaval'. He refers back to the highly influential metaphor of *antropofagia* (cannibalism) proposed in the 1920s by the poet Oswald de Andrade – the idea that Brazil critically digests the universal cultural heritage – calling it 'a positive contribution that Brazilian culture can make to the possibility of co-existing with difference'.

Cildo Meireles

Work biographies

Cildo Meireles has generously provided an account
in his own words of the origins of every work or
series in the catalogue. Unless otherwise indicated
his statements are taken from interviews with Felipe
Scovino, specially commissioned for this publication
and recorded in Rio de Janeiro in August and
September 2007. Other sources of the artist's
statements are shown by symbols as follows:

¤ Interview with Nuria Enguita, in Nuria Enguita
 and Bartomeu Marí, *Cildo Meireles*, exh. cat.,
 IVAM Centre del Carme, Valencia 1995.

Ø Interview with Gerardo Mosquera, in Paulo
 Herkenhoff, Gerardo Mosquera, Dan Cameron,
 Cildo Meireles, London, Phaidon Press, 1999.

\# Interviews in Paulo Herkenhoff and Ileana
 Pradilla, *Cildo Meireles: Geografia do Brasil*,
 Rio de Janeiro 2002.

‡ Interview with Hans-Ulrich Obrist, *Cildo Meireles*,
 exh. cat., Musée d'Art Moderne et Contemporain,
 Strasbourg 2003.

¶ Interview with Hans-Michael Herzog, *Seduções:*
 Valeska Soares, Cildo Meireles, Ernesto Neto,
 exh. cat., Daros Foundation, Zurich 2006.

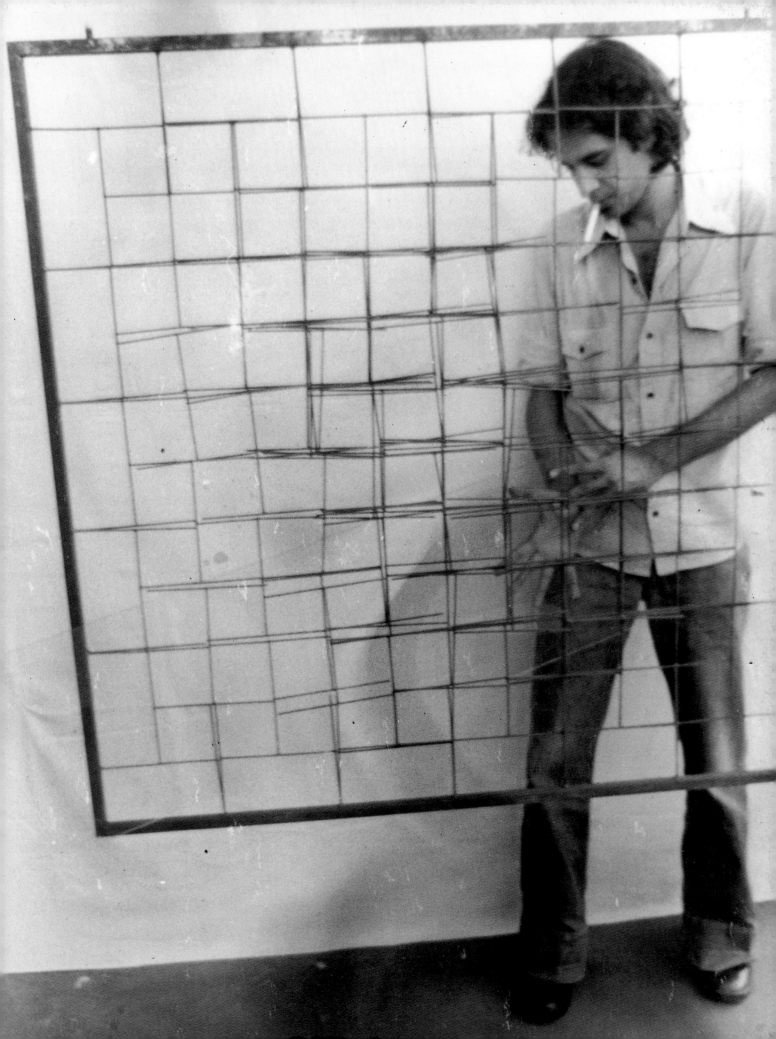

Canto II
Corner II
1967–8/81
Wood, canvas, paint,
woodblock flooring
305 × 100 × 100

Espaços Virtuais: Cantos, 1967–8
Virtual Spaces: Corners

" In 1967 I began a series of works based on Euclidean principles of space, which included *Virtual Spaces: Corners*; *Virtual Volumes* and *Occupations*. *Virtual Spaces: Corners* used three planes to define a figure in space. Looking for a way of making this abstract idea more concrete, I decided to show it through a model reconstruction of the corners in a typical domestic room. ⌀

Two specific things explain how this work came about. The first is an episode that took place when I was eight years old, at my grandmother Otília's home in Goiânia. I was a very active child, the first to get up

and the last to go to sleep. I never went to bed right after dinner. But one day, after lunch, I decided to take a nap. I lay down in bed and suddenly, when I wanted to get up, I couldn't. I found that strange. I tried to make another movement but … nothing. I could hear sounds coming from the yard and from the kitchen – voices near, far, the rooster, yet I was unable to move or make a sound. While I was in this state, a face began to materialise in the corner. I saw a woman with painted fingernails; she was laughing as she came out of the corner. She seemed very old, heavily made up and roaring with laughter. She walked in my direction, came to the foot of the bed, levitated, and leaned towards me. I began to say all the prayers I could think of but

they weren't working. I remember when I recited the 'Hail, holy Queen', the old woman started to move away slowly, still laughing. I only regained control of my movements when she disappeared back into the corner.

The other situation occurred in 1967, in the men's room of a bar in Rio de Janeiro's Laranjeiras quarter. There was a urinal in one corner [that coincidentally resembled] the R. Mutt *Fountain* by Marcel Duchamp. The place was dark but a light coming through the ventilation flap above the door projected my shadow across the urinal in the corner. "

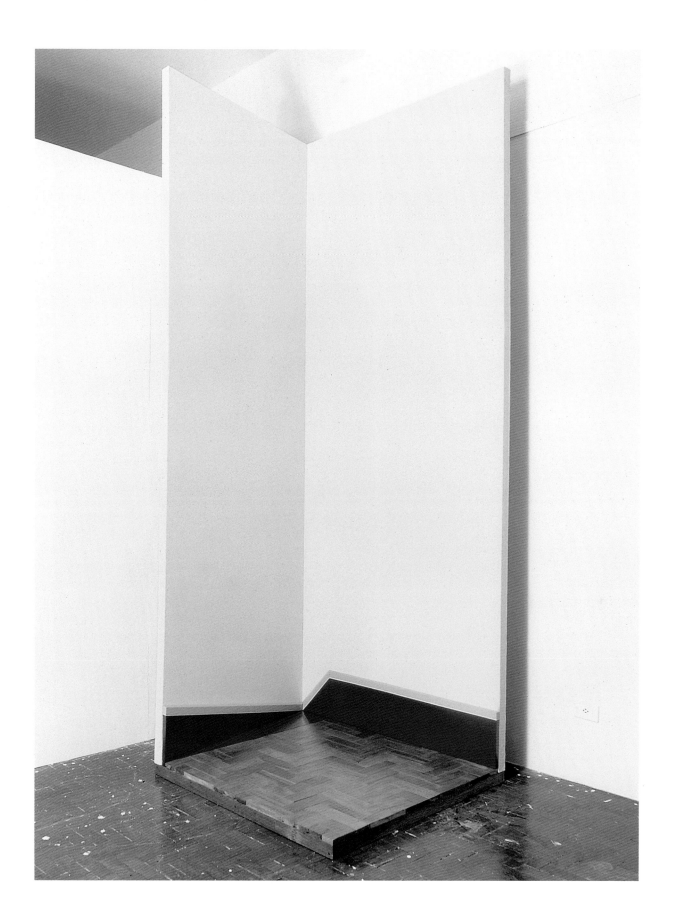

Espaços Virtuais: Cantos
Virtual Spaces: Corners
1968
Ink and graphite on millimetre
graph paper
32 × 23

Espaços Virtuais: Cantos
Virtual Spaces: Corners
1968
Ink and graphite on millimetre
graph paper
32 × 23

Canto IV
Corner IV
1967–8/74
Wood, canvas, paint,
woodblock flooring
305 × 100 × 100

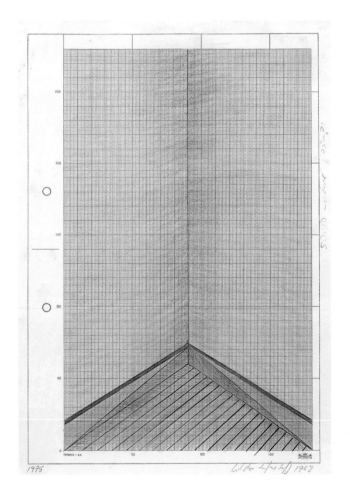

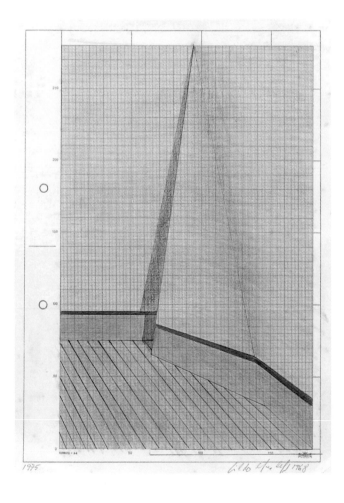

1975

1975

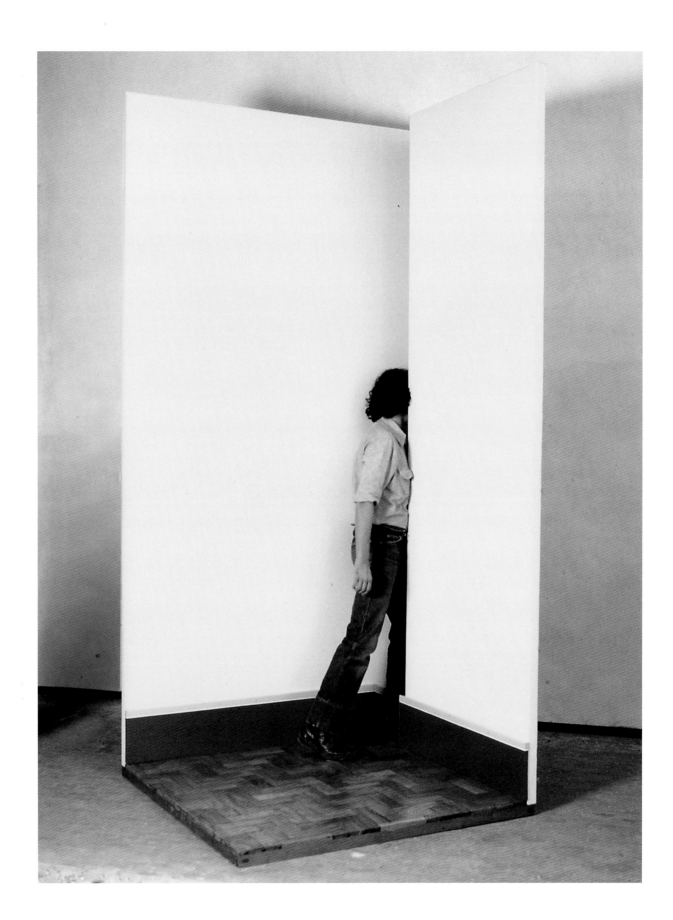

Volume Virtuais
Virtual Volumes
1968–9
Graphite on millimetre graph paper
28.8 × 39.3

Volumes Virtuais, 1968–9

Virtual Volumes

" In 1968, after the *Virtual Spaces,* I began
to make pieces with string; they were also
edges of spatial situations. I wanted to
paint shadow. I called it *Virtual Volumes.*
They came from an experience that was
graphic, but they were already implicit
in the *Corners* – some of them deal with
the same problems that were in the
Virtual Spaces. "

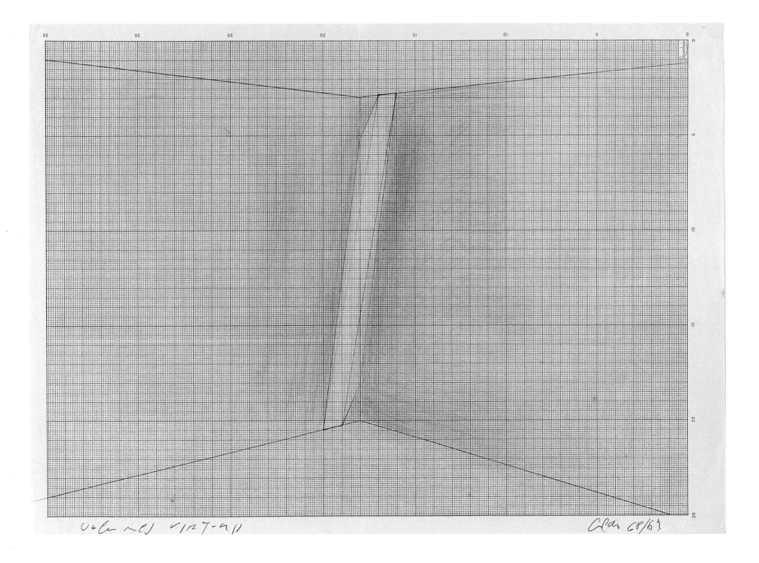

Volume Virtuais
Virtual Volumes
1968–9
Graphite on millimetre graph paper
28.8 × 39.3

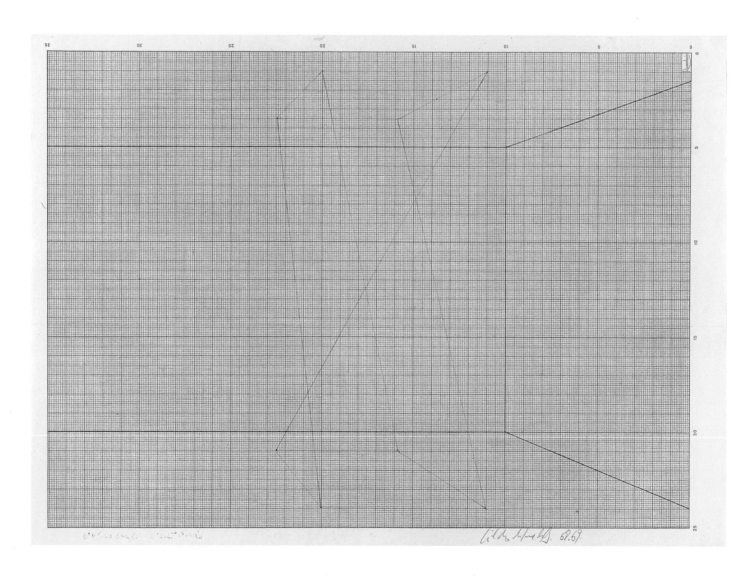

Volume Virtuais
Virtual Volumes
1968–9
Graphite on millimetre graph paper
28.8 × 39.3

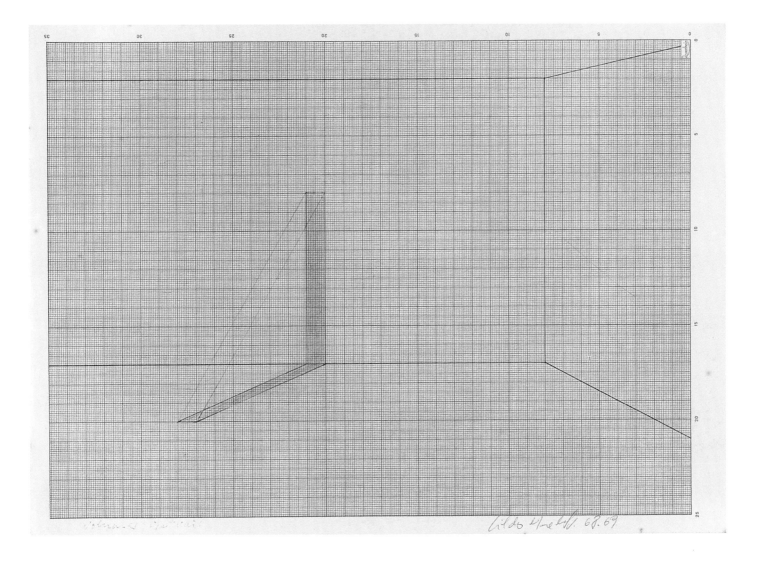

Ocupações
Occupations
1968–9
Chinese ink and graphite
on millimetre graph paper
32 × 47.7

Ocupações, 1968–9
Occupations

❝ *Occupations* was meant to be a unique work in a room. Each was to have been a single canvas (a panel, in fact) that would occupy a gallery space. As the name says, they are a way of occupying, an almost violent taking possession of space. In literal terms, the existence of the work will always presuppose the absence of the spectator in that spot.

They were not actually carried out until 2004. From a spatial reference point I used the main hall of the Petite Galerie in Rio de Janeiro. The project works with one, two or three large planes dividing up a space. The idea is to have a single surface (canvas) occupying the entire exhibition hall. *Occupations* was an attempt to create a strong perceptual relationship between the spectator and the physical element dividing up the environment. # ❞

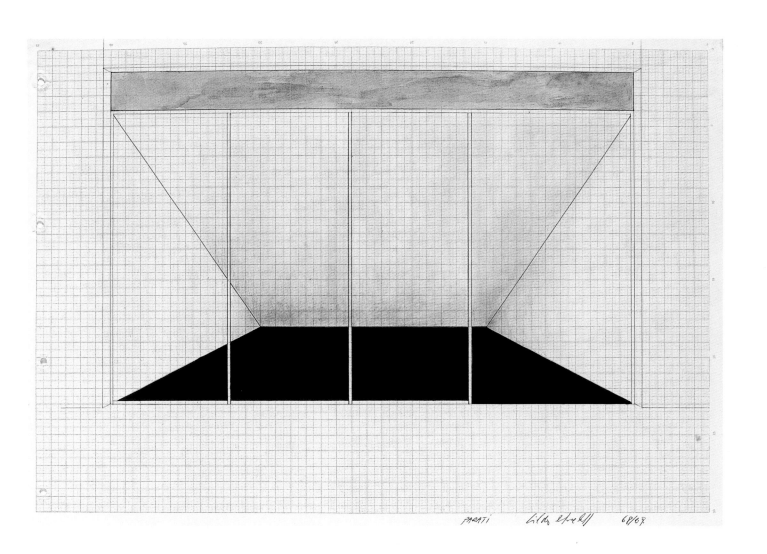

PARATI Lili Dujourie 68/69

Ocupações
Occupations
1968–9
Chinese ink and graphite
on millimetre graph paper
32 × 47.7

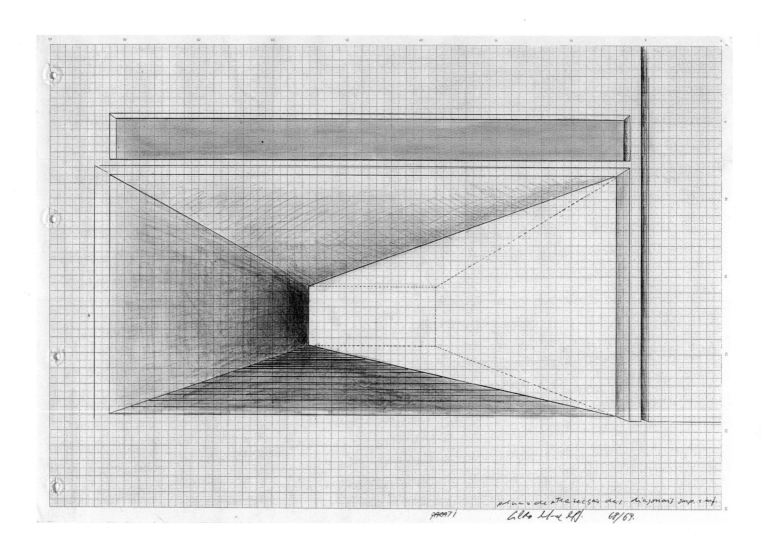

Ocupações
Occupations
1968–9
Chinese ink and graphite on
millimetre graph paper
32 × 47.7

Ocupações (overleaf)
Occupations
1968–9
Chinese ink and graphite on
millimetre graph paper
32 × 47.7

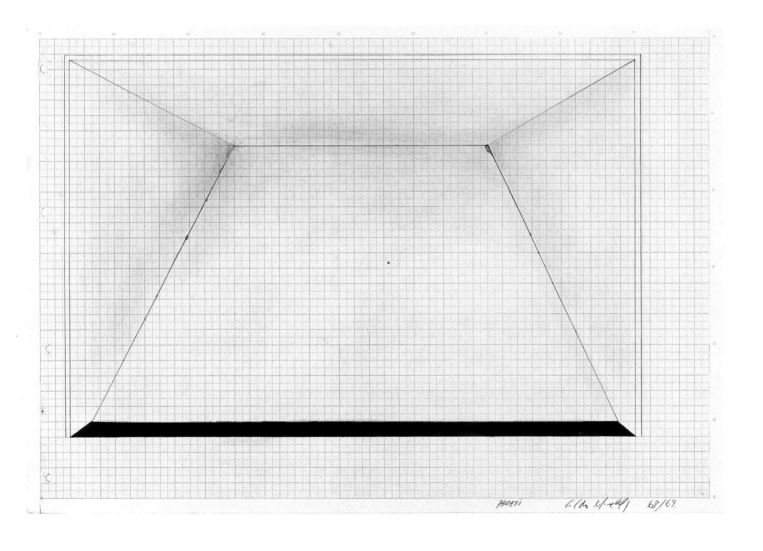

31

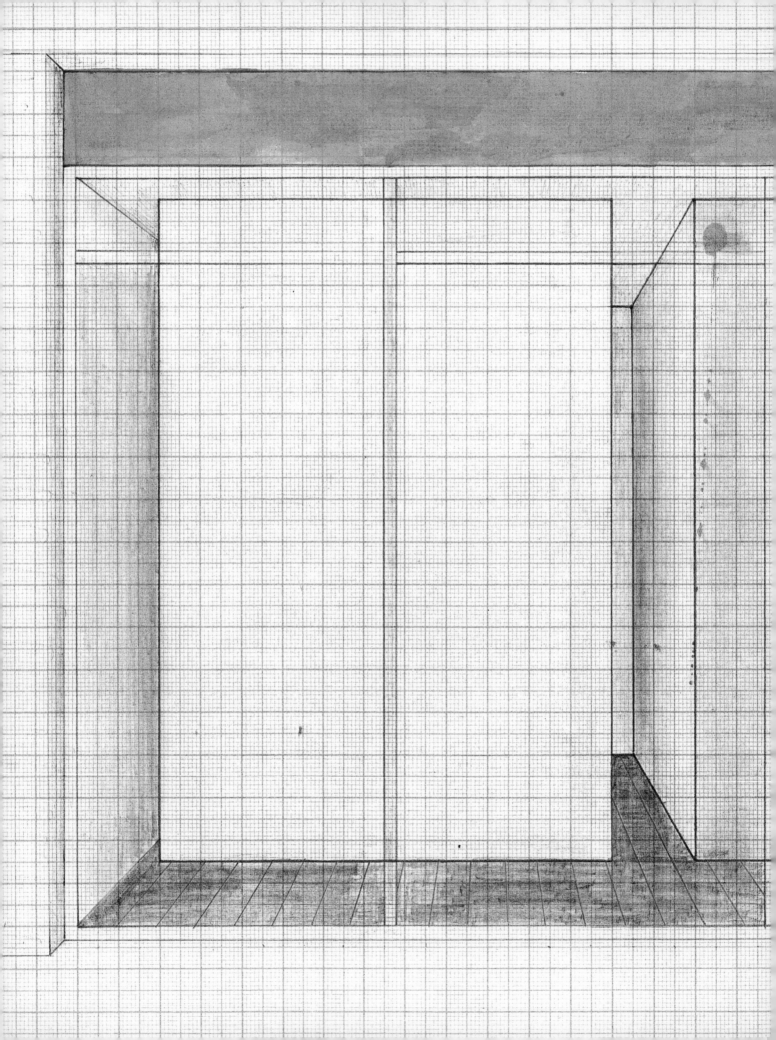

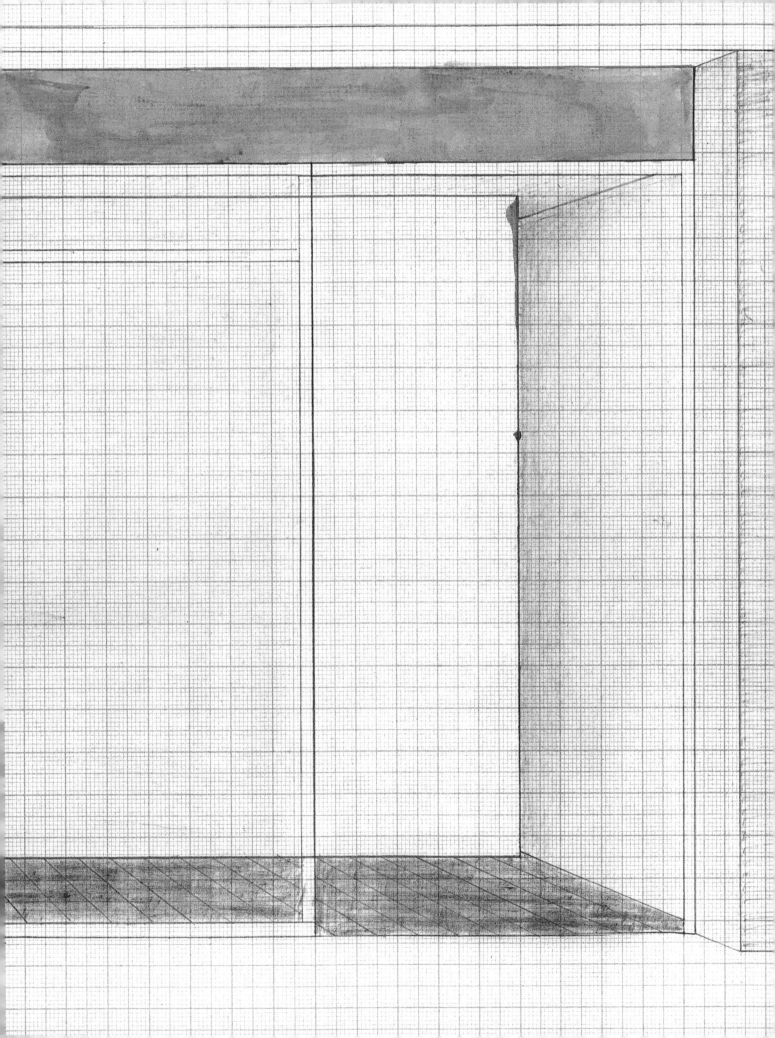

Ocupações
Occupations
1968–9
Chinese ink and graphite on
millimetre graph paper
32 × 47.7

Ocupaçõe I
Occupation I
1968–9/2004
Canvas and wood
300 × 500 × 400

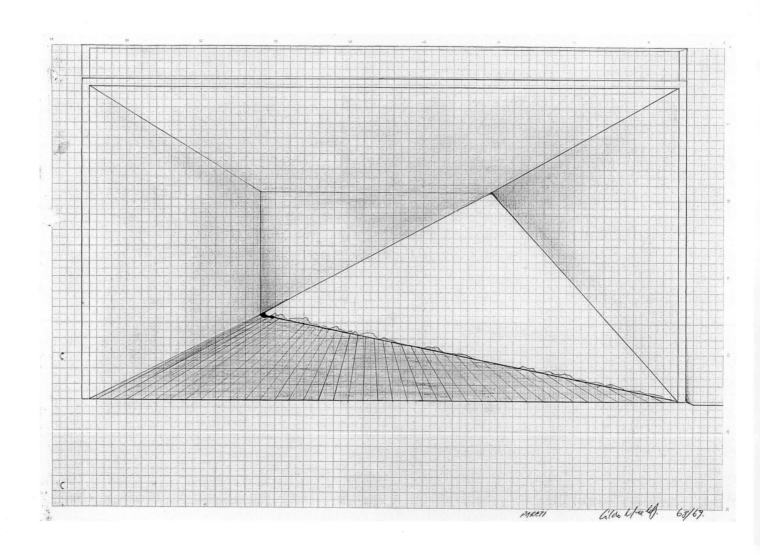

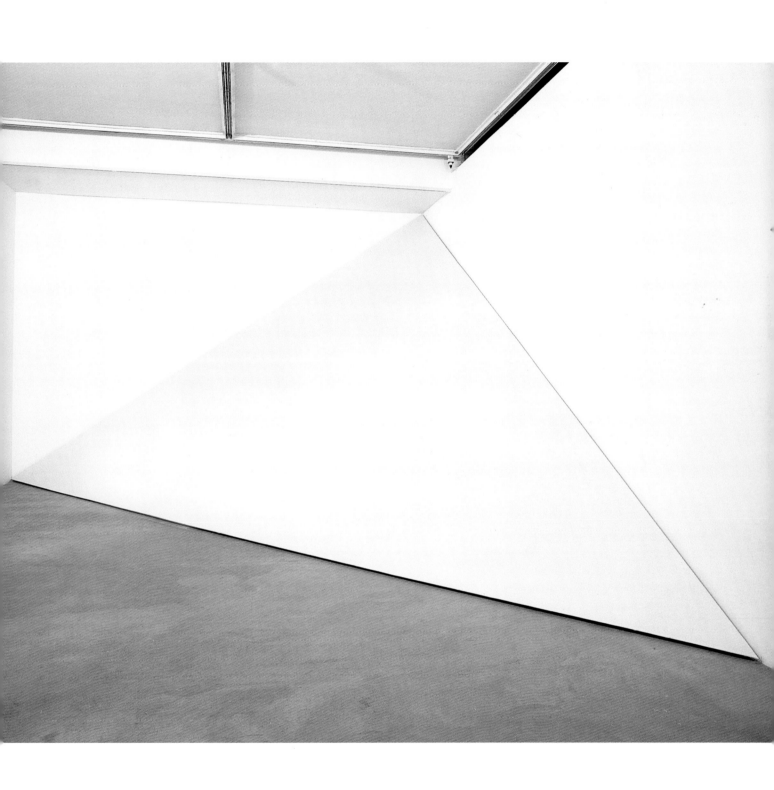

To be curved with the eyes

Cildo Meireles once told me a story about his old teacher Félix Alejandro Barrenechea Avílez, whose student he had been from 1963 to 1965 in Brasília. Avílez had moved to New York after receiving a scholarship and very little was heard from him for many years. When, in 1999, Meireles went to New York for his exhibition at the New Museum of Contemporary Art, he was eager to get in touch with his old teacher. He found the telephone number and they agreed to meet in front of a large bookstore. Meireles was a little surprised by this meeting place, but went there at the agreed time. When he arrived, he found Avílez selling his paintings out on the street. He was happy and full of energy and totally content with his street-level life as an artist. Meireles said that this was the last, important lesson that his teacher gave to him.

The story is echoed in Meireles's first memory of an artistic experience, which took place when he seven or eight years old. He was spending some time at his mother's house out in the countryside. One afternoon, he saw a man walk by among the bushes and the trees, a man who was 'strange-looking, with ragged clothes'. During the night, he noticed that the man had made a fire on the beach. The next morning, he went to look for him:

He had already gone, but what I found in the place where he had been was perhaps the most decisive influence on the path I have followed in my life. During the night he had built a little shelter, a miniature house made of small branches; a perfect house with windows that opened, and doors – I was really thrilled by it. It made a great impact: it showed me the possibility of making things and leaving them for others.[1]

Meireles is a story-teller. His art tells tales about us, our lives, the ways we live together in the world. They are concerned with you and me, with us and them, and how we share our common space and time.

In the period 1970–5, Meireles's art was actively directed against the repressive and cruel politics of the military junta in Brazil. But today, we know better than ever that the banality of cruelty is no local issue. These works share the quality of wishing to go beyond the metaphor in order to participate in real-life processes. Through the years, Meireles's interest has been directed more towards what could be called the 'amnesia' that exists at the centre of our information age. It could be seen as a kind of ghetto-phenomenon, where information is becoming too dense, as Meireles has described it. He is shooting arrows at the common unconsciousness that makes us float on the surface of life and prevents us from seeing the complexity and sad truth of the situation. His means of expression have become more and more universally applicable and comprehensible. They are at the same time local and global, timely and untimely, and their target is a sense of common-ality, the beauty and pain of being a human being

1 Cildo Meireles, 'Places for Digressions' interview with Nuria Enguita, in Nuria Enguita and Bartomeu Marí, *Cildo Meireles*, exh. cat., IVAM Centre del Carme, Valencia 1995, p.160.

both at this specific time, and in the continuum of memories and history. How can we as individuals and as societies ensure that life and history will continue?

Immersed in all Meireles's works is a deeply felt motivation to create spaces of freedom. It is very much a philosophical approach, when philosophy is understood as free and critical thinking. He shuns existing political rhetoric and programmes, leading us instead to a situation, a space, where our own ethical judgment and its consequences are challenged. He leaves us at the border zone of painful awareness of impending danger and our responsibility to decide what to do about it. This is a new kind of political awareness that has come to be understood only recently as a consequence of the deep crisis in democracy through which we are living.

The British philosopher Simon Critchley has made an analysis of the situation against the background of both the religious and political disappointment that we are experiencing in today's world. Neither is any longer able to give real meaning to our lives. He sees the need for a new kind of ethics as the solution to enable us to go further: 'If we are going to stand a chance of constructing an ethics that empowers subjects to political action, a motivating ethics, we require some sort of answer to what I see as the basic question of morality.'[2]

One of the strategies that Critchley recommends in dealing with this 'tragic fate' is humour. In this highly explosive field of ethics and morals, it is a fresh alternative to the tragic-heroic model that we know from earlier philosophy. According to Critchley, we should acknowledge 'a notion of *originary inauthenticity* at the core of subjective experience which opens in relation to the facticity of an ethical demand that I cannot fully comprehend and to which I am not adequate.'[3] This calls for a method of sublimation that does not belong to 'the tragic-heroic paradigm'. Humour seems to be able to alleviate the suffering and absurdity of the situation. 'In the absence of Aristotelian happiness, in a world where happiness has been reduced to the maximum satisfaction of transient inclinations, it is in practices like humour that we find an experience of non-delusory, non-desultory and non-heroic sublimation.'[4]

It is easy to recognise in Meireles's work and thinking this kind of humorous, non-heroic attitude based on shared responsibility and equal participation. He always refers to ordinary, real-life situations, where small decisions are made.

Space is an integral part of his visual grammar. His interest in this phenomenon is 'in the physical, geometric, historical, psychological, topological and anthropological sense of the word'.[5] For spectators, these spaces in Meireles's works are more like gardens grown and attuned to enable us to enter an invisible space in our minds where the drama is taking place. The key, the visual clef, to these spaces is his work *To be Curved with the Eyes* 1970 (p.105). The work is a wooden box containing two iron bars,

2 Simon Critchley, *Infinitely Demanding: Ethics of Commitment, Politics of Resistance*, London and New York, Verso, 2007, p.7.
3 Ibid., p.78.
4 Ibid., p.82.
5 Enguita and Marí, p.168.

one of which is curved while the other is straight. Revealingly, he has stated that this work should be shown in all his exhibitions. It proposes, playfully, that the gaze exerts a physical force, but also that we actually create the meaning of an art work in our minds.

The political aspect of Meireles's work is created in an antagonistic moment when our awareness of the long-term consequences of our decisions collides with the real or imagined needs of the present moment. The stage is set for us to make a decision between the two. We have been brought to the border of order and chaos. What is characteristic in Meireles's way of treating and presenting this classical theme is the way in which he upholds a balance between the two. He doesn't create scenes of horror and catastrophe. He presents scenes of formal beauty, paying attention to millimeters in measurement and seconds in timing. He seems truly to enjoy the beauty of things and moments, while also being aware of the deceptiveness of what we see and sense. His works seduce us into a new understanding and responsibility. They are built of paradoxes and references to what could be defined as a Shakespearean idea of our blindness to how things really are, as opposed to how they seem. The road to insight is paved with alluring beauty and alleviating humour, the wonders of which we are invited to share with the artist. It is left to us to give ourselves the time to follow and re-weave the stories based on sensory experiences, references to art, science, history, fable and myth. And paradoxically, to do so we must curve our eyes back from the space of art to the space of real life and our place within it.

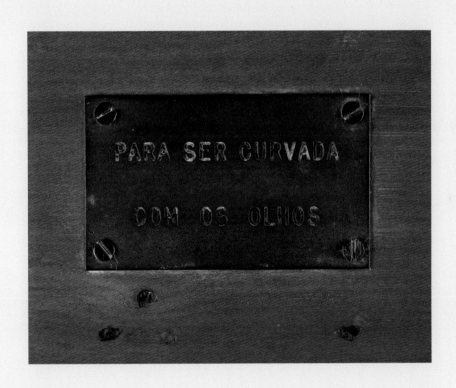

Arte Física, 1969
Physical Art

Arte Física
Physical Art
1969
Ink, graphite and collage on
millimetre graph paper
32 × 45

[Physical Art: Ropes: Horizon line.
Lay a rope along the summits of
mountains that contour our field of
vision, or at the extremity of deserts,
open spaces, expanses, in a way that
will match the horizon line.]

" The *Physical Art* series consists of a number
of projects, most of them never realised.
In 1969 I undertook *Cords/30km Extended
Line* and *Brasília Boxes/Clearing*. These
works are an attempt at reducing some-
thing to its abstraction.

I particularly like one project that was
never realised, which would have used
cords to demarcate different kinds of area,
like street protests, carnival groups, etc.
The work was of a scale that attracted me,
not too big for you to be able to see where
you were. Its existence depended on its
physicality, its location in space. "

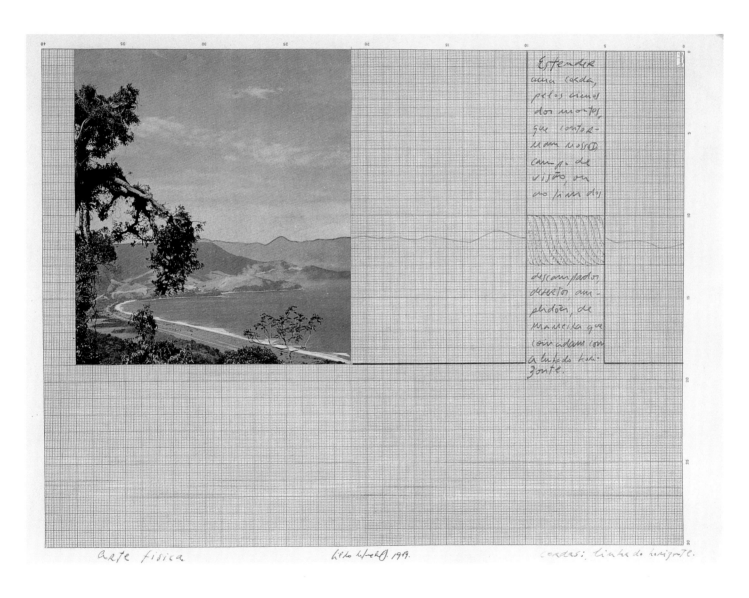

arte física lello helen 1979. cordas: linha do horizonte.

Arte Física
Physical Art
1969
Ink, graphite and collage on
millimetre graph paper
32 × 45

[Physical Art: Marks:
Tordesilhas. Brazil.]

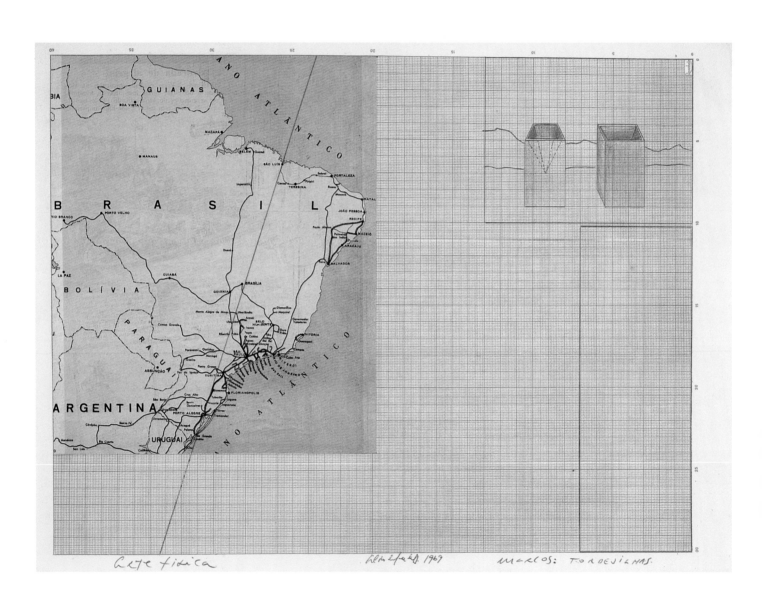

Arte Física
Physical Art
1969
Ink, graphite and collage on
millimetre graph paper
32 × 45

[Physical Art: Ropes: Areas (solitudes).
Location on the South Coast, where
I spent 4 days in 1969. Memory.
Ropes; Area (Loneliness, Past).]

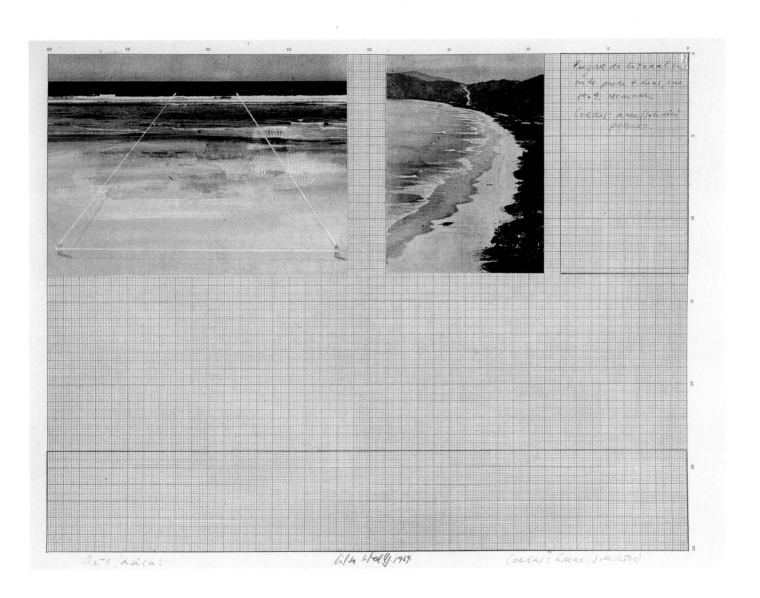

Arte Física
Physical Art
1969
Ink, graphite and collage on
millimetre graph paper
32 × 45

[Physical Art: Geographical
Mutations: Vertical frontier.
1 – From the summit of Pico da
Neblina take away more or less
1 cm of material.

2 – In its place plant a gem/gold
(rubies, emeralds or diamonds).
Something from the depths of Brazil.
Geographical Mutations: Cloud 1979,
1998.]

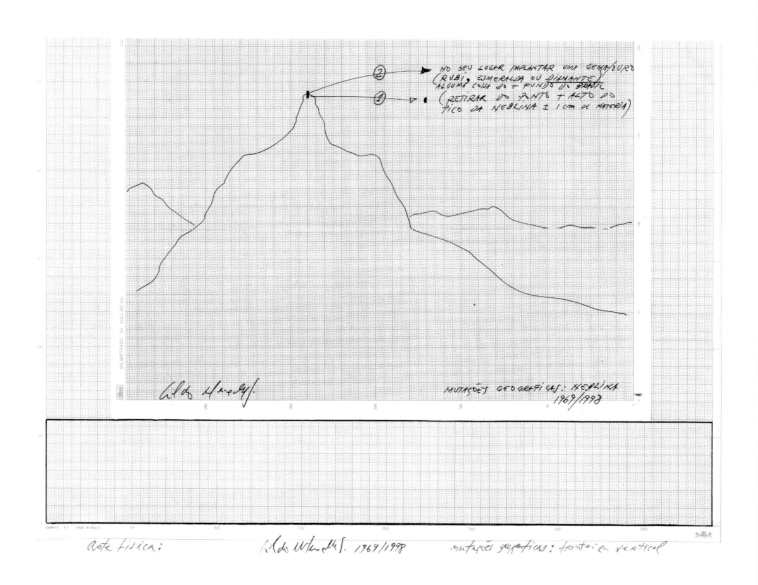

Arte Física
Physical Art
1969
Ink, graphite and collage on
millimetre graph paper
32 × 45

[Physical Art: Action: Cravan Project.
At the North Pole, when totally
melted, sail in a small canoe, paddling
in the direction of the Earth's rotation,
to become a bit younger. West/East]

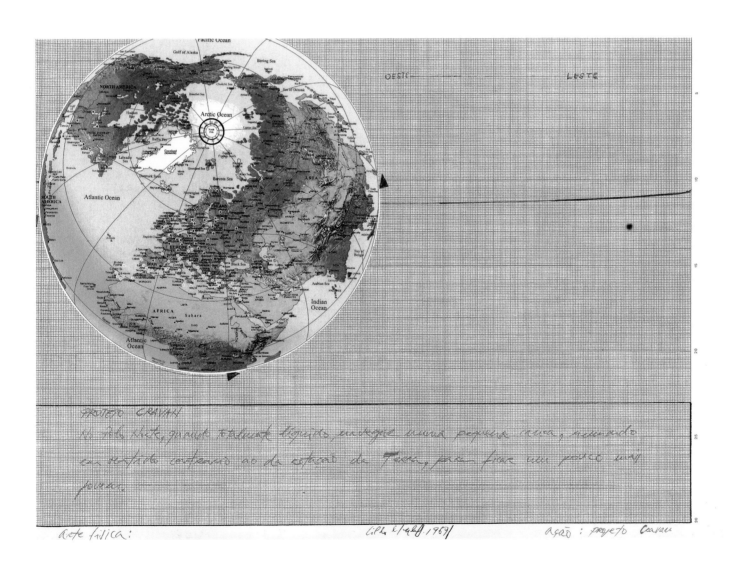

Arte Física, 1969
Physical Art

Mutações Geográficas, 1969
Geographical Mutations

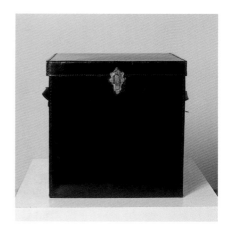

❝ The *Geographical Mutations* series ends up being a confrontation between man and territory, the relationship that constitutes this country or state. I had the idea of altering a series of extreme points; those were the *Geographical Mutations* projects.

The *Border Rio-São Paulo* is a work of *Physical Art* and *Geographical Mutations*. It was made at the border between the counties of Paraty in the state of Rio de Janeiro and Cunha in the state of São Paulo. I dug a hole on each side of the border, and placed the earth on either side of the compartmented box, which each had a smaller compartment to hold a sample from the opposite side. I made a first box, but we were in the mountains where it was damp. It had rained so much that the leather, which had not been tanned, rotted away in months. I made the definitive box in late 1969. ❞

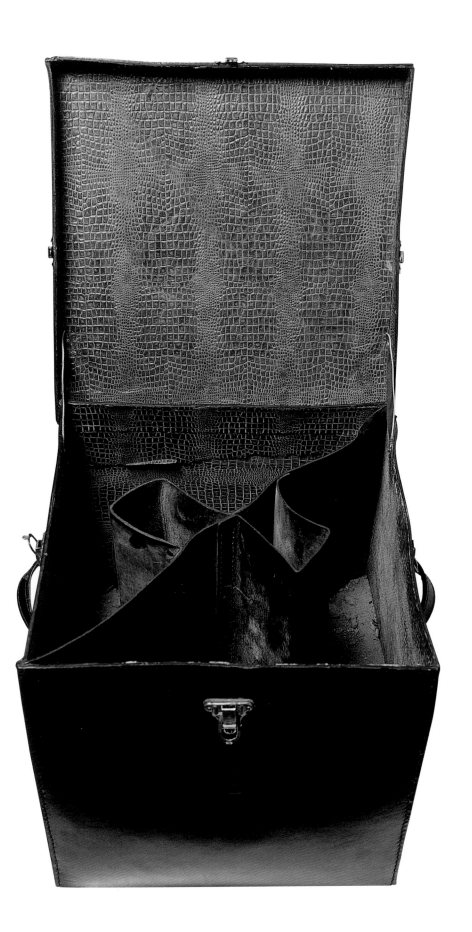

Arte Física: Cordões/30km de Linha Estendidos
Physical Art: Cords/30km Extended Line
1969
Industrial cord, map, wooden box
Closed 60 × 40 × 8

Arte Física: Caixas de Brasília/Clareira
Physical Art: Brasília Boxes/Clearing
1969
Sequence of photographs and maps; three boxes of earth
Photographs 60 × 90
Map 60 × 80
Each box 30 × 30 × 30

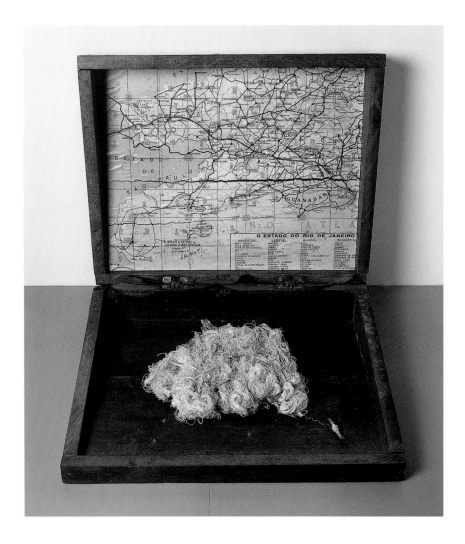

" In July of that year, I made the Brasília box, which consisted of three containers; they were three 30 cm cubes made out of Duratex and wood corners. This work initially consisted of establishing an area that was then outlined by four stakes and cord, which already belonged to the *Physical Art: Cords* series. All the vegetation from this delimited area was cleared, collected and incinerated. I put the ashes from the fire – which created the clearing – into one box with some of the earth from a hole we had dug to bury the box. The box was then closed and buried in the hole. The two remaining boxes contain residues of earth, cord, the stakes that were used and ashes and coal. The final work consisted of those two boxes, their contents, and a panel with a photographic sequence of the actions. There is also a map with the location – a map of Brasília in which I point out where the action took place and the place where the box was buried – in addition to the third box proper, which remained at the site. I never went back to see if the box was still buried there. "

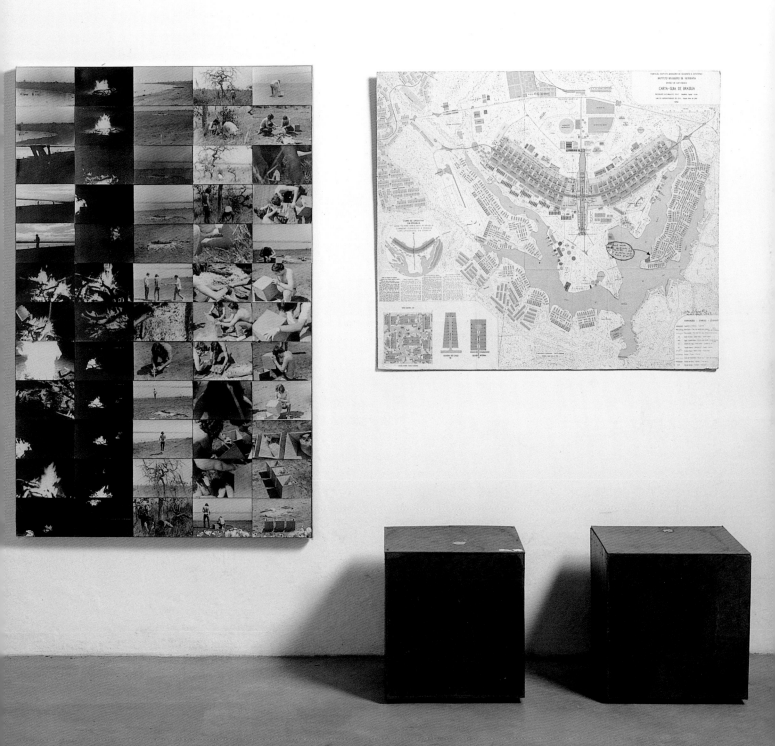

Condensado I – Deserto
Condensation I – Desert
1970
Yellow gold, white sapphire,
one grain of sand
2 × 2 × 2

Condensado II – Mutações
Geográficas: Fronteira Rio/São Paulo
Condensations II – Geographical
Mutations: Border Rio/São Paulo
1970
Soil, white gold, onyx,
amethyst, sapphire
2.2 × 2 × 2

Condensados, 1970
Condensations

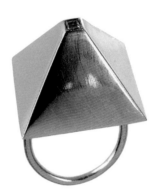
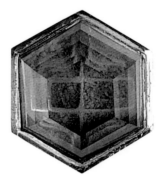

" Condensations are miniatures of works already done/made – the *Geographical Mutations.*

The *Rio-São Paulo Condensation* finger ring has the same design as the Geographical Mutations box. In contains earth from both states; however, the base is hexagonal instead of square. It also contains onyx, sapphire and amethyst, which represent the São Paulo and Rio de Janeiro state flag colours.

The idea of *Desert* was once again the problem of scale, which is a general problem in the *Condensation* [series]. The sense being that, each time you see it, it would evoke the desert: you have the pyramid, that yellowness, and that grain of sand, based on which you could construct a sort of pocket desert. That was the allegory. The (single) grain of sand in the uppermost section of the ring will always signify the 'root' of the desert.

Bombanel was made in 1996, for the *Pequenas coisas* [*Small Things*] exhibition I did with Claudia Saldanha at the Espaço Cultural Sérgio Porto (Rio de Janeiro). It resembles a miniature oil barrel. The piece of glass on top is a lens that converges, seeking a given point, a focal distance. A second part is made of glass. The third part (the bottom of the barrel) contains compressed gunpowder! So it's like that game where you get a lens, a piece of glass and put it in the sun, get the newspaper and burn it. Therefore, the focal distance of this lens is on the surface of the gunpowder; if you wear this ring in the sun, it will explode. *"*

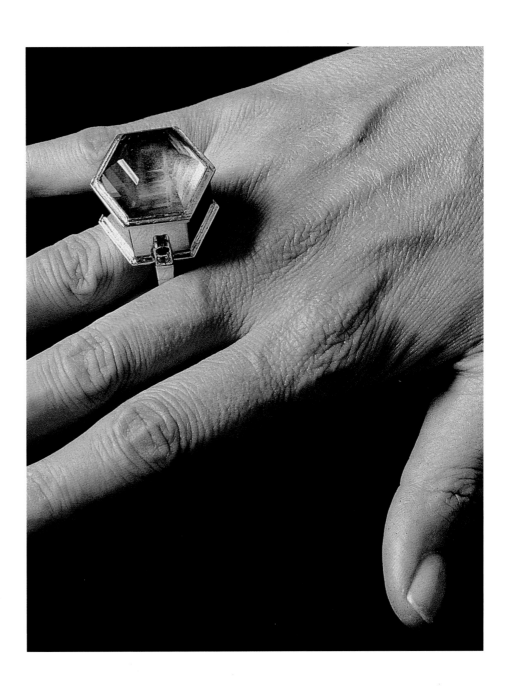

Drawing for Condensado III –
Bombanel (detail)
Drawing for Condensation III –
Ringbomb
1970/96
Chinese ink on graph paper
21.4 × 29.7

Condensado III – Bombanel
Condensation III – Ringbomb
1996
White gold, magnifying glass,
glass and gunpowder
3 × 2

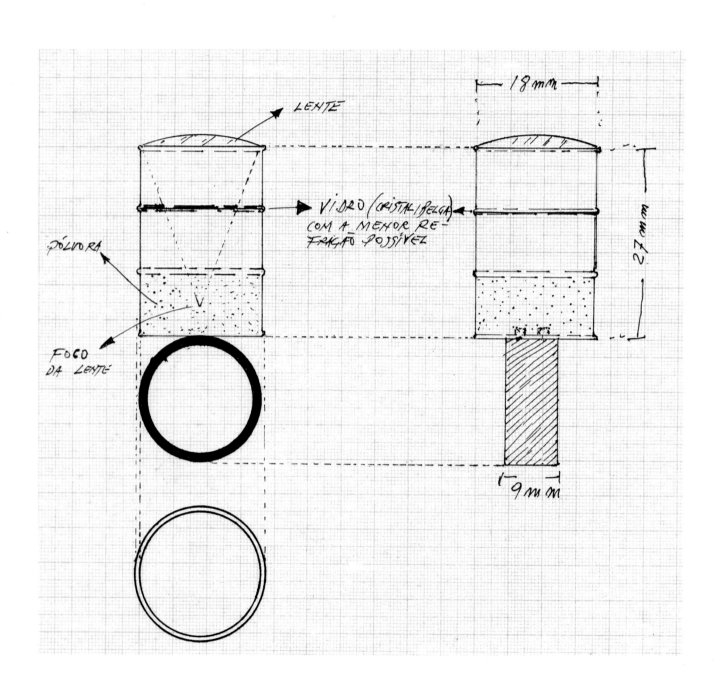

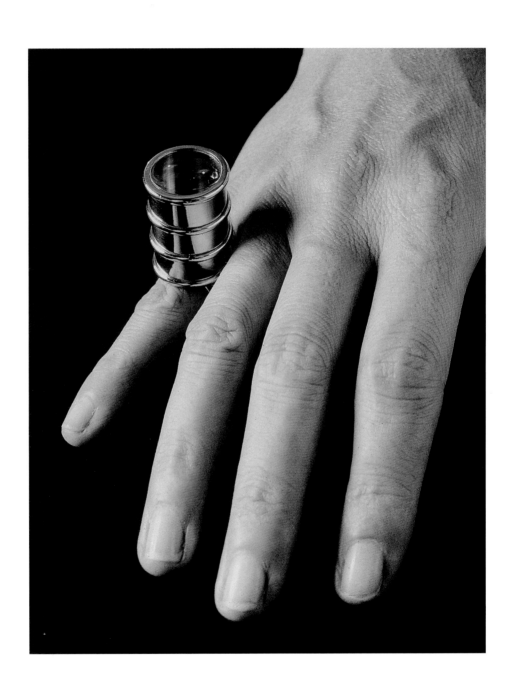

Human murmur / cosmic studio

The world imagined is the ultimate good.
This is, therefore, the intensest rendezvous.
Wallace Stevens[1]

LU MENEZES

If contemporary art can encourage those who walk into a gallery to be as bold and brave as an astronaut exploring new modalities of space,[2] the work of Cildo Meireles achieves this to a prodigal degree. His work does not derive from a fascination with materiality in itself, but from the many kinds of material procedures comprised in his huge, complex and always surprising poetics. This essay will briefly comment on certain works in which some of these procedures are evident, involving new relations between different spaces (visual, acoustic, tactile, olfactory); creating scale contrasts, chiasmic structures, overlappings, ellipses, potential invisibilities and the 'temporalisation' of colour.

The repertoire of Meireles's materials – among which sound stands out – implicates the entire cosmos as a studio. In his early work, they range from *Condensation I – Desert* 1970 (p.50) a ring with a grain of sand in a sapphire compartment on top of a gold pyramid (for, as the artist has declared, 'the root of the desert is a grain of sand') to *Mebs/Caraxia* 1970–1 (p.95), a vinyl record in which Meireles, by means of sound-graphs recorded with a frequency oscillator, makes audible the topological structures of a Moebius strip and a spiral. The absence of sides in these figures has determined their conversion into sound, like them an entity 'without sides'. Based on a visual similarity, the title *Caraxia* combines the Portuguese words *caracol* (snail) and *galáxia* (galaxy) – disparate elements in discordant harmony (*concordia discors*).

Geographical Mutations 1969 (pp.46–7), an exchange of earth samples at the Rio-São Paulo border,

deposited in a leather valise with compartments that clearly configure a chiasmus, belongs to the same period. Later, a remarkable chiasmic structure was created between the two canvas chambers of *Cinza (Grey/Ash)* (1984–6), respectively covered with chalk and charcoal, in such a manner that, by stepping on one floor after the other, the visitor produces a 'grey' cross-breeding of these substances. Another important mirror effect would arise in *Kukka Kakka* 1999 – where an exchange of the smells of flowers and faeces takes place through the confrontation of the natural products with their artificial, odourless plastic imitations. Exchanges have always played a crucial role in Meireles's work.

In *Southern Cross* 1969–70 (pp.58–9), the *symbolic* permeates the contrast between the work's minimal materiality and its cosmic field of action. On the floor, a cube measuring 9 × 9 × 9 mm is surrounded by a vast empty space. The cube is composed of two types of wood (pine and oak) whose fire, produced by friction, made them sacred to the Tupi Indians. The larger the space in which the work is shown, the more the cube will physically diminish, until, at a given distance, it apparently 'disappears'. If, on the one hand, *Southern Cross* points metaphorically to the transcendence of a mythical space, endowed with infinite potential expansion, on the other hand, the tiny cube's potential invisibility attracts us to a vertiginous 'atomical' immanence in which we may, in fact, 'believe'.[3]

Another symbolic 'cube' – this time with the very real potential of bursting into flames – appears in Meireles's work: the great block made up of boxes of

1 Wallace Stevens, 'Final Soliloquy of the Interior Paramour', in *The Collected Poems of Wallace Stevens*, New York, Vintage Books, 1990, p.524.
2 See Marshall McLuhan and Harley Parker, *Through the Vanishing Point: Space in Poetry and Painting*, New York, Harper and Row 1968, p.9.
3 Guy Brett sees in Meireles's work a 'cosmological sensitivity which runs through all his work... There is always in the background an unresolved question as to what constitutes "the human scale" in relation to the vastly expanded sense of space and time which has come with modern scientific discoveries.' See Guy

Brett, 'Five approaches', in Cécile Dazord (ed.) *Cildo Meireles*, exh. cat., Musée d'Art moderne et contemporain de Strasbourg, Strasbourg 2003, p.146.

Fiat Lux safety matches at the centre of *The Sermon on the Mount: Fiat Lux* 1973–9 (pp.82-5), surrounded by a simultaneously repressive and luminous circle of bodyguards and of mirrors inscribed with Christ's Beatitudes.[4] *Fiat Lux* – in which Meireles sublimely mirrored the pressure that the accumulation of twenty 'leaden years' of dictatorship in Brazil had rendered unbearable – belongs, like *Southern Cross*, to a group of works in which fire offers itself up in various configurations.

The hunger for freedom that reigned from 1964 to 1984 in Brazil, also intensified the rejection of aesthetic limits. However, Meireles did not simply reject them: he used limits to nourish his work. In *Through* 1983–9 (pp.138–46), tactile and visual limits mix 'through' a myriad of obstacles to the body's passage – obstacles that belong to countless contexts and promote a generalised cleavage of perception. Such physical barriers (bars, nets, canvases, trellises, fences, etc) allow themselves to be partially crossed by the gaze, which is induced to contemplate the limits of transparency and opacity in the trembling space of *Through*. Thus, it is the partial transparency of the fish gliding in the aquarium, not its form, that coexists with the materiality of the water and the glass, glass also in shards covering the floor, whose sonority when walked on enriches the tactile-visual space. A space of intervals, engraved and sculpted by its materials; vibrant as if the air itself became more tactile in traversing the innumerable openings of the meshes. In *Through*, a multifarious beauty sharpens the perception of the infinity of 'limits' in our lives.

The problematising of the relationship between sight and touch in *Through* is also a common denominator of *Eureka/Blindhotland* 1970–5 (pp.111–15) and *Glovetrotter* 1991 (pp.161–3), permeated by limits and anti-limits, rules and anti-rules. Often in Cildo Meireles's installations, when a specific rule is obeyed, an anti-rule stemming from another sensorial experience or another *modus operandi* disobeys it. In *Eureka/Blindhotland*, such 'disobedience' occurs through a chain of concealments. The apparent absolute homogeneity of 200 rubber balls is relativised when our haptic sense discovers their great diversity of weights. Simultaneously, on the scales of *Eureka*, in the centre of *Blindhotland*, the logic of weight is itself contradicted by means of a hidden piece of lead. Thus, two logics are sabotaged: a visual one in *Blindhotland*, and one of weight in *Eureka*.

Nevertheless, in certain of Meireles's works, the absolute solidarity between conception and materiality resists any split between an abstract 'principle' and its concrete realisation. Such is the case in *Mission/Missions (How to Build Cathedrals)* 1987 (pp.99–101), made from materials of symbols and symbols of materials: a mass of coins on the ground, connected by a column of communion wafers to bones suspended from the ceiling. Or the reverse process: for if an *ascending* gaze would transfer to the wafers the circularity of the coins, 'elevating' them to the bones, a *descending* gaze would convert the coins into the eschatological counterpart of the bones and the wafers. This ambiguous and ironic syntactical flux confers a decisive negativity upon

4 Taken from the Sermon on the Mount, in
 the Gospel of St Matthew, 5: 3–12.

materials already charged with meaning by the paradigms to which they belong. Such uniqueness prevents *Mission/Missions (How to Build Cathedrals)* from being an illustration of the historical situation that gave birth to it.[5] Instead, it suggests verbs such as 'to consume', 'to consummate', 'to ingest', 'to digest', and puts into circulation concepts such as 'body', 'value', 'belief', 'sacrifice' and 'death'.

With an economy of means that joins concreteness and abstraction, *Glovetrotter* is the most haiku-like of Meireles's installations. To contemplate it is to activate a visual tactility or a tactile visuality: an overlapping of both senses. On the floor, a wide steel mesh covers spherical forms of different types and sizes (from a pearl to a basketball). This abstracting skin highlights their different diameters, while hiding almost completely the underlying identity. The undulating surface captures the imagination. A lunar landscape? A *cordillera* of strange worlds? Before naming it *Glovetrotter,* Meireles considered *Brave New Worlds.* In fact, although it alludes to medieval armour, it is the universe of high technology that the metallic cover principally evokes. It refers us to some extraterrestrial future, rendering these 'worlds' at our feet remote, and making mentally immense the short physical distance that separates us from their paradoxical simplicity.

In the expanding universe, the redder the light of a galaxy moving away from Earth, the greater the speed of this distancing – the 'red shift' which allows to calculate how far the galaxy is from us. Such a measure of cosmic distance and Meireles's installation *Red Shift* 1967–84 (pp.120–31) depend upon a colour *in time,* a travelling red. In the installation, we traverse a succession of three environments, three states of colour, as if in a chromatic-narrative three-dimensional poem. The first state, 'Impregnation', is a standard-issue living-room in which every object or element is red. Although saturated with red, its walls are white: Meireles didn't want an 'easy' red, but a redness that was born 'from inside out'. Only through monochromatic accumulation should the environmental red splendour come forth. However, 'Impregnation' inaugurates not the platonic search for an archetypical red, but a chromatic trajectory. 'Although my mind perceives the force behind the moment, / The mind is smaller than the eye',[6] says Wallace Stevens, seeming to synthesise the disproportion between the mind and the sensible implied in the feeling of the sublime – as does the second stage of *Red Shift*, 'Spill/Surrounding'.[7] Here a dramatic discontinuity asserts itself: the flagrant disparity between a large puddle of red liquid on the floor and the small flask from which it appears to have come.[8] In the coalescence of the red puddle in 'Spill', the paradigm of the proliferation of reds in 'Impregnation' is summed up, abstracted and articulated to the fluidity of the third and last stage, 'Shift'. This is composed only of an inclined sink in the darkness, red liquid pouring from the tap; red

5 At the invitation of curator and critic Frederico Morais, the artist created *Mission/Missions (How to Build Cathedrals)* for the exhibition *Missões: 300 anos – A visão do artista* in 1989. The 'Missions' (also called 'cities in the jungle' and 'theocratic states') were settlements built by Jesuit missionaries on the Brazilian–Paraguayan–Argentine border for the conversion to Christianity of the Guaraní Indians between 1680 and 1730.

6 Wallace Stevens, 'A fish-scale sunrise', in *The Collected Poems*, p.160.

7 See in particular Immanuel Kant, 'Analytique du Sublime', in *Critique de la faculté de juger* (trans. A. Philonenko), Paris, Librairie Philosophique J.Vrin, 1989, pp.84–114.

8 The evocation of the 'knowledge parable' in the *Confessions* of Saint Augustine made by Paulo Herkenhoff in reference to 'Spill' has contributed to its association with the 'sublime' here. See Paulo Herkenhoff, 'A Labyrinthine Ghetto: the work of Cildo Meireles', in Paulo Herkenhoff, Gerardo Mosquera and Dan Cameron, *Cildo Meireles*, London, Phaidon Press, 1999, p.59.

flow reconfiguring with abstracting impetus the static puddle of 'Spill', now shifted downwards. As for us, we return to the beginning and retrace the multifaceted trajectory of this vital colour that is vaster than life.

Life, and human life, are also implicated in *Marulho* (*Murmur of the Sea*) 1997, in which sound is of paramount importance. As if hovering over a 'meta-sea' – a sea of open books printed with blue images of water – we hear an unintelligible surge of human voices similar to the sound of the sea: the word 'water' spoken by people of both sexes and different ages, in eighty languages. In the dense poetics of this work, a succession of overlappings and ellipses evokes the millions of years between the appearance of life and the invention of spoken language, and between the latter and writing; the long distance between thing and word, between the murmur of the sea and our own murmur on the face of this planet.

Sound is also the 'soul' of *Babel* 2001 (p.169), although, in the dark space, its little coloured lights recall a building in the electrified urban night. Before hearing the simultaneous transmissions from the countless stations of Meireles' tower of radios, one might think of the *Broadway Boogie Woogie* of a trans-secular Mondrian. *Babel's* intelligibility depends upon our proximity to the radios: the slightest distance can make us slide from meaning to non-meaning and cacophony. As if on a Moebius strip, the ear glides from singular to plural or from difference to resemblance, and we understand better this voice of ours: the murmuring of the species, the human murmur that the work of Cildo Meireles intensely reignites.

Translated from the Portuguese by Stephen Berg

Cruzeiro do Sul
Southern Cross
1969–70
Wooden cube, one section pine,
one section oak
0.9 × 0.9 × 0.9

Cruzeiro do Sul, 1969–70

Southern Cross

Southern Cross was initially conceived as a way of drawing attention, through the issue of scale, to a very important problem, the over-simplification imposed by proselytising missionaries – essentially the Jesuits – on the cosmogony of the Tupi Indians. The 'white' culture reduced an indigenous divinity to the god of thunder when in reality their system of belief was a much more complex, poetic and concrete matter, emerging through the mediation of their sacred trees, oak and pine. Through the [rubbing together of] these two timbers the divinity would manifest its presence. The fire created was a form of evocation of the divinity. This cosmogony is found again and again throughout almost all the civilisations of South America – we are children of fire, children of the sun. The Jesuits almost totally overlooked the delicate refinement of the process, of the notion that each time that you created fire you were reifying the divinity. #

The cosmogony I wanted to materialise was the Southern Cross although I was simultaneously interested in keeping it as hidden, as condensed as possible, to keep it moving towards physical near-disappearance. It was also a density. It is so dense that it is compacted into itself. In that sense, the idea came about to combine the smallest possible amounts of wood grain. Initially I wanted it to be much smaller than this; but when I sanded it down to my nails, I lost patience and stopped at 9 mm.

The *Southern Cross* belongs to 'humili-minimalism', that is, a small object, an almost nothing, really, a minimalism, that endorsed a character of humility. But it also had the irony of being a sort of practice of 'baroque humiliminimalism' because, in fact, it was loaded with stories, mythologies and symbols. It was exactly the opposite of American Minimalism, which is a sort of final stage of the classical readymade, of one of the ideas that surrounds the idea of the readymade, which proposes choice devoid of a type of aesthetic or emotional value. It was the rule that this evokes a sense that 'it is what you see', but is devoid of any symbolic or discursive intentionality.

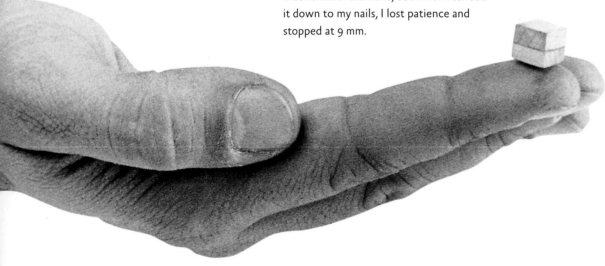

Inserções em Jornais
Insertions in Newspapers
1969–70
Advertisement placed in *Jornal do Brasil*, 13 January 1970
57.8 × 37.5

Inserções em Jornais, 1969–70
Insertions in Newspapers

" The first *Insertion* is dated January 1970. It is from a 1969 project called *Clearing*. I wanted to produce a clearing in a page of the classified ads so I took one out. The only thing written on it was: 'AREA NUMBER 1. CILDO MEIRELES. JANUARY 70. When I dropped the ad off at the *Jornal do Brasil*, I left an artwork for it to correct scale, but the paper wanted to help and set the word AREA in much larger type. I had paid for something smaller. The idea was for that classified ad to be a blank space, with the text nearly illegible.... I wanted an absence of classified there, a sort of 'clearing', as it were, which is a type of territorial possession. You clean up the area you are going to occupy.

Then I made another one in June 1970. The first was before I made the *Insertions into Ideological Circuits*. When I made the second Insertion, the path was becoming less interesting to me. A newspaper, for example, has a wide circulation, but it is a centralised control circuit, which is to say that very few people significantly control the circuit. Therefore, you are under control, under surveillance, so I wasn't interested in this for purposes of the work. The newspaper itself had censorship control, as did radio, TV, or the mail system. So how would I be able to talk about someone who was imprisoned, who had vanished, been tortured or killed? Therefore, something done at the newspaper would automatically be subject to the same censorship. This was something that limited the idea of the work. So, apparently, the *Insertions into Ideological Circuits* provided this type of autonomy from control mechanisms.

The second insertion contained the following text: 'AREAS. VAST. WILD. FARAWAY. LETTERS TO CILDO MEIRELLES. RUA GAL. GLICÉRIO 445 APT. 1003. LARANJEIRAS. GB.' The text referred to the Amazon. At the time, I didn't even have a permanent address. I gave the address of a friend's parents' home here in Rio. But it wasn't a sale, it wasn't a purchase, it wasn't a rental. Verbless text. "

MÁQUINAS E MATERIAIS

Matrizes para linotipo
Vendem-se fontes completas e incompletas. Ver e tratar na Av. Rio Branco n.º 110, 1.º andar, com Sr. Gilberto.

MÁQUINAS INDUSTRIAIS

MATERIAL DE CONSTRUÇÃO

Areia do Guandu
Diretamente do nosso areal, entregamos em sua obra, em qualquer parte da cidade. O menor preço da praça. Tratar tel. 232-9954 228-0418 228-3121 E. L. BARSALI.

Cimento Mauá
Pôsto Obra 7,50 231-0774

Materiais de construção
Areia, Pedra, Tijolos, Telhas, Portas, Janelas e Louças etc. Coloca-se e tira-se aterro, tudo pelo menor preço, e em qualquer região. Faça uma visita a FORMACO. Est. do Quitungo, 125, Brás de Pina. (P

MÁQUINAS E EQUIPAMENTOS DE ESCRITÓRIO

Azulejos decorados
Preços a partir de NCr$ 35,00. Executa-se qualquer desenho. Entrega em 10 dias. Atelier Luiza Prado. Super Shopping Center Copacabana, Rua Figueiredo Magalhães, 598 G. 139 e Rua Siqueira Campos, 143 Grupo 139 — Térreo. Tel. 235-3640. Horário 9 às 12 e 15 às 18 horas.

ENSINO E ARTES

COLÉGIOS, CURSOS E PROFESSORES

ANIMAIS E AGRICULTURA

ANIMAIS E AVES

DIVERSOS

DECLARAÇÕES E EDITAIS

Comunicado
CONTADORIA GERAL DE TRANSPORTES CADERNETAS QUILOMÉTRICAS

Faço público que, conforme Portaria n.º 3-24DG, de 30/12/69, do Departamento Nacional de Estradas de Ferro, publicada no Diário Oficial da União de 6/1/70 (Seção I — Parte II), a partir de 1.º de fevereiro de 1970, as cadernetas quilométricas de 12.000 quilômetros emitidas pela Contadoria Geral de Transportes, custarão NCr$ 192,00.

MARIO WOLTER
Diretor

Edital de Citação
O Dr. Ernesto Jencarelli, Juiz de Direito da 1.ª Vara de Órfãos e Sucessões.

Pelo presente, indo por mim assinado e devidamente subscrito pelo Escrivão Subst.º faço saber, aos que o presente edital virem ou dêle conhecimento tiverem, que no prazo de trinta (30) dias, CITO e CHAMO, a êste Juízo, Cartório do 1.º Of.º, que funciona à Rua Dom Manoel, 29 — 5.º andar, os fideicomissários Julio Cesar, representando seu pai Raul Calvet de Azevedo e José Calvet de Azevedo; e, Juani, filho de João Avellar Magalhães Calvet, para no prazo de 30 (trinta) dias, a contar da 1.ª publicação do presente edital, habilitarem-se e dizerem sôbre as 1.ªs declarações, avaliação e atos praticados no inventário dos bens deixados pelo finado Dr. Raul Fernandes, na sobrepartilha a requerimento dos Drs. Antonio Pinto de Avellar Fernandes e Roberto Pinto Fernandes, testamenteiros e inventariantes do mencionado espólio do Dr. Raul Fernandes. E, para que chegue ao conhecimento dos referidos fideicomissários, ou de quem interessar possa, mando lavrar o presente edital e mais dois de igual teor, que serão publicados pela imprensa e afixados no lugar de costume, na forma da lei. Rio de Janeiro, 12 de janeiro de 1970. Eu, José Braga, Escrivão Subst.º subscrevo. (a) Juiz de Direito — Ernesto Jencarelli.

Está conforme.

Escrivão — (a.) José Braga.

Edital de Citação
O Dr. Ernesto Jencarelli, Juiz de Direito da 1.ª Vara de Órfãos e Sucessões.

Pelo presente, indo por mim assinado e devidamente subscrito pelo Escrivão Subst.º, faço saber, aos que o presente edital virem ou dêle conhecimento tiverem, que no prazo de trinta (30) dias, CITO e CHAMO, a êste Juízo, Cartório do 1.º Of.º, que funciona à Rua Dom Manoel, 29 — 5.º andar, os fideicomissários Julio Cesar, representando seu pai Raul Calvet de Azevedo e José Calvet de Azevedo; e, Juani, filho de João Avellar Magalhães Calvet, no prazo de 30 (trinta) dias, a contar da 1.ª publicação do presente edital, habilitarem-se e dizerem sôbre as 1.ªs declarações, avaliações, cálculos, e demia, digo, e demais têrmos do processo, sob as penas da lei; no processo de extinção de fideicomisso, a requerimento de Antônio Pinto de Avellar Fernandes e Outros, que se processa em apenso ao Inventário dos bens deixados pelo Dr. Raul Fernandes; por falecimento, também da fiduciária D. Lucie Fernandes. E, para que chegue ao conhecimento dos referidos fideicomissários, ou de quem interessar possa, mando lavrar o presente edital e mais dois de igual teor, que serão publicados pela imprensa e afixados no lugar de costume, na forma da lei. Rio de Janeiro, 12 de janeiro de 1970. Eu, José Braga, Escrivão Subst.º subscrevo. (a) Juiz de Direito — Ernesto Jencarelli.

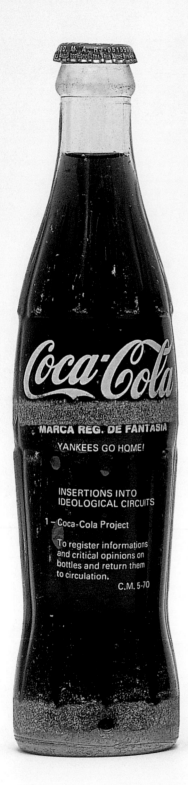

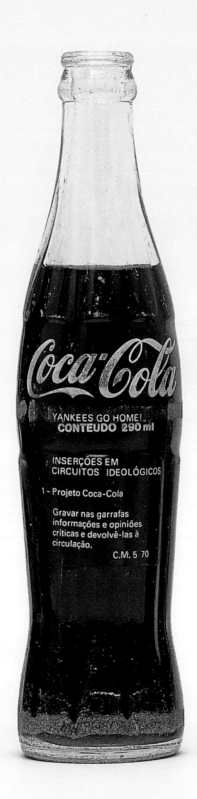

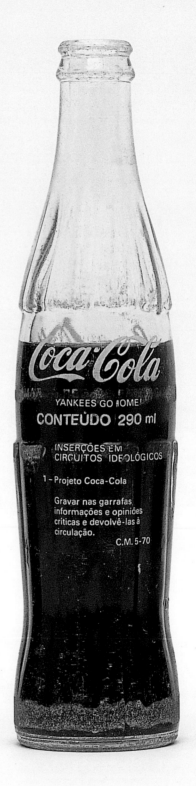

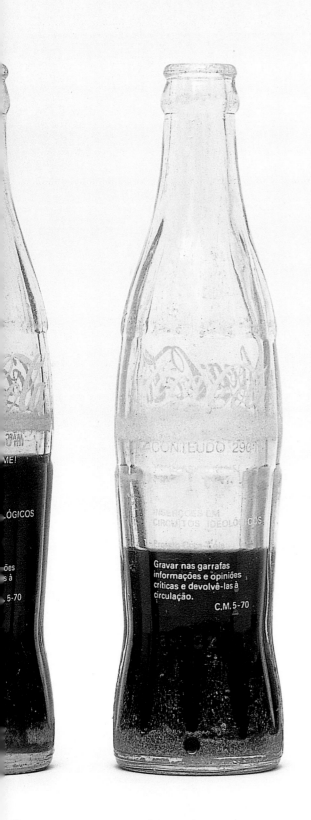
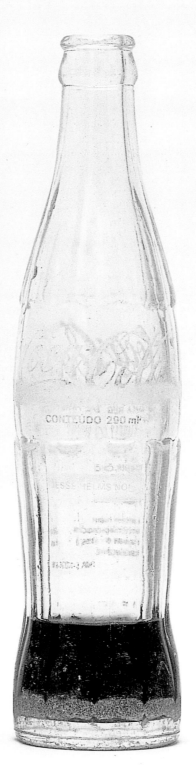
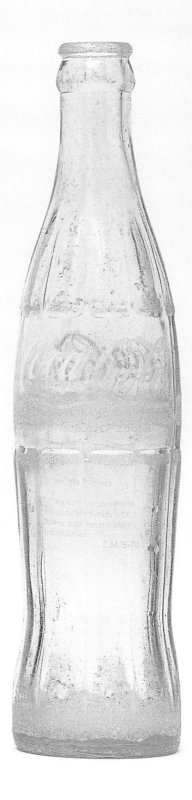

Gravar nas garrafas
informações e opiniões
críticas e devolvê-las à
circulação.

C.M. 5-70

Inserções em Circuitos Ideológicos:
Projeto Coca-Cola
Insertions into Ideological Circuits:
Coca-Cola Project
1970
Transfer text on glass
Each 25 × 6 × 6

Inserções em Circuitos Ideológicos, 1970
Insertions into Ideological Circuits

I created a work which I have never wanted to sell: the *Insertions*. They belong to a period that I would call a pretension of youth: even if they were not exactly the opposite of [Duchamp's] readymade – a concept I like very much – they were none the less meant to take another direction. Not a different sense, but a different direction. A readymade involves taking an industrial product and making it unique through a subjective process. The basic premise of *Insertions* is the opposite: starting from a small, individual thing, you can then reach a very large scale through ramifications and branching out (another extremely important concept in my work). ‡

On the first Saturday after returning from Belo Horizonte, where the *From Body to Earth* event took place in April 1970, and where I realised *Tiradentes: Totem/ Monument to the Political Prisoner*, I remember we went to the beach. On the way back from the beach – it must have been about

❝ Between 1968 and 1970 I knew I was beginning to touch on something interesting. I was no longer working with metaphorical representations of situations; I was working with the real situation itself. Furthermore, the kind of work I was making had what could be described as a 'volatised' form. It no longer referred to the cult of the isolated object; it existed in terms of what it could spark off in the body of society. This is what one had in one's head at the time; the necessity to work with the idea of the public. Many Brazilian artists were including everyday materials and actions in their work; directing the work towards a large, indefinite number of people: what is called the public. ∅

three or four in the afternoon – we stopped at a restaurant in [the] Barra da Tijuca [quarter]. The neighbourhood was half deserted. At the end of the meal someone at the table remarked that if you put an olive stone inside a Coca-Cola bottle it would never come out. I started thinking about this and, that same day, I wrote the text which initiated the *Insertions into Ideological Circuits*.

Information (production, circulation and control) is at the source of the *Insertions* – that olive which no one, in the process of industrial washing, would ever eliminate. The work was also linked to the bottles of castaways. Sometimes the business of throwing the bottle into the ocean brings about confusion. But if I threw it in the ocean I would be limiting the efficacy, the possible efficacy of the work to one person. My idea was precisely to use the extension of this total circulation of bottles, that circuit of permanent move-ment, in order to reach different people. The project's messages normally grew out of information or news that had reached me, that people had shared with me, messages about people who had been arrested or who had not been found; at times, people I didn't even know.

Orson Welles's *War of the Worlds* is another work at the (unconscious) source of the *Insertions*. It is an example of an object that exists precisely at this borderline between fiction and reality – it belongs to those two worlds simultaneously. I consider the readymades and the *War of the Worlds* to be two or three of the greatest art objects of the twentieth century.

The sequence of bottles photographed or displayed in the museum is not the work: it is a relic, a reference, a sample. The work exists only in so far as it is being done. Its place is a little like that of the third ball in the juggler's hand. It is there in passing. # ”

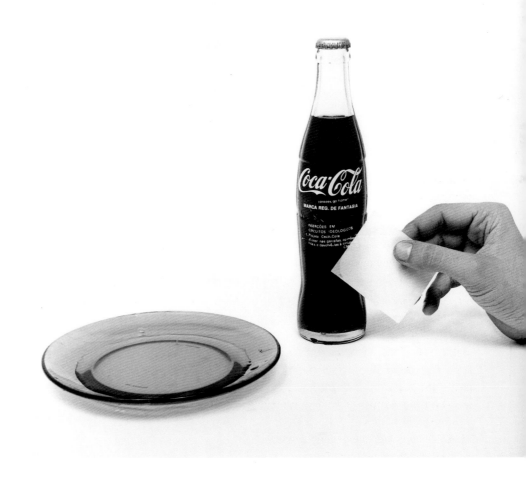

❝ The *Coca-Cola Project* was almost like a metaphor for what I consider the real work, the *Banknote Project*, which was contemporaneous. In this project, banknotes were stamped with political messages and re-inserted into circulation. ∅

It was the banknote that worked and, at that time, people's inscriptions on money already existed: mechanisms, really, that are recovered, re-used. The project's messages normally grew out of information or news that had reached me, that people had shared with me, messages about people who had been arrested or who had not been found; at times, people I didn't even know. ❞

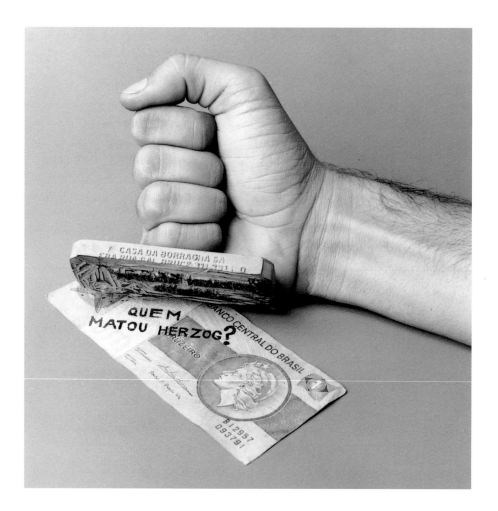

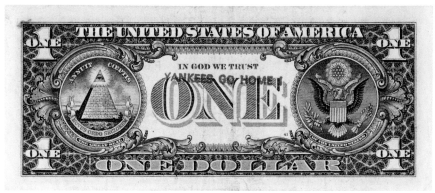

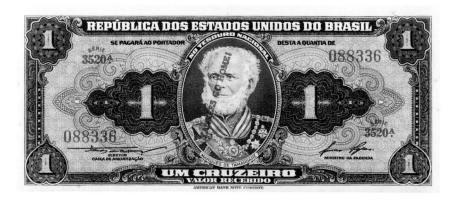

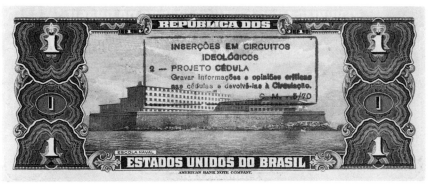

67

On the politics of disaggregation: Notes on Cildo Meireles's Insertions into Ideological Circuits

OKWUI ENWEZOR

Thwartings

In a monograph dedicated to his work published in 1999, Cildo Meireles selected an excerpt from one of Jorge Luis Borges's fables: *The Garden of Forking Paths*, as his choice of a literary entry to accompany the book's interpretive essays.[1] The choice of this story is both apt and self-revealing, being as it is Meireles's recognition of the affinities that his work shares with Borges's lapidary writing on the incongruities of reality and phenomena. In the same manner that Borges's stories are labyrinthine, a phenomenological map of puns and allusions, continuities and discontinuities, so too are many of Meireles's projects, particularly in large installations such as *Through* 1983–9 (pp.138–46), *Red Shift* 1967–84 (pp.120–31), and *Fontes* 1992 (pp.165–7), or small sculptures like *Blind Mirror* 1970 (p.107) and *The Shortest Distance Between Two Points is a Curve* 1976. Each of these works, covering distinct periods of his practice, are also decidedly Borgesian both in their titles and in the structural and phenomenological investigations they set up. Most significantly, they seem to draw from Borges's manner of constructing a tale – be it tall or convoluted – as a process of discovery, in which the reader traverses the contours of the ever unfolding story, seeking clues that nevertheless confound the standard logic of a story's narrative progression.

What, then, might a visitor find in the present exhibition? Perhaps what will become manifest to viewers is a series of artistic detours: paths taken, cut short in mid-motion, deferred, thwarted into units of both unfailing structural complexity and schematic incompleteness. Or yet, they may encounter a fully elaborated discourse on forms and gestures that might permit a strong condensation to build that will link the tangled paths and reveal the unifying logics and strategies of Meireles's practice.

Circuit breaker, retrospectives, ceaseless returns

My motive is twofold: first, I want to cast a critical look at one project, *Insertions into Ideological Circuits* 1970 (pp.62–7), for which Meireles has come to be known far more than any other work of his over forty-year career. Like Borges's forking paths, Meireles's *Insertions* operate at the gap between circuits, between material flows, ideological structures and nodes of value (symbolic, social, economic, political). In tactical terms, the 'insertions' represent the brutal scoring onto the sheets of public consciousness of the wild rumours of human existence caught in the grip of unaccountable power. Thus, they are procedures of disaggregation carefully insinuated into spheres of everyday practice. In seeking to analyse and attack these scenes of production, communication, dissemination and domination, Meireles in *Insertions* formulated a counter-ideological discourse, one that addressed its intended public by means of dispersal and detour into social structures and institutional systems. In so doing, his idea was to appropriate these systems – money and consumer products – as media of ideological transmission and communication within the democratic public sphere; as forms of

1 See Paulo Herkenhoff, Dan Cameron, Gerardo Mosquera, *Cildo Meireles*, London, Phaidon Press, 1999.

artistic and political critique of the commodity and imperialistic power.

In a text reflecting the motivation behind the conception of *Insertions* and the operative critical stakes in the work of a young Third World artist, Meireles writes:

The scenario for this text and the projects is this momentous period (the late 1960s and early 1970s) in the cultural synthesis of Western culture's history, which impelled a Brazilian artist in his early twenties to produce work that considered the following issues:

1. The painful political, social, and economic reality of Brazil – a consequence to a large extent of:
2. The American system of politics and culture and its expansionist, interventionist, hegemonic, centralizing ideology – without losing sight of:
3. The formal aspect of language.[2]

These considerations offered by Meireles direct attention to my second point, which concerns the exhibition model of the retrospective. I want to examine how looking back at *Insertions* and its intervention nearly forty years ago into the circuits of capital exemplified by American hegemonic policies around the world, might also be linked to the historical circumstances and context in which the work first appeared. This raises the question of whether the retrospective is not simply a way of looking back but also an occasion for ceaseless returns to a historical period that haunts contemporary art today. It is within this context that the

issues brought up by Meireles's project will become clarified. He was operating under a climate of politics that demanded all kinds of formal and conceptual responses from artists, cultural practitioners, student movements, labour, civil rights and guerilla organisations.

Retrospectives are necessarily about historical returns. They are about circuits in which the indelible marks of everyday experience become reanimated in the present. In museum practice such returns are themselves a curatorial medium. Meireles's retrospective is surely the scene of reappraisals, returns to circuits of production, thinking and action.

The 1960s: some look back in dumb admiration, many with nostalgia, while others, especially the neo-conservative forces, see the decade as the landscape of moral disaster. No recent historical period has been more earnestly analysed for its failures, lost illusions and unfulfilled promises. In our own times, in which historical periods have become tools of media commodification, fashion, escapism, the 1960s is by turns aggrandised and mythologised both for its breakthroughs in artistic logic and proposals, and for its radical political cultures and social experiments. Yet, not all who look back return with lessons for how contemporary art might offer, through its political and artistic models, practices that are not merely stylistic samplings of the ideological energies operative then, particularly, amongst leftist practices. Whether by curators, critics or artists, ideas and works developed during this period of political turmoil and world-changing

2 Cildo Meireles, from *The Latin American Spirit*, exh. cat., Bronx Museum of the Arts, New York 1988. Reproduced as 'Information 1970/89' in ibid., p.108.

events have become proven repasts, picked apart for insight into how formal aesthetic choices produce radical forms, thus engendering new artistic materials that cater to the market of commodity objects circulated in the name of contemporary art. One wonders and worries then, about the critical efficacy of *Insertions* when its remains are incarcerated in the fetish box of the museum's mummifying and marmoreal pristineness as merely the carcass of the artistic past. Might it not be better to return to the work's originary temporal conditions by reasserting its structure of circulation and reception back into the economy of social redistribution when it makes its appearance in London?

Commencement

The 1960s, then, is a veritable scene of ceaseless returns. It shows us the potential and the contradictions of contemporary art writ large. It is a good place to start, a place of commencement. The shadow of radical activism and aggressive assertions of sovereignty by the dispossessed that exploded in the 1960s across the world continues to be projected over the field of critical artistic practice, especially in instances where forms of public speech have been stifled in the name of 'security'. This is the watchword of contemporary reality. Everything is now subordinated to the vast apparatus of watching and keeping watch over, a pathology of surveillance that knows no end. Everywhere in the field of contemporary culture in which there is an utterance

of concern for public safety, one is likely to find the handprint of official, institutional, extremist and reactionary discourse. In these instances, the emergence of the security state becomes a spectre linked to the zone of incarcerated life. It was incarcerated life, particularly of the colonised and subjugated working classes, that the radical forces of 1960s activism sought to liberate.

Upheaval

Though Meireles's *Insertions* project was developed at the end of the 1960s, its significance in Brazil – at a time of political turmoil and uncertainty that followed the coup d'etat of 1964, when the military took command, and subsequently, through social repression and ideological conservatism asserted control over the public sphere – is relevant to its political and aesthetic efficacy. The work was specifically designed to operate in the interstices of the official spheres of military jingoism supported by American interventionist politics in the Southern Hemisphere in the guise of anti-communism.

As with many artists operating during this politically charged period, Meireles's work emerged out of another transitional moment in Brazilian art, between the Cartesian logic of neo-concrete abstraction and the expansive, performative procedures of Conceptual art that were to recast the relationship of contemporary artists to the critical language of social address. The confrontation between politics and modes of social subjectivity would prove a

fertile ground for artists intent on elaborating a different course of action in order to make the public sphere relevant and open to everyday life, and as such to bridge the distance between social practices and artistic experiments. These reflections on the very potential of contemporary art as a site of discursive production, contestation and sociality produced some of the most engaging and philosophically diverse bodies of work by artists operating in a postcolonial environment. However, Brazil occupies a unique cultural bridge between continents, since its artistic heritage is fundamentally linked to Europe, even if on a popular level it is culturally syncretic. One attempt to resolve the tension between the Western cultural model and the Brazilian popular and vernacular culture occurred under the inter-disciplinary procedures of the Tropicalia movement, which combined popular and experimental forms.[3]

Deviation

It goes without saying that Meireles's work is still deeply indebted to the legacy of advanced practices of European avant-garde modernism in Brazil. It also belongs fully to the era of the Brazilian neo-avant-garde, a period of artistic and cultural transition and regeneration in Brazilian art. However, seen alongside the output of his generation, what is most surprising about Meireles's work is its heterogeneity. In his work, seemingly opposing ideological and aesthetic agendas – politics and poetics, aesthetic and anti-aesthetic, form and anti-form, the concep-

tual and the baroque – are collapsed to produce one of contemporary art's most engaging, unclassifiable practices. Meireles's work is unclassifiable not because there is a lack of consistency in his thinking, but because his formulations of the artistic object bear no relation to a unified artistic style. Each of his works can be approached as a series of monadic units within which the temporal conditions of the work's realisation vitiates any notion of continuity in an assembly line of production. The absence of continuity between works, however, does not mark a break with the continuity of the philosophical model that animates the sensorial and somatic experiments that have been the key elements of his projects. In fact, it is the philosophical and the conceptual rather than the formal qualities of a style that link the works together.

Neo avant-garde Brazilian art of the 1960s saw artists shifting from an aesthetic of form that had inflected the practices of the 1950s with a strict sense of modernist abstraction, to a politics of form that sought to bridge the gap between advanced art, Brazilian public culture and marginal communities. That artists during this period would shift away from the cult of the autonomous commodity object in order to elaborate an idea of art as a proximate, social object in everyday life is not surprising. Art, as Hélio Oiticica's *Parangolés* and Lygia Clark's *Bichos* demonstrated, was for empowerment, community, ritual, healing. But it was also crepuscular, as evidenced in Artur Barrio's dispersal of fresh carrion

3 For an exploration of this convergence
 see Carlos Basualdo, *Tropicália:
 A Revolution in Brazilian Culture*,
 exh. cat., Museum of Contemporary Art,
 Chicago 2005.

across neighborhoods in his actions, serving as a disturbing reminder of the regimes of violence that dominated everyday life.

Communicative actions

To alleviate the conservative strictures of Brazilian official cultural classes that oriented artistic investigations towards Europe, artists such as Meireles created a radically rigorous series of detours in their work. They aimed to shatter the conservative modernist vessel of artistic practice by marrying the aesthetic parameters and sensibility of late modernism with postmodernist and postcolonial structures of practice. In this way, the artists sought solidarity with a broader population of Brazilians, across class, ethnicity and gender. The radical Brazilian theatre director, Augusto Boal, developed the *Theatre of the Oppressed* during this period. Against this backdrop of political and social solidarity, and the struggle to demilitarise the public sphere, Meireles developed *Insertions into Ideological Circuits* for the exhibition *Information* organised by Kynaston McShine at the Museum of Modern Art, New York, in 1970. However, while *Information* was a distillation of conceptual artistic practices that emerged in the late 1960s internationally, with its emphasis on textual messages and communication it seemed to have been mapping specific ideological ruptures that were noticeable in the political orientation of a number of artists' works. Meireles was one such artist. With the Vietnam War and the concerted political repression orchestrated by the Nixon administration against anti-war or dissident activists, including radical political groups in the United States at the time, McShine emphasised and underscored models of communicative action in the work of many artists, including Oiticica, Meireles, Hans Haacke and others.

The question of the responsibility of the artist in response to social and political crisis was one of the visible themes of the exhibition. In fact, *Information* seems a clear response to the crisis of the public sphere in advanced Western democracies in which 'information' had become a product, a commodity traded and sold, controlled and manipulated by media companies, press organisations, and a prime material in the State's ideological struggle with its citizens. In his introduction to the catalogue of the exhibition, McShine was as explicit in targeting the concept of autonomous work of art, especially the traditional painting on canvas, as he was in shining a bright light on the options left for artistic action. For him, 'information' is both material and linguistic, tactical and philosophical, political and ideological.

Meireles responded to McShine's initiative with *Insertions*. Both currency and commodity (money and Coca-Cola bottle) were adapted into broadcast media, as tribunes through which the artist could formulate messages, address questions and organise critiques directed to a broad public that would receive them through the formal cycle of economic transaction. In the circuit, the messages are received first through the mode of consumption and then proliferated through the action of random distribution.

The *Banknote Project* (p.66–7) and the *Coca-Cola Project* (p.62–5) consisted of a series of typographical and linguistic interventions. These interventions were designated as 'insertions' by Meireles, thereby making clear that they were not merely objects of critique but also part of the structures being critiqued. The insertions took the form of rubber stamps for the *Banknote Project*, in which on every currency note spent by Meireles, a question, statement or slogan was stamped. On the reverse side of the note, a description of the project as deliberate statement was also stamped.

The *Coca-Cola Project* functioned with a similarly crafted series of slogans, statements, and declarations screened in white text onto empty Coca-Cola bottles, which at that time circulated on a deposit system in Brazil. The embedded messages were invisible when the bottle was empty, but were revealed when it was refilled at the factory. One such message: 'Which is the place of art?' took the direction of the question posed in McShine's introduction. Another statement employed the following list of terms: 'Molotov: pavio, fita adesiva, gasoline'. The allusion to the Coca-Cola bottle as a Molotov cocktail is meant to provoke in the receiver the idea that all political struggles belong in the realm of public discourses of opposition on the streets, in counter-ideological messages, what Meireles calls 'the dialectical content of the work'.[4]

Organised as a series of statements and questions addressing the larger condition of public access to media, the work was adapted through forms of exchange and systems of circulation inherent in the medium of money and the commodity. The specific agenda of *Insertions* thus operated at the level of social infiltration of the State's ideological circuits (money, currency) and the circuits of consumption controlled by global capital and American cultural imperialism (consumer product) as a means of reclaiming a public realm that was subordinated to the two forces. In his interventions, Meireles initiated a radical project of disaggregation both as a counter-ideological project of political communication and as a critique of the aesthetic commodity of surplus value. But ultimately, *Insertions* reveals through its structure of circulation, exchange and circuits the degree to which historical grounds have proved today the site of ceaseless returns.

4 Cildo Meireles, 'Insertions into
Ideological Circuits' in Herkenhoff et al.
1999, p.112.

Inserções em Circuitos
Anthropológicos
Insertions into
Anthropological Circuits
1971
Metal tokens for
dispensing machines,
telephones or transport,
empty matchboxes, clay
Dimensions variable

Inserções em Circuitos Anthropológicos, 1971
Insertions into Anthropological Circuits

“ The *Insertions into Anthropological Circuits* were made in New York, in 1971. In the case of the token, I was thinking about subway turnstiles, which operate according to two standards of function – one being the token's weight and the other its size. Those two elements are what make the turnstile turn. But after a time the weight would not work, only the size, which allowed me to use different materials. So the idea was to use material that was free. I used linoleum, which had almost the same thickness, a reasonable weight and was free: you'd be walking on the sidewalk, see the trash cans, there was always someone renovating their apartment, pulling up linoleum. Linoleum was the image of ease, of being surrounded by abundant material.

The whole series of *Insertions into Anthropological Circuits* consisted of the fabrication of objects and their circulation. ”

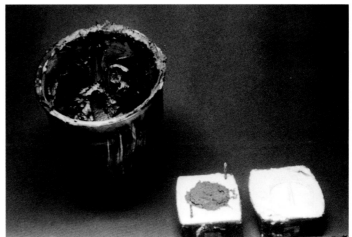

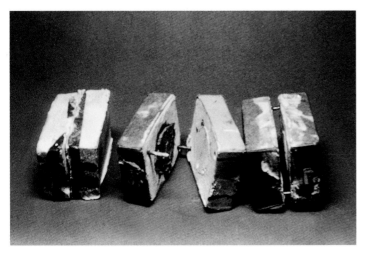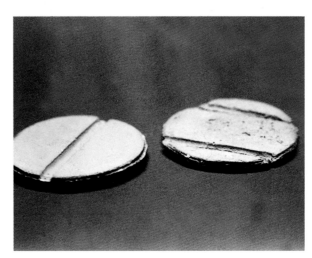

Árvore do Dinheiro
Money Tree
1969
100 folded one-cruzeiro banknotes
Notes 2.5 × 7 × 6

Árvore do Dinheiro, 1969

Money Tree

" Some of the idea dates back to 1968, but I formalised it in 1969. It was during a trip to Brasília, in late 1968, Christmas 1968, end of the year holidays; I had gone to visit my family. During a party, I remarked to someone that an American artist had created a work in which he took several banknotes, tied them all together and said that it cost twenty times more.

So the *Money Tree* was the object, the physical thing, which first began to help me to clear a field of action and the possibility of a material, also. It contained a uniqueness in itself that dealt with this idea of dubiousness that reappears in various works, of being simultaneously raw material and symbol. There was this ambiguity that interested me. This third bank of the river business.* It is a spatial model that has always interested and fascinated me.

In a way, I believe it cleared away the entire series of nebulosities in the idea of pointing out a paradox of value: symbolic value and the real value of things, exchange value and use value. It is a work that remains between fiction and reality. "

* The artist is alluding to the short story 'The Third Bank of the River' by Brazilian author João Guimarães Rosa.

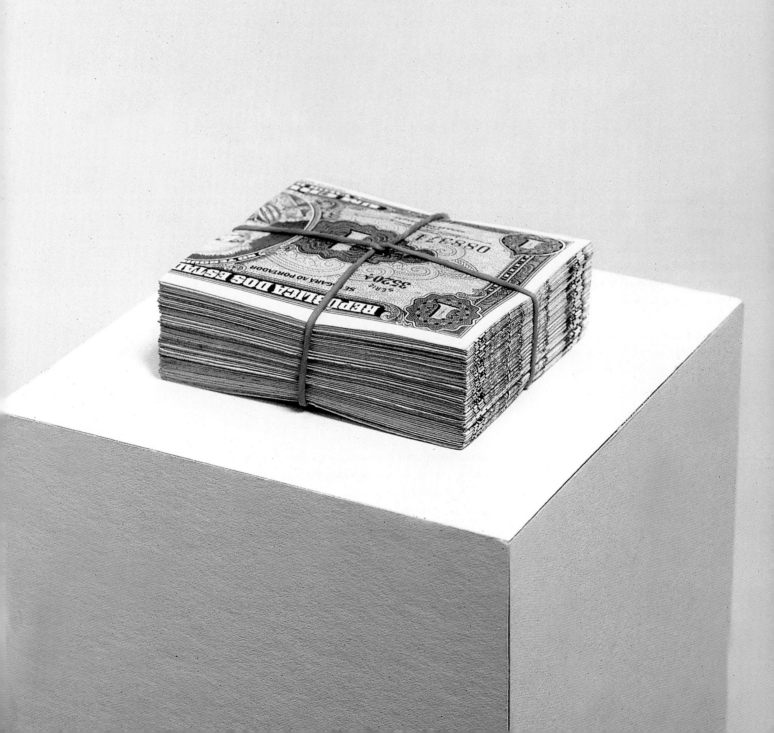

Zero Centavo
1974–8
Metal
Unlimited editions
Diameter 1.3

Zero Cruzeiro
1974–8
Offset print on paper
Unlimited editions
6.5 × 15.5

Zero Cruzeiro, Zero Centavo, 1974–8

Actual size

Zero Cruzeiro and *Zero Centavo* were born together, from a note I composed in 1974. They were born from the action of thinking about that pile of banknotes [*Money Tree*]. It was a rare thing, but when I had the occasion to contemplate a small pile, it was as if the work were forming itself in front of me and disappearing, because I had to buy lunch and, therefore, at that exact moment the sculpture would evaporate. The work possessed that flexibility, that universality where you could mount it anywhere, in any context.

Zero Cruzeiro was therefore already based on the reflection of thinking about the concept of the *Money Tree*. The *Money Tree* spoke to the history of art, to the art object, to the art object market, to the socio-economic factor; furthermore, the material that the work was made from was money itself. It therefore possessed several readings and offshoots. But of course the core was in the clash between cost value and market value.

The banknotes were printed in offset. I used to cut the zeros from two and three cruzeiro notes and glue them on. Later, we made photolithographs, which we printed. That was *Zero Cruzeiro*. However, making the *Zero Dollar* banknote was another process. It was designed by a friend named João Bosco Renaud. He was a fine engraver who designed money for the Casa da Moeda.*

In a way, the *Zeros* are examples of *Insertions into Anthropological Circuits* and they are sometimes mistaken for the *Insertions into Ideological Circuits*. In fact, *Zero Cruzeiro* was the opposite of *Money Tree*. It said: 'This isn't worth anything', which was a lie to begin with, I mean, a denial, a paradox insofar as what that was. There is a chiasma between the *Money Tree* and the *Zeros*.

As with the *Money Tree*, *Zero Cruzeiro* always ran the risk of being mistaken for a commentary or criticism of inflation … regionalising the work, locating it, limiting its meaning. Actually, what I was interested in discussing there was that *gap* between symbolic value and real value, use value and exchange value which, in art, is always a continuous, permanent operation. "

* The Brazilian equivalent of the Bank of England – it is
 the agency responsible for issuing currency.

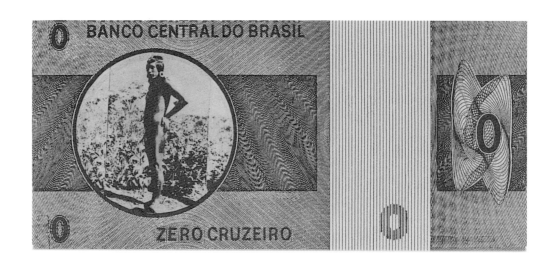

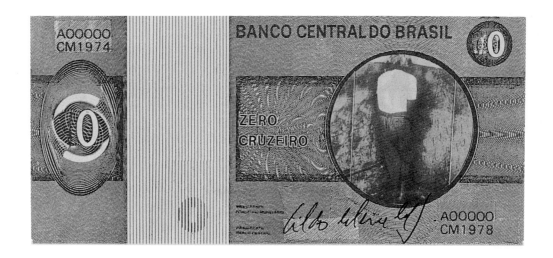

Zero Cent
1978–84
Metal
Unlimited editions
Diameter 1.5

Zero Dollar
1978–84
Offset print on paper
Unlimited editions
6.8 × 15.7

Zero Dollar, Zero Cent 1978–84

Actual size

" By using the dollar in my work,
I specifically hoped to escape from the
stereotypical association of Brazilian
money with inflation by doing a direct,
simplistic thing. That didn't happen with
the dollar – it was more universal. Because
in *Zero Cruzeiro*, the problem is isolated
even further. People pick up the bank
note and ask: 'What is a cruzeiro?
What language is this?' "

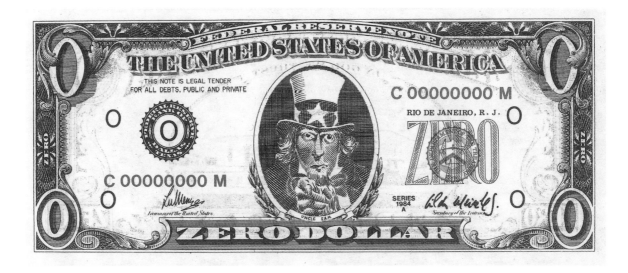

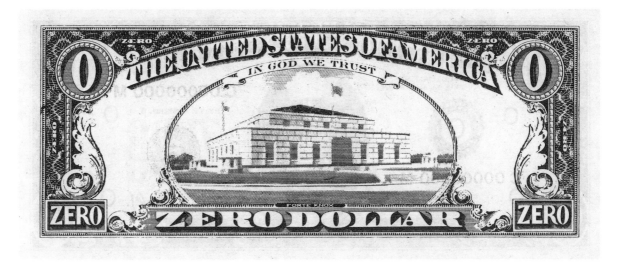

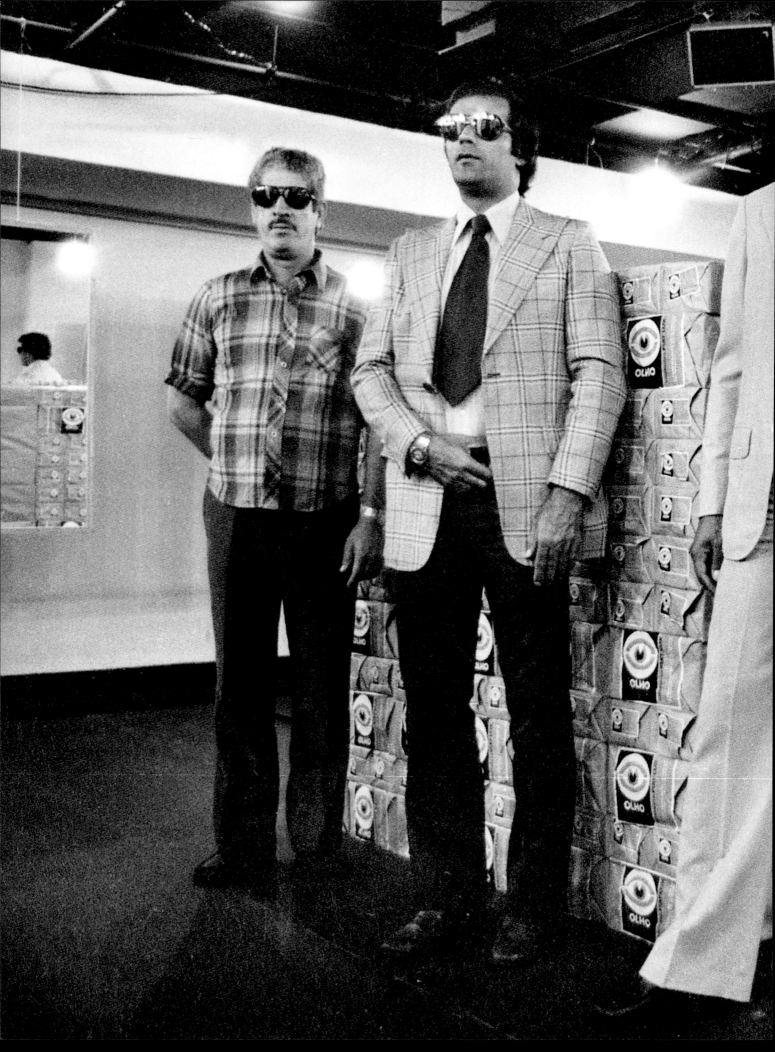

O Sermão da Montanha: Fiat Lux
The Sermon on the Mount: Fiat Lux
1973–9
Duration 24 hours
Documentation photographs of
installation/action at Centro Cultural
Cândido Mendes, Rio de Janeiro, 1979

O Sermão da Montanha: Fiat Lux, 1973–9

The Sermon on the Mount: Fiat Lux

“ [The block of matches] is surrounded by actors dressed as security agents who look like gangsters, with their hands in suspicious positions inside their jackets (as if at any moment they might draw a gun from inside); they 'protect' the matchboxes from the spectators. Around the cube, eight mirrors with transfers of the beatitudes [taken from the Sermon on the Mount in the Gospel of Matthew 5: 3–12] on their surfaces. The presence of the beatitudes was an instinctive strategy, which I try to preserve whenever I can – using as a material something that possesses this quality of ambiguity: of being, simultaneously raw material and symbol. It is a sort of revisiting of the codes that usually seem to regulate society and socially neutralise the collective.

In *Fiat Lux*, I deal directly with gunpowder. You can walk into any bar and buy matches. Why not buy 126,000 boxes? Create a situation of danger through a legal procedure? In fact, you aren't committing a crime. You're exercising your rights as a consumer. Such is the perverse logic of the system. The explosion could kill everyone in the gallery. The danger was evident. My idea was to take away the psychological crutches. The art space already creates a sort of safe territory for experiments. You are inside a museum and, therefore, you will always be covered by a mantle of certainty that you are safe. But there are always shifts and that is what I am interested in.

This project is from 1973. In order to find the matches, I had to go to the Fiat Lux factory.[*] To this end, I contacted the factory's director of public relations who happened to be a [retired] colonel. I went to his office, told him I was a visual artist and that I had a project that required Fiat Lux brand matchboxes. The colonel said: 'The first thing you need to do is come and visit our factory.' So off I went. The factory was near Niterói and was very interesting. When you get inside that space what you find is an Amazon Forest of all those little sticks. The production of matches fascinated me; it was an experience that made a profound impression on me. The factory agreed to sponsor the project and I finally got my matchboxes.

However, when I took the poster for the exhibition (which also doubled as an invitation) to the colonel, a terrible thing happened. The poster was an image of four hundred superimposed razor blades held together by two screws, forming a sort of solid block. Underneath this image was a caption reading 'unity makes strength'. The fact is that the work gives the lie to unity making strength; in point of fact, unity neutralises. One blade is dangerous but a stack of four hundred blades is harmless. The problem was that the brand name Gillette stood out in the image of the razor blade. The colonel thought it was a case of industrial espionage and sabotage to the Wilkinson razor blade that Fiat Lux was to put on the market! He replied that he could not sponsor the exhibition because it was his job that was at stake as well as the company's name. Tunga, Paulo Venâncio Filho, myself and some friends spent the night covering the name Gillette with spray. We spent the night doing them one by one.

I returned to the colonel's office with the 'corrected' posters and asked: 'If we do them this way, would you be satisfied?' He said yes and 126,000 matchboxes were eventually delivered to the exhibition venue per our agreement.

For this work, which lasted precisely twenty-four hours, I wanted everyone associated with the gallery space to be absent (secretary, employees, etc). The space would be guarded. ”

*Fiat Lux is the best known brand of Brazilian matches

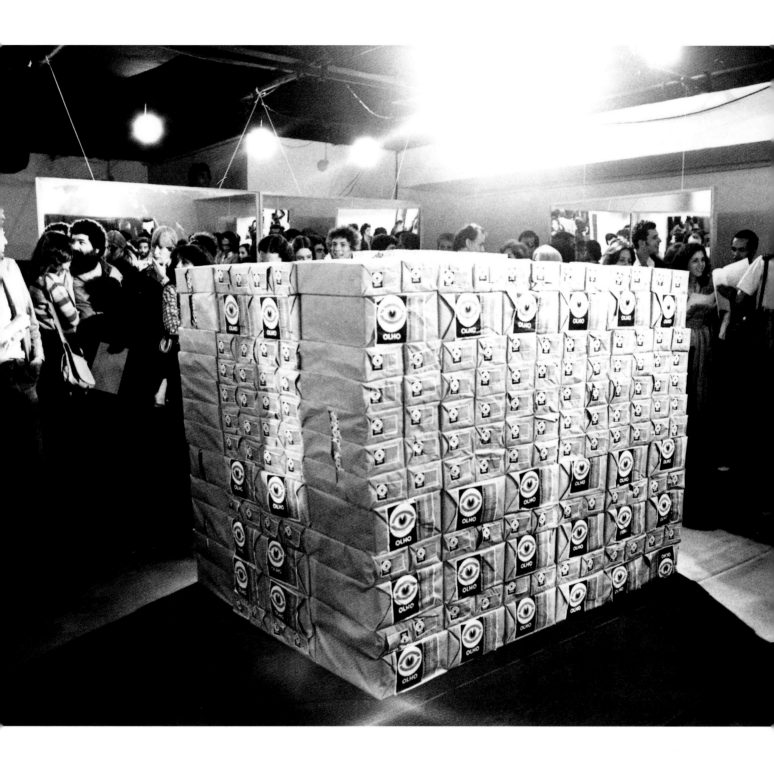

Let there be light

GUY BRETT

In December 1968 the Brazilian military regime issued its 'Fifth Institutional Act'. It was a stark encapsulation of dictatorial power: suspension of all legislative bodies indefinitely, authorisation for the executive to rule by decree, and the provision of a legal basis for the purge of political critics. Two years later, in 1970, an exhibition/event took place at the Municipal Park of the city of Belo Horizonte that not only dared to comment on the socio-political repression but also proposed a radically new practice of art. This was *From Body to Earth*, organised by the artist and critic Frederico Morais and including works by Cildo Meireles, Artur Barrio, Luiz Alphonsus, Alfredo Fontes, Umberto Costa Barros, Thereza Simões and other artists. The co-existence of political reaction and artistic innovation, which is such a striking characteristic of the Brazilian scene of the 1970s, may be a product of a cycle of events or forces that were playing out to different degrees in many parts of the world at the time: youth/student rebellion prompting state repression, spurring in turn people's passionate defence of their creative freedom.

The artists of *From Body to Earth*, in Morais's words:

responded viscerally to the new events, engaging with the arts system in a sort of artistic guerrilla [tactic]. All but banished from museums and galleries, they sought the nomadism of the streets, transforming the city into a great exhibition space or taking advantage of the few opportunities offered by the art circuit – the Bússola [Compass], Verão [Summer] and National Exhibitions – in order to disseminate their radical work. They suffered every manner of difficulty, diving to the bottom of the well, risking everything – life itself.[1]

'We work with fire, blood, bones, mud, earth and debris', Morais went on to say.[2] Artur Barrio left his *Bloody Bundles* around the streets of the city like the horrific remnants of some act of torture or assassination. Cildo Meireles was driven to take a shocking and desperate measure unique in his work: the immolation of live chickens, tied to a stake, on a shabby building site at the opening of the show. His work was called *Tiradentes: Totem/Monument to the Political Prisoner*, and was made in protest against the military's appropriation of a revered figure of Brazilian history.[3] Also in 1970, Antonio Manuel famously linked the idea of liberation in the political and aesthetic realms by presenting himself 'as his own art work', totally naked, at the opening of the National Salon of Modern Art in Rio de Janeiro. Depsite the difficulties, it was a time of close contact between artists, collaborative ventures, debates and manifesto publications like *Malasartes* and *A Parte do fogo*.

It should be remembered that in the same year, Meireles made works of quite a different kind from *Tiradentes*, subtle experiments with the complex relationship between material, our bodily experience, and perception. These include *Eureka/Blindhotland* 1970–5 (p.111–15), *To be Curved with the Eyes* 1970/5 (p.105) and *Blind Mirror* 1970 (p.107). Perhaps it was a

1 Frederico Morais, 'Retrato e auto-retrato da arte brasileira' (1984), *Frederico Morais: Pensamento Crítico*, (org. Silvana Seffrin), Rio de Janeiro, 2004, p.59. Translated for this publication by Stephen Berg.
2 Frederico Morais, interviewed by Francisco Bittencourt, *Jornal do Brasil*, Caderno B, 9 May 1970, p.2.
3 Joaquin José da Silva Xavier (1746–92), known as Tiradentes, was a martyr of the early struggles for Brazilian independence from the Portuguese crown.

rumination on these two realities – of action and contemplation, so to speak – that led Meireles to cast the metaphor of fire in a new conceptual framework that deepens his social and philosophical insights. The result was *The Sermon on the Mount: Fiat Lux* (pp.82–5), one of the most brilliant, audacious and thoughtful works of that time, and since, in any country.

The Sermon on the Mount: Fiat Lux is dated over a span of six years (1973–9). While this may partly represent the artist's period of thought about the idea, it also reflects the fact that he was thwarted in two attempts to stage the work publicly in the late 1970s, until finally it was shown at the Centro Cultural Cândido Mendes in Rio de Janeiro in April 1979. The exhibition/event lasted just twenty-four hours and exists today only as documentary photographs, a film and the memories of those who attended it. Therefore, although it could not be included in the present exhibition, it seemed essential to include it in the catalogue.

Like Manuel's intervention at the Salon, Meireles's work plays on the art world's traditional ritual of self-recognition: the private view or vernissage.[4] Attendees arriving at the Cândido Mendes building descended into a claustrophobic basement where they were faced by a huge cube made up of stacked packages of – they would have recognised this instantly – boxes of matches of the familiar 'Fiat Lux' brand. These goods could have been brought directly from a warehouse. Something odd

Political cartoon of the 1970s by Nilson. An Everyman walking in the city comes across a mirror and looks into it. Over the mirror is the legend 'Wanted'. He is immediately arrested and marched off, as another hapless citizen appears to repeat the process.

4 I am grateful to Paulo Venâncio Filho, Lu Menezes, Luciano Figueiredo and Meireles himself for sharing with me their memories of the event. Figueiredo described it as 'an extraordinarily powerful experience, one of the most immediate and striking I have ever had with a work of art'.

was going on. There had been no sign at the entrance, nor was there any receptionist or desk that would have indicated that this was an art gallery and therefore comfortingly confirmed that one was in the presence of an artwork. Instead, the stack was surrounded by five men with the unmistakable dress and demeanour of body-guards, government agents, or even members of a Death Squad. And they behaved aggressively, inspecting the packages and pushing people about. Furthermore, their shoes, indeed the shoes of everyone present, rasped against a floor of rough paper of the kind used to strike matches, the sound of which was amplified through hidden microphones.

Additionally disconcerting was the presence of mirrors on the surrounding walls. If one looked into the reflection of the assembled company one also caught sight of Jesus Christ's Beatitudes from the Sermon of the Mount, which were inscribed on the glass: Christ's critique of society and his elevation of the powerless.

The response of many was uncertainty, fear and apprehension. They remember that it was impossible to tell at first what was real and what was fiction. Some were angry, thinking that the art event had been invaded by the authorities as an aggressive symbol of the dictatorship's power: 'Even here, too?', they asked themselves. Others were afraid that the huge accumulation of phosphorous could explode. At one point, this became a serious possibility as a few rash spirits took matches from the packages and began striking them. The film shows that during the evening, the military police arrived: real police, not the actors who were playing the body-guards. But they too were uncertain what was going on. There was nothing for them to do so they withdrew.

The brief duration of the piece and its immediacy for those who were present may disguise its multiple layers of meaning, its wit and rich ambiguities. Even the biblical title is a mixture of new and old testaments, of a societal and cosmological reference. Then, in terms of genre, there is a deft interplay between sculptural, spatial and performance elements. There is a dual link with moments in art – with the historical avant-garde in the shape of the Duchampian readymade, and with the then contemporary movement of Minimalism, which Meireles both paid homage to and exceeded. Meireles is of the generation that re-encountered Marcel Duchamp and discovered further possibilities in his ideas. Echoing the procedure of the readymade, the artist simply went out and bought a commonplace commodity – a box of matches – shifting it from a familiar to an unfamiliar context. Then he went a step further: by accumulating the box in excessive quantities beyond the pattern of its normal use, he showed that its state could be transformed qualitatively into something else – from one of safety, domesticity and containment to one of illegality and danger. This was simply a problem of the contradictory nature of the one and the many.[5] The cube of matchboxes may echo the Minimalist work of artists like Carl Andre, Donald

5 The poster announcing the event
 reversed this relationship by showing
 a photographic image of hundreds of
 razor-blades held together in a clamp.
 One blade cuts, but a large number
 bound together is harmless.

Judd and Sol LeWitt – monumental works built from the incremental repetition of identical elements, which glory in the plain, self-evident, non-symbolic 'objecthood' of their materials – but in Meireles's case the incremental process creates a new state of the material: its explosivity.

This brings allegory into the equation, something that was anathema to the Minimalists. The central feature, the great cube, is a symbol of fire and light. The whole ensemble may then be seen not only as a social critique, but as an allegory of art itself, a complex one because the presence of the guards can be read in two ways. Either the cube is guarded because of its potential physical danger to the public, casting the action of the guards in a benign light; or it is guarded in order to repress and inoculate enlightened and emancipatory ideas, of which it is the symbol. It is precisely by means of its ambiguities between a real and a fictional scenario, between the actual and the symbolic function of art's materials, that the piece sharpens our thinking and our ability to tell these two states apart.

Of the period of avant-garde artistic experiment in Brazil under the conditions of dictatorship, Meireles has said that 'things existed in terms of what they could stimulate in the social body . . . At that time our objective was to reach as large and indefinite a number of people as possible.' His *Insertions into Ideological Circuits (Coca-Cola and Banknote projects)* 1970 (pp.62–7) epitomise that aim by attaching themselves to already existing mass-circulation systems, 'a type of practice over which there can be no type of control or authorship'.[6] *The Sermon on the Mount: Fiat Lux*, on the other hand seems, partly at least, devised to address a specific public of intellectuals and artists, who were invited as if to a private view (the notion of a 'private view' of the *Insertions* would be absurd!) Addressing that public's self-image in highly original terms, *Fiat Lux* continues to magnetise us as an allegory placed at a key crossroads of thought about the work of art, its effects, its efficacy, its potency. It is a work about potential, on a tension-point between repression and release.

6 Cildo Meireles, from an unpublished interview with Antônio Manuel, quoted in Gerardo Mosquera, Paulo Herkenhoff, Dan Cameron, *Cildo Meireles*, London, Phaidon Press, 1999, p.110.

Malhas da Liberdade, 1976
Meshes of Freedom

" In the 1960s I was always doodling, like anyone who is bored. First I'd draw a line, then another that intersects it, and so on, until I'd made a grid. In 1976 I decided to do the same with more rigid materials. Then it was no longer a matter of lines over lines; the second line was on an altogether different plane. This is the origin of *Meshes of Freedom*, of which the grid is just one manifestation. The work consists of a module and a law of formation: how the module intersects the previous one determines how it is then intersected by a third, and so on. The composition creates a grid, which spreads over a plane, but it also starts to grow in space, to create a volume. Theoretically, this structural principle could be used to make an endless variety of forms, from cubical, to spherical, to random structures. It has no formal limitations, but allows rather the passage from one part of the structure to another, at any point of the structure.

I tried to find information, especially in mathematical literature, about this principle of growth. I thought it was so obvious. Why had nobody done it before? If it had never been done, perhaps this was to be my greatest work! However, I suspected it had already been done, in network theory. At the time, I asked some friends who were mathematics lecturers in the University of Brasília for more information and background, but they couldn't help me. Later I learned of the work of Mitchell Feigenbaum, a North American physicist who published this theory, apparently for the first time, in 1977, the same year I sent the work to the Paris Biennial. He developed the theory of the universal coefficient, a number that appears many times in the most diverse circumstances. In transitional states, you always find this number, a mathematical constant, based on a concept of branching forms, known as 'cascades of bifurcations'. A similar concept appears in Borges's story, 'The Garden of Forking Paths' (1944). For the Paris Biennial I wanted to make a cell-like space, the sides of which would be made of grids using the structural principle … What I had wanted to send was strips of paper, with instructions for constructing this ambiguous and paradoxical space from paper strips. Finally I sent the metal version of it. ∅

I recognise a great deal of myself in this work. It is more or less the way in which I surprise myself in reasoning, because it forks and this forking generates a fork that generates another fork. Thus, I am oftentimes extremely far from where everything began. I mean, reasoning as an increasing distancing from this initial point. This could be good or it might delay things quite a bit. "

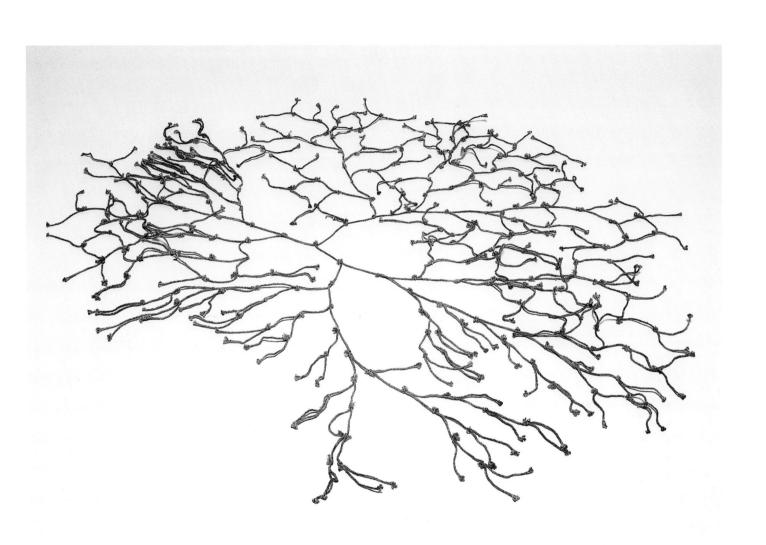

Malhas da Liberdade III
Meshes of Freedom III
1977
Iron, glass sheet
120 × 120

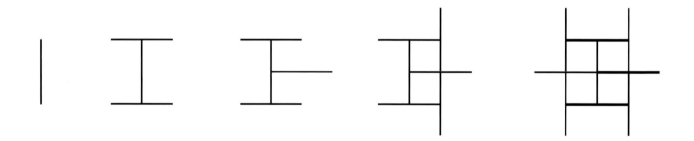

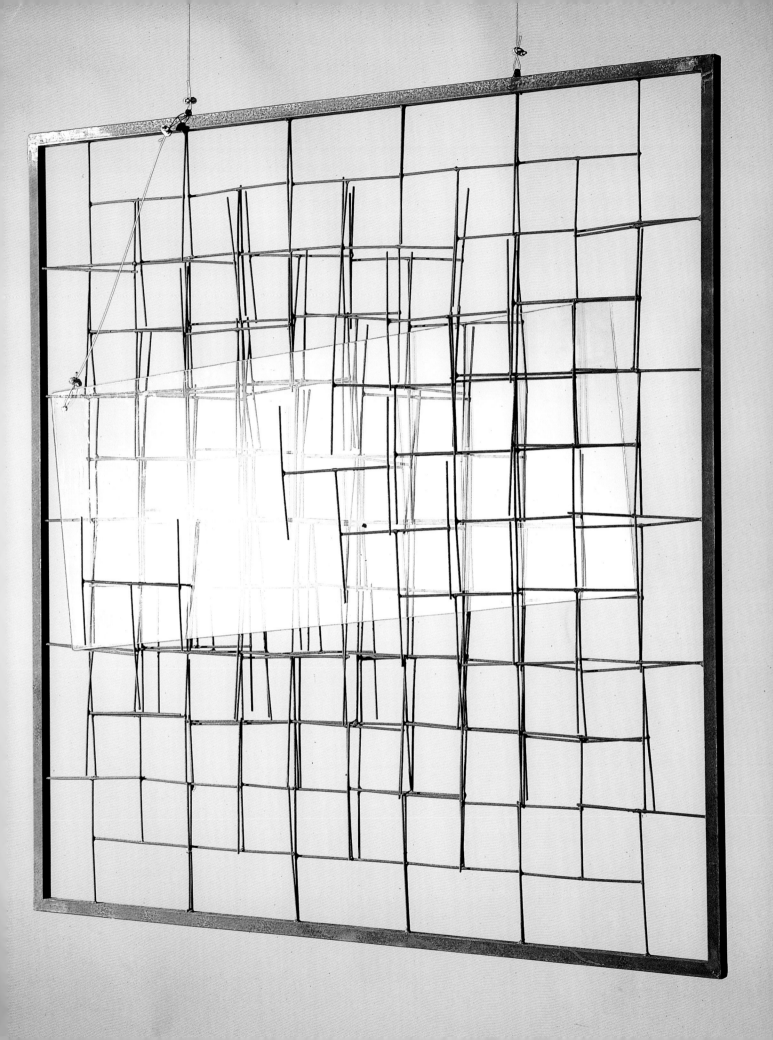

Mebs/Caraxia
1970–1
Vinyl record, recorded with
frequeny oscialltor
Two-track recording
Diameter 17.6

Mebs/Caraxia, 1970–1

" In 1969–70, I began to list a series of ideas that were linked to the object 'disc'. At the time, they were made of vinyl. I thought that, through sound, I could advance a bit more in works that dealt, for instance, with the problem of topology. The first compact vinyl disc was *Mebs/Caraxia*, the title of which comes from two sound graphs. My idea was to do a sound sculpture. We began recording it in December 1970, and it was ready a month later. One side was called *Mebs* because of the Moebius strip; the other side was a spiral, and for the title of that spiral I decided to use the union of two words that refered to spiral structures: [the Portuguese words *caracol* (snail) and *galaxia* (galaxy)]. Hence the title *Caraxia*. The sound in *Mebs/Caraxia* is frequencies being altered. I had a graph and I followed it.

We established an axis and then the frequency was either above or below this axis. So we reconstructed the graph as we went; the idea was literally to make sound graphs. The graph dealt with frequency and time. So I had a frequency axis and a time axis.

At some point, I became interested in experimenting with the materials. So the idea was to use wooden, clay, ceramic, steel or even round sandpaper discs in lieu of vinyl. The record itself damaged the player. We could only play them once. Each time we played them, we had to change the needle – when we used sandpaper, for instance. What I was interested in at that moment was the needle retransmitting the sound of the attrition. But this idea never moved past the project stage. "

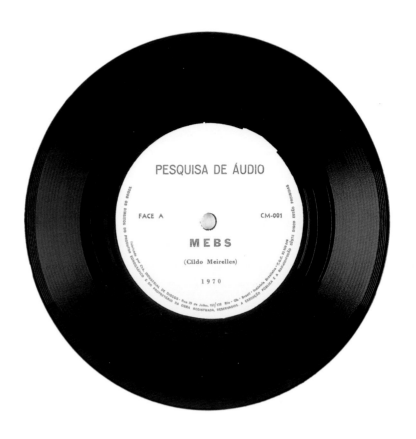

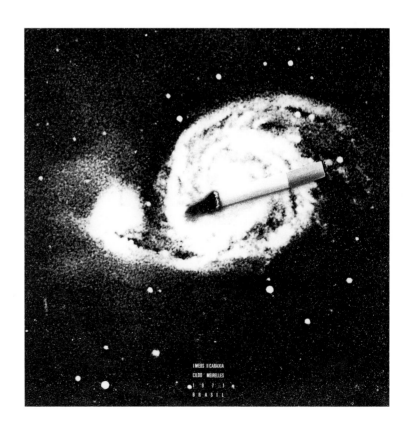

Sal Sem Carne
Salt without Meat
1975
Vinyl record, eight-track recording
Diameter 30.2

Sal Sem Carne, 1975
Salt without Meat

" The idea of *Salt without Meat* was the ghetto; that is to say, something that begins with a restriction of some kind – whether ethnic, ideological or economic – and how, the minute that ghetto situation is established, the exchange of information accelerates in such a way that, after a while, an inversion occurs. The trend is that the ideology of the ghetto spreads and occupies the discriminating – and descriptive – part of the equation. The idea was to use the problem of the colonisation of Brazil as an example of this: the confrontation between the arrival of the Portuguese and the natives and the way those two cultures interacted. And that was *Salt*

without Meat, which I made soon after I returned to Brazil [from the US] in 1973. Of the eight tracks, four are associated with white Portuguese culture, and four are associated with Indigenous culture. One of the four channels associated with white culture, specifically the time broadcast [of the radio station that broadcasts time and frequency] lasts fifty minutes, and is the axis of the work. The work contains a recording of the feast of the Divine Eternal Father, in Goiás state; there is a recording at a camp in São Cotolengo, in Trindade, which is one of the two or three largest religious processions in Brazil. I remember people walking in front of my grand-

mother's house in the 1950s and 60s, praying, walking on their knees, carrying objects and following the procession. In addition to this, there is an interview with Zé Nem, the Xerente indian, whose story refers back to *Zero Cruzeiro*. A record was made and on one of the channels there are these four 'white' channels and, on the other loudspeaker, you can balance the discourse of the 'whites' and the 'Indians'.

All the sounds were recorded in Brazil: the Radio Relógio was recorded in Rio de Janeiro. The rest of it was recorded in Goiás. "

**Missão/Missões
(Como Construir Catedrais)
Mission/Missions
(How to Build Cathedrals)**
1987
Approximately 600,000 coins,
800 communion wafers,
2,000 bones, 80 paving stones
and black fabric
235 × 600 × 600

Missão/Missões
(Como Construir Catedrais) 1987
Mission/Missions (How to Build Cathedrals)

" This work was created for the exhibition *Visão do Artista*, a group exhibition of Brazilian artists to commemorate a moment of Brazilian history: Os sete povos das Missões, the seven mission settlements founded by the Jesuits in the South of Brazil, Paraguay, and Argentina between 1610 and 1767 to cathechise the Indians. The exhibition was curated by Frederico Morais.

The idea of the project was for a group of artists – we were ten or twelve – to each learn about a part of this historical episode, and to base a work for the show on that. We were taken to São Miguel das Missões, where we spent a number of days, visiting, getting to know the place, and obtaining information from different people linked with the exhibition project. On returning home, each of us had about three weeks to a month to prepare and begin production. ¶

I wanted to construct something that would be a kind of mathematical equation, very simple and direct, connecting three elements: material power, spiritual power, and a kind of unavoidable, historically repeated consequence of this conjunction, which was tragedy. I wanted a sky of bones and a floor of money, and a column of communion wafers to unite these two elements. If some day I were to remake *Mission/Missions*, instead of making it square, I would most certainly make it cylindrical. I would make the metallic structure that holds the bones and the lighting cylindrical. The lights that are mounted in the structure pierce through and specifically light the coins. The light of the work depends on local currency, on what metal it is made of. In Brazil, the centavo is silver. In the USA and in England the small value coins are copper, so it's a reddish colour. In France it is yellow because the coins are golden. Actually, the light of the piece is the light of the reflection of these lamps on the coins. Basically, that's it.

I believe in all the gods and respect them, but I am not able to bring myself to believe in religion. And, in fact, the communion wafer is a clear element of Catholic culture. The Missions, which disappeared with the extermination of all the seven nations around 1770, were something of a socialist experiment, perhaps … Yet, basically, the entire emancipatory process is destructive, there is a degree of genocide involved no matter how good the intentions. The unembellished fact is that one culture or civilisation is absorbing another. ¶ "

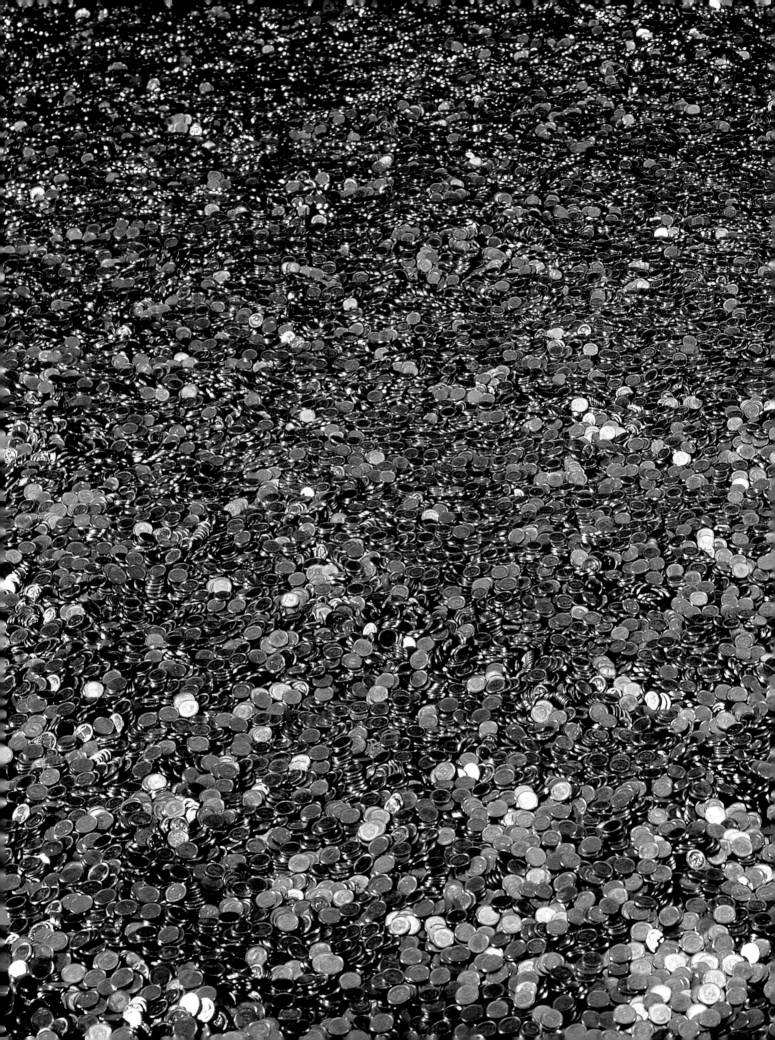

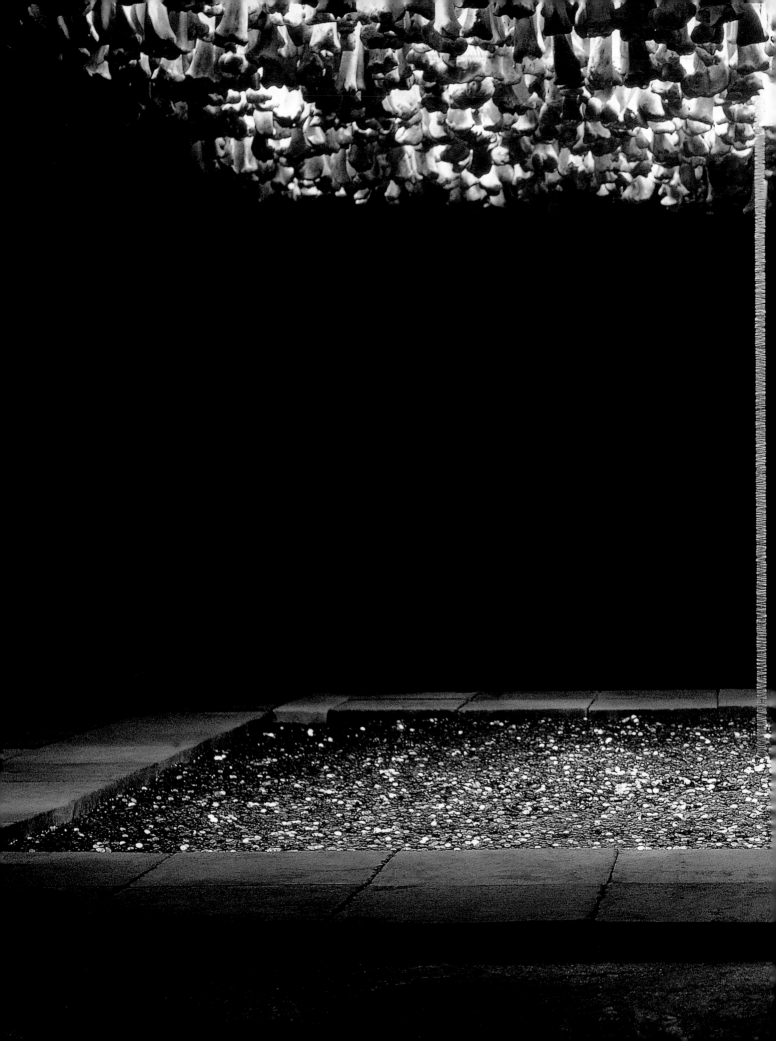

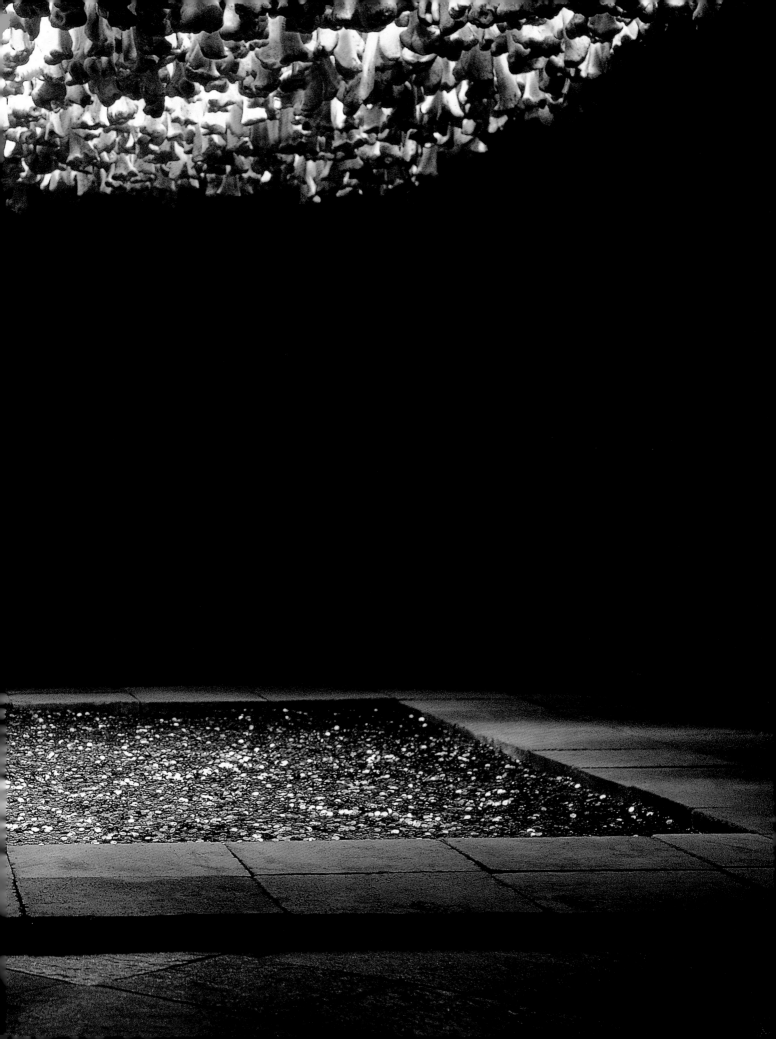

Obscura Luz
Dark Light
1982
Wood-based industrial sheeting,
electric light, lightbulb
66 × 66 × 22

Obscura Luz, 1982
Dark Light

" *Dark Light* is one of those things that appeared as if someone had lit the work up in front of me. Like imagining you are looking at a given place. Suddenly a black light bulb appears radiating light. The title refers to [poet] Carlos Drummond de Andrade's *Claro Enigma* [Clear Enigma]. This is the instance of paradox: managing to make the source of the light we are physically seeing be the dark image there in the centre of all that light, which is actually the shadow of another light bulb. "

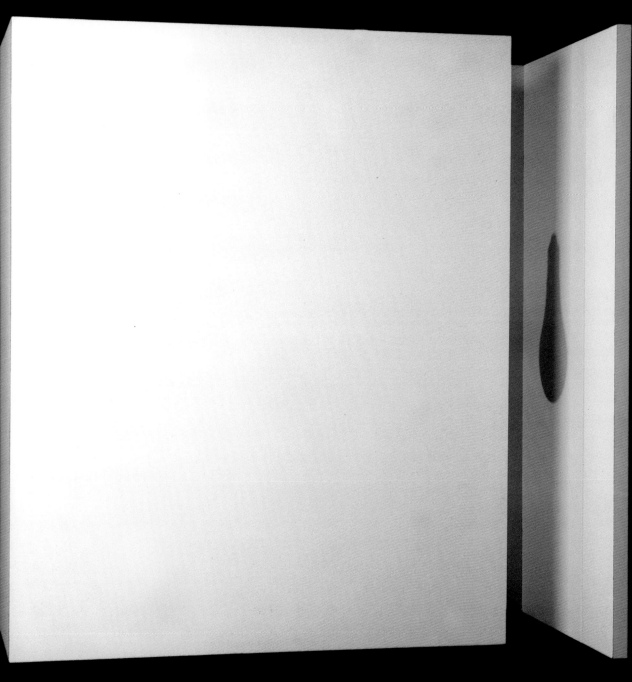

Para ser Curvada com os Olhos
To be Curved with the Eyes
1970/5
Wooden box, iron bars, graph paper,
bronze plaque, enamel plaque
12 × 50 × 25

Para ser Curvada com os Olhos, 1970/5
To be Curved with the Eyes

" The idea of this work is that, no matter what exhibition I prepared, it would always be there, until one day, slowly, the second bar would also become curved by the sum total force of the gaze of the spectators. And the way to get lots of people to look at it was that, no matter what the exhibition, *To be Curved with the Eyes* had to be part of it until the bar was curved.

There is a link between *To be Curved with the Eyes* and *Blind Mirror*, and not only because they belong to the same period (1970). The idea behind *Blind Mirror* is to obtain a result through a displacement of senses. In *To be Curved with the Eyes*, this means talking about an energy of the gaze. The two works are related. They complement one another, as it were. Additionally, touch is encouraged by one of them while, in the other, touch is forbidden. *To be*

Curved with the Eyes is based exclusively on the gaze, that is, without touch. That is how they relate to one another: one is 'Please do not touch under any circumstances', while the other is 'Please touch'.

There is a clear reference to Magritte in those works. And, in turn, to the source of Magritte's works, such as *This is not a Pipe*, which lies in the readymades, if for no other reason than because (in terms of art history) they preceded him. Within the readymade, the phrase that would synthesise the whole idea behind the work is: 'This is art'. Exercising this descriptive authority was an attribute of the readymade. For me, Magritte expanded that concept, worked with its variations and possibilities. "

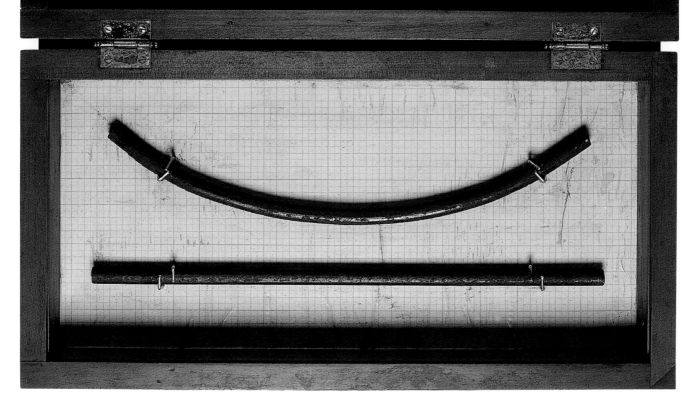

DUAS BARRAS DE FERRO
IGUAIS E CURVAS

© 1970

CM 1975

Espelho Cego
Blind Mirror
1970
Wood, mastic, metal
49 × 36 × 18

Espelho Cego, 1970
Blind Mirror

" *Blind Mirror* was born at the same time as *Eureka*. I always associated one with the other: the cross and the two bars. And in principle, I mean, the work was exactly what the title proposed. *Blind Mirror* was fundamentally about making a mirror that would meet the representational or mirroring needs of a blind person. Actually, the original title was in English. But I didn't want to say 'mirror for blind people'; I preferred 'blind mirror'.

The function of the mirror was literally to obtain not an image but a volumetric replica or low relief of a face or any other form. In a way, the comprehensibility of the 'image' took place through touch instead of through the gaze. It is perception of the object through touch.

The mirror is made of mastic, a material that stays soft almost forever. You press your hand in and it remains moulded in that substance. The dough doesn't return to its original [state]. Someday I'm going to make it with *memory plastic*, that is, a type of plastic that has memory: it deforms and then returns to that perfect surface. But, at the time, no one thought of that.

It is a mirror that will reproduce something but in relief, so you really do have to read it with your hands. It will record whatever you press onto the mastic, but always in a temporary way because the material will always take another form, whatever object next touches the mirror. The images are replaced, superimposed; it is in constant movement, always being transformed into something else. "

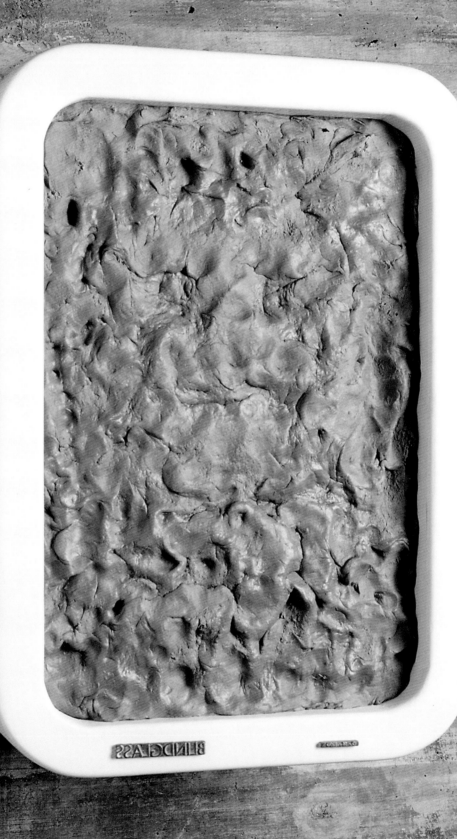

A Diferença entre o Círculo e
a Esfera é o Peso
**The Difference between the Circle
and the Sphere is the Weight**
1976
Texts and drawings on paper
Various dimensions

A Diferença entre o Círculo e a Esfera é o Peso, 1976

The Difference between the Circle and the Sphere is the Weight

" The work signals an awareness of the plane, in its most primitive form, which is the sheet of paper, and its subjection to an action – in other words, crumpling the paper. It is a sort of passage of drawing to sculpture, from the plane to three-dimensional space. In doing this, the fact is that what was already there (on the sheet) becomes more eloquent, which is the instance of weight. I believe it was weight that classically (or generally) defined those two fields: the piece is a drawing and a sculpture. Calder was one of the pioneers in isolating this problem. But after him, it became evident. At any rate, this work is born from that primary gesture: transforming one dimension into another. "

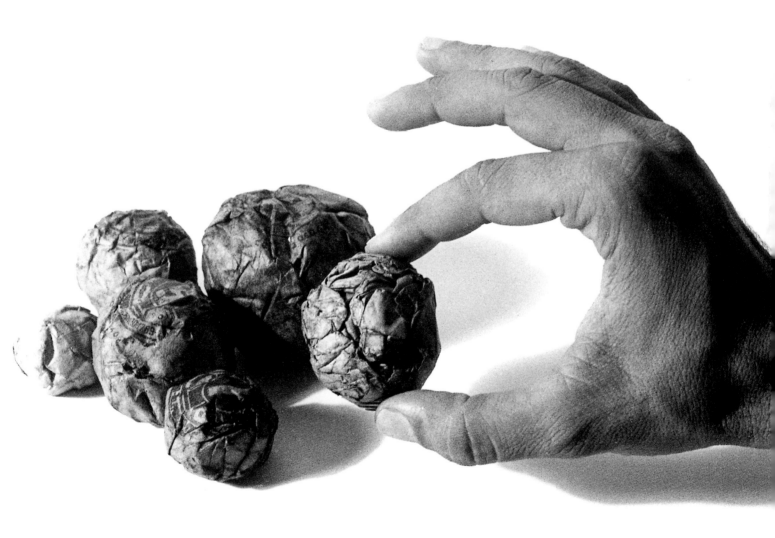

Eureka/Blindhotland
1970–5
Rubber, fishing net, metal, cork,
wood and audio
400 × 700 × 700

Eureka/Blindhotland, 1970–5

Eureka [consists of] a wooden cross, placed on a weighing scale, and two identical bars of the same wood, placed on the other scale. They are both seen to weigh the same, although the perceiver would assume they had different weights. ∅

[*Blindhotland*] is the generic name given to a series of works begun in 1970, in which the dominance of the visual gives way to a 'blind' perception of reality through the senses of hearing, smell and taste; through awareness of density, heat, and so on. ∅

The second part consists of 201 rubber balls, whose weight varies between 500 grams and 1500 grams, with 5 gram differences.

The third part was the soundtrack, which I titled *Expeso*, spheres of different weights falling from different heights, at different distances from the microphone. There are eight situations: it's the same weight with the balls falling a metre away from the microphone, with fifty spheres; then, fifty different spheres of different weights, being cast from different distances and different heights. Therefore, there were always three different elements: the height of the fall, the distance from the microphone and the weight of the sphere.

It was always possible for people to enter the piece, so much so that three balls were stolen from the first exhibition. As for the net, the idea was to create a special autonomy for the piece itself – a sort of intimacy that would simultaneously function as an occupation, as a demarcation, a structure that is permeable to the gaze, in addition to being functional, one that would keep the spheres from spreading all over the place. So much so that I ended up using these nets in *Through* as a way to demarcate space and/or borderlines.

This work came about in 1970. My intention was precisely not to propose a paradox, but to attempt to foil Archimedes and the problem of density, which, for the history of art, is almost a sort of simplified model, because it deals with problems of substance and appearance, form and content, mass and volume. The formula for density is mass divided by volume; therefore it is almost the essence of artistic practice. "

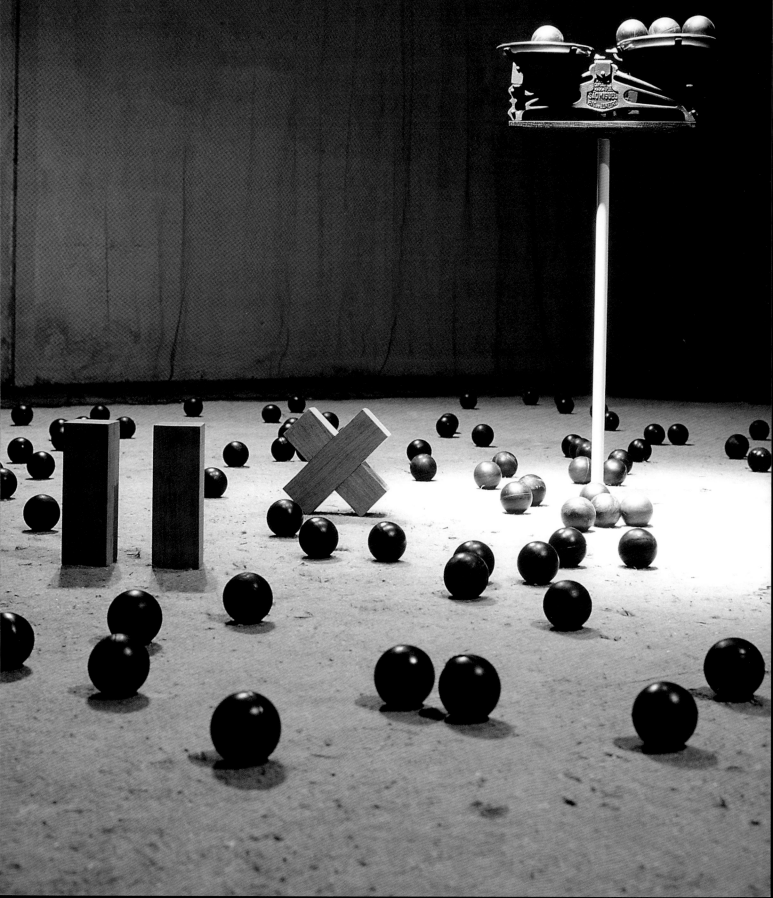

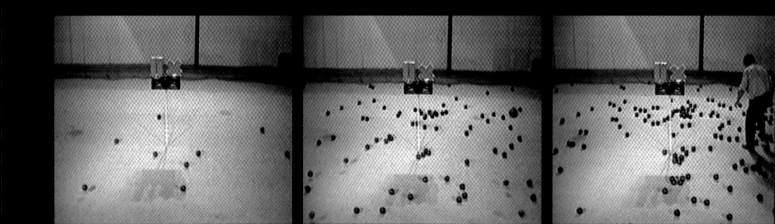

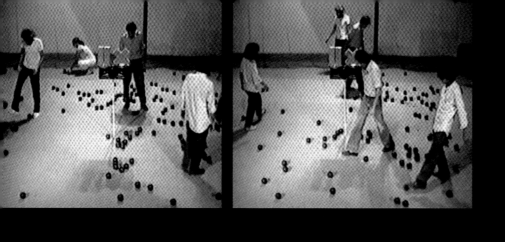
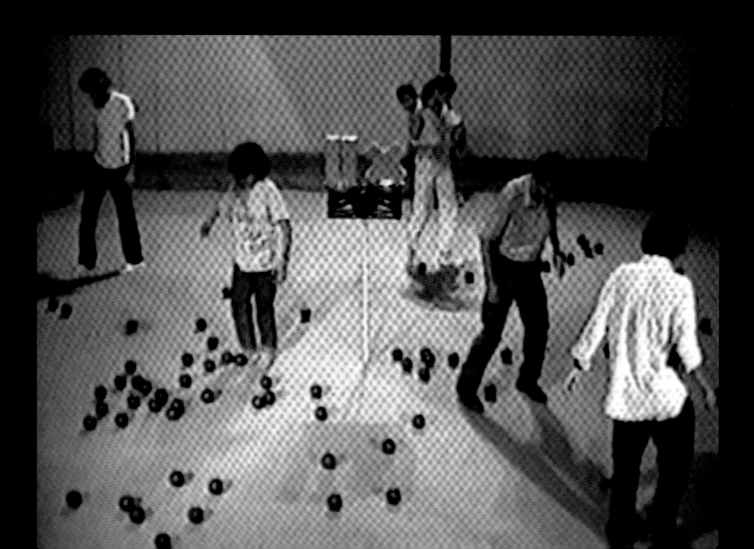

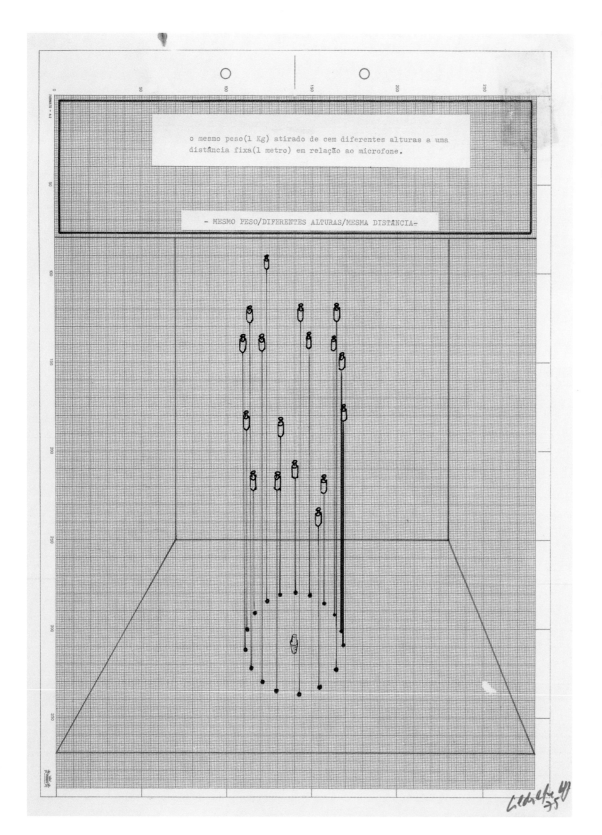

o mesmo peso(1 Kg) atirado de cem diferentes alturas a uma distância fixa(1 metro) em relação ao microfone.

– MESMO PESO/DIFERENTES ALTURAS/MESMA DISTÂNCIA–

Eureka/Blindhotland:
Expeso
1970–5
Ink on millimetre
graph paper
70 × 50

[The same weight (1kg)
dropped from one hundred
different heights at a fixed
distance (1 metre) from
the microphone.

– SAME WEIGHT/
DIFFERENT HEIGHTS/
SAME DISTANCE –]

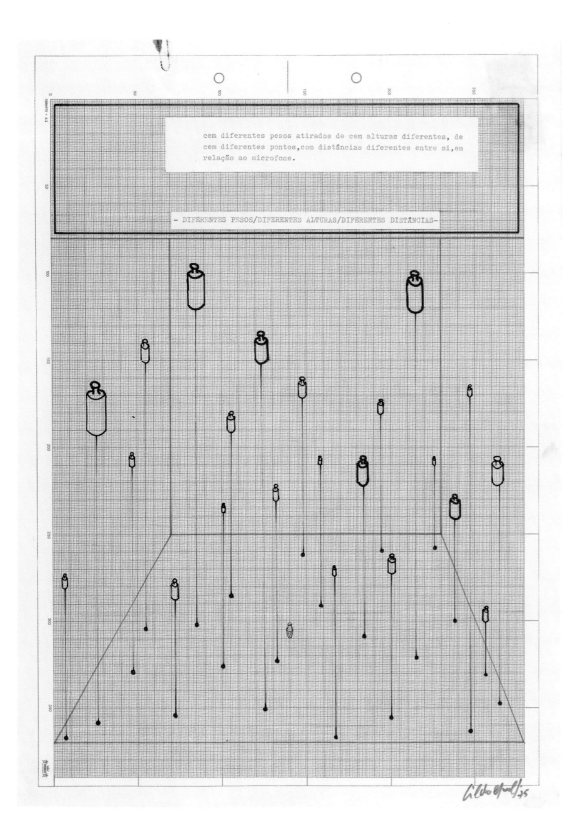

cem diferentes pesos atirados de cem alturas diferentes, de cem diferentes pontos,com distâncias diferentes entre si,em relação ao microfone.

- DIFERENTES PESOS/DIFERENTES ALTURAS/DIFERENTES DISTÂNCIAS-

Eureka/Blindhotland:
Expeso
1970–5
Ink on millimetre
graph paper
70 × 50

[One hundred different
weights dropped from
one hundred different
heights, from one hundred
different points, at
different distances from
the microphone.

−DIFFERENT WEIGHTS/
DIFFERENT HEIGHTS/
DIFFERENT DISTANCES−]

Worldmaking

*Although conception without perception is merely empty,
perception without conception is blind (totally inoperative).*
Nelson Goodman[1]

LYNN ZELEVANSKY

Cildo Meireles is best known for his large-scale, theatrical installations; at once seductively beautiful and foreboding, they are environments in which viewers can observe and act. In these works, the artist examines issues of perception, a concept with both rational and non-rational implications. As an academic discipline, perception encompasses psychology, philosophy, neuroscience and biology, fields associated with logic and reason. The word also connotes intuitive understanding of moral, psychological or aesthetic qualities, apprehensions informed by the senses that are usually more emotional than intellectual.

Meireles explores the psychic and physical impact of space on the viewer's body. His minuscule (9 × 9 × 9 mm) wooden cube of 1969–70, *Southern Cross* (pp.58–9), sits spot-lit on the floor. Ideally, it should be the only object in an otherwise empty museum.[2] The cube, half soft pine, half hard oak, is named after the constellation that marks due south and guided early explorers of the Southern Hemisphere as they sailed.[3] Approaching it, a conceptual shift occurs. Viewers may see the work as tiny, or themselves as huge; *Southern Cross* might be a giant monument observed from a vast distance; or perhaps it provides a 1970s view, from a culturally marginalised Brazil, of art in the capitals of Europe and North America.

A related Lilliputianism (a shifting back and forth in one's perception of size, one's own and that of other objects) is at work in *Eureka/Blindhotland*, which Meireles developed between 1970 and 1975 (pp.111–15). It is composed of four parts: *Eureka, Blindhotland, Expeso* and *Insertion*. For *Insertion*, he placed uncaptioned, paired images of a catatonic man and a black rubber ball in eight different Rio de Janeiro newspapers to coincide with the installation's opening in 1975 (p.119).[4] In one pair, the person is large and the ball is small; in another the reverse is the case; in a third both images are small; in another both are large. In the next set of four, the order of the images is reversed. Systematically organised, the pairs are never the same.[5]

Surrounded from floor to ceiling by a soft net, a kind of gridded curtain, *Eureka/Blindhotland* was Meireles's first work to define and control a discrete space.[6] *Eureka* is comprised of a set of scales on top of a post located in the midst of the environment; two wooden blocks sit on one side of the scales, a cross made of identical blocks on the other. The two shouldn't balance (there is less wood in the cross because the blocks intersect) but they do. *Blindhotland* contains 200 rubber balls, strewn across the floor of the piece and around the scales. They appear to be identical but are of radically different weights. Vision alone is insufficient to comprehend this installation; it is only by entering it and picking up the balls that one begins to gauge its meaning.

The work's fourth part, *Expeso* (roughly translating as 'Against Weight'), is an audio recording of eight methodically composed variations of the

1 Nelson Goodman, *Ways of Worldmaking*, Indianapolis, Indiana, Hackett Publishing Company, Inc. 1985, p.6.

2 Meireles has shown *Southern Cross* alone in large rooms but he has yet to be given an entire museum for the work.

3 Soft pine and hard oak are sacred to Brazil's Indians, who rubbed the two together to make fire.

4 *Eureka/Blindhotland* was shown at Rio's Museum of Modern Art in October 1975.

5 This part of *Eureka/Blindhotland* is related to Meireles's *Insertions into Ideological Circuits* 1970 (pp.62–7), the anti-government slogans that he pasted on empty Coca-Cola bottles and stamped on paper currency before recycling them or sending them back into circulation.

6 The date of Meireles's installation *Red Shift*, 1967–84, suggests that it was conceived or in development earlier than *Eureka/Blindhotland* but not realised until much later. *Eureka/Blindhotland* was the first of the major installations to be realised.

sound of the balls dropping.[7] Variables include the height from which the balls are dropped, the weight of the balls, and the distance of the balls from a microphone situated at the centre of the installation. First, 100 identically weighted balls were dropped from a hundred different heights, all at the same distance from the microphone; then the same number of balls of varying weights were dropped from 100 different heights, at 100 different distances from the microphone. Each situation recorded creates a different sense of space.

Eureka/Blindhotland was inspired by Jorge Luis Borges's story 'Tlön, Uqbar, Orbis Tertius', which focuses on the power of individual perception. It recounts the invention of a country in the seventeenth century by a secret society of scientists, and its discovery and reinvention as a planet by an eccentric US millionaire in the nineteenth century. The narrator encounters a tiny metal cone that is so heavy, a grown man can scarcely lift it. He is extremely disturbed by this absolutely unfathomable object.[8] The cone is akin to Meireles's rubber balls.

Meireles also greatly admires filmmaker Orson Welles, in particular his infamous 1938 radio broadcast of the H.G. Wells novel *War of the Worlds*. Welles situated the book's Martian invasion in the US state of New Jersey (as opposed to England), and treated it as a series of news flashes that escalated in frequency and concern. Extremely realistic, the programme caused widespread panic.[9] Like Borges, Welles created a distinct world. *Eureka/Blindhotland*

suggests a similarly self-contained sphere. Meireles has said that, while conceiving the piece, he read about the itinerant Brazilian circuses of the late nineteenth and early twentieth centuries that died out with the advent of radio, cinema and television.[10] Within those circus tents, a different reality prevailed. The net that encircles *Eureka/Blindhotland* is meant to function as those tents once did.

Eureka/Blindhotland's underlying conceptualism, its challenge to visual perception, and its pleasure in confounding its audience, recall Marcel Duchamp. His 1921 sculpture *Why Not Sneeze Rose Sélavy?* is composed of a cuttlebone and a thermometer that are stuck amid what appear to be sugar cubes. All of these elements are encased in a small birdcage. The work's title, inscribed on the underside of the cage, is visible only when the cage is lifted. The sculpture appears light but is, in fact, extremely heavy: the 'sugar cubes' are made of marble, functioning like the weighty rubber balls in *Eureka/Blindhotland*, while the scales in Meireles's work suggest Duchamp's measuring device, the thermometer. The net encloses the entirety of the installation as the birdcage does the readymade.[11]

There are many interpretations of *Why Not Sneeze?* Duchamp said that the thermometer was to measure the temperature of the marble. The work has associations with weight, promised (and foiled) sweetness, and missing warmth. The sneeze may represent sexual catharsis.[12] Time, unfortunately,

7 Meireles coined the term *Expeso* combining the Latin *ex*, meaning 'against' and the Portuguese *peso* meaning 'weight'. Telephone conversation with the artist, 3 November 2007.
8 Jorge Luis Borges, 'Tlön, Uqhar, Orbis Tertius', in *Labyrinths: Selected Stories and Other Writings*, New York, New Directions Publishing Company 1964, p.17.
9 The Orson Welles radio broadcast took

place in New York City on 30 October 1938. It was a Halloween special presented as part of CBS's *Mercury Theatre on the Air*.
10 Unless otherwise attributed, comments from Cildo Meireles were drawn from a telephone conversation with the author, 6 September 2007.
11 As is the case with so many artists of Meireles's generation, Duchamp was a

major influence. However, in this instance, that influence was not conscious and the connections between *Why Not Sneeze Rose Sélavy?* and *Eureka/Blindhotland* are drawn by the author.
12 Janis Mink, *Marcel Duchamp: Art As Anti-Art*, Cologne 1995. See http://www2.english.uiuc.edu/finnegan/English%20256/why_not_sneeze.htm

has robbed it of one of its most essential properties: *Why Not Sneeze?* was made to be lifted, but today viewers are unable to touch it. Within its Plexiglas vitrine, it has been reified, made into an icon of modernism. Its active, physical engagement with the observer is nullified. In contrast, *Eureka/ Blindhotland* remains performative and dynamic. Anyone who enters the installation has the opportunity to affect it. In his art, Meireles often allows for a degree of randomness that comes with viewer participation: visitors leave tracks in the talc of *Volatile*; crush the glass beneath their feet in *Through*, and shift the positions of the balls in *Eureka/Blindhotland*. These alterations are often subtle. You would have to live with the works over time to take them in fully; but the existence of change is significant. It connotes a partnership with the audience, and suggests the spirit and dynamism of daily life.

Like much of Meireles's art, *Eureka/Blindhotland* resists cohering into a single narrative. In Meireles's major works, meaning is shaped by years of configuring and reconfiguring influences, concepts and theatrical gestures. As a result, even he can't always remember where an element or idea originated. He says that he chose the wooden blocks and cross in *Eureka*, not as symbols, but because they are elemental forms with multiple meanings. Do the scales represent justice? Produced during the Brazilian dictatorship, could *Eureka* be read as

political commentary? The word 'eureka' is associated with Archimedes, the Greek mathematician, physicist and inventor, who is said to have shrieked it when, while sitting in the bathtub, he suddenly realised that the volume of an object could be determined by the amount of water it displaced when submerged.[13] This could reflect Meireles's interest in density (the weight of the balls). It's possible that *Blind* in the title refers to the dominance in the work of touch and hearing over retinal perception. Considered with the scales, it suggests the notion of 'blind justice', which implies both objectivity and a legal system that, to a negative extent, is inured to the circumstances of each situation. Asked about *hotland*, Meireles seems unsure of its meaning. *Land* may connote a field of experience; perhaps *hot* refers to Brazil.

Whatever its intellectual associations, the physical experience of the work is preeminent. Meireles undermines exclusively retinal perception and interpretation but, in his work, retinal sensation – the experience of beauty – remains important. The elegance of the work's fundamental geometry (the grid of the net, the elements on the scale, the circular balls) communicates almost viscerally. Meireles's art proposes 'a path whose end we don't know yet'.[14] With it, he simultaneously sustains and discomforts viewers, believing that a degree of anxiety heightens awareness.

13 This discovery allowed Archimedes to detect the amount of alloy that was mixed with gold in the crown of the King of Syracuse, a challenge that had been posed to him.

14 Frederico Morais, interview with Cildo Meireles, in *Cildo Meireles: Algum Desenho / Cildo Meireles: Some Drawings (1963–2005)*, exh. cat., Centro Cultural Banco do Brasil, Rio de Janeiro 2005, p.63.

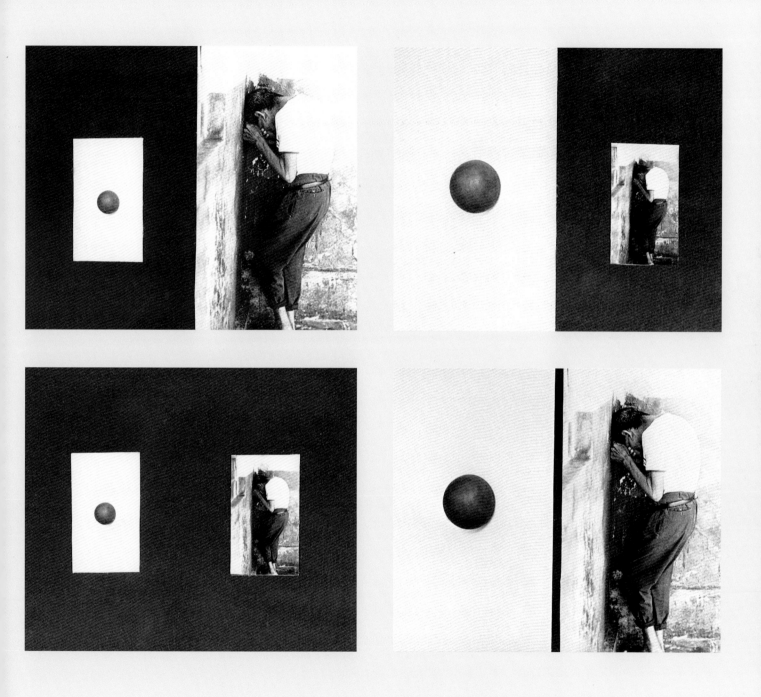

Desvio para o Vermelho:
I. Impregnação
Red Shift: I. Impregnation
1967–84
White room, red objects including
carpet, furniture, electric appliances,
ornaments, books, plants, food,
liquids, paintings; DVD
300 × 1000 × 500

Desvio para o Vermelho, 1967–84
Red Shift

" *Red Shift* came into being as a hybrid of sorts, because at that time I was making the first projects and models for the *Virtual Spaces: Corners*, during the second half of 1967. I did two hybrid projects. In one you would establish that virtual plane through placement of the objects in the scene. And the other was precisely to imagine a place in which someone, for some reason – whether due to preference, mania, imposition or circumstance – would accumulate in a given place the greatest possible number of objects in different shades of red. That is the origin of *Red Shift*.

The idea was born at that time, but it was completely outside what I was interested in at that moment. So the project matured until 1981. In the meantime I had been taking notes for two independent works. One was a very tiny bottle out of which came a disproportionately large spill; the other was a sink with water flowing from the tap, but the sink was tilted. I remembered the 1967 project – a place in which, for some reason, there would be an accumulation of things which, in themselves, are not impossible to collect. It is precisely this accumulation of things – the most varied utilitarian or decorative objects in a room or house – with the greatest possible range of hues in a given place. In the 1967 project the place was already filled with red objects.

I would like to believe that red is the colour that has most meaning, that opens up most directions. When I mounted this work for the first time in 1984, at the Museu de Arte Moderna do Rio de Janeiro, I collected notes that people left on the desk of *Red Shift* by the end of the show. The range of associations this colour produces vary from menstrual cycles to violence, love and sentiments. Ferreira Gullar* wrote a text praising the work for its possible ideological implications. For this piece, I always thought more about the physical and poetic elements than the political component, although I admit that there may be political readings of it.

I don't see the first part of *Red Shift*, 'Impregnation', as a metaphor, but as a symptom of some procedure of choice. Just as people collect pipes, they can collect colours, for instance. Perhaps the bottle can be read symbolically, in the sense that the content is greater than the form. This always gives rise to associations. In addition to the shift proper – the inclination of the wash basin. These two cases are more symbolic than the first part.

The first part is called 'Impregnation' and it is a collection of collections; collections of clothes, books, furniture, paintings, displays. In theory, the collection would be interminable. Nothing stops you from adding things to it. Even if the structure is very flexible, it is simultaneously a sort of 'baroque constructivism', because it has a very precise law of formation.

Red Shift possesses a circular quality in the sense that, when you enter it, you will already be aware of the end of it. Liquidity is a state that runs through the entire work. As you go in, the first thing you notice on your right is the sound of water in the sink, which actually comes from a DVD or videocassette and, at the same time, the sink is the last thing you will find in the work.

The name of the work refers to physics – to the shift of red waves, that is, to the pattern of the shift; red is chosen because it shifts very little. The wavelength of red is long; it is the longest wavelength of the radiation spectrum. It shifts the least as it moves about space. You use it to measure distances, it functions as a pattern. "

* Ferreira Gullar (b. São Luís do Maranhão, 1930) is a poet and co-author (with Reinaldo Jardim, Theon Spanudi, Amílcar de Castro, Franz Weismann, Lygia Clark and Lygia Pape) of the 'Neo-concrete Manifesto' (1959). He also wrote 'Theory of the Non-object' (1959).

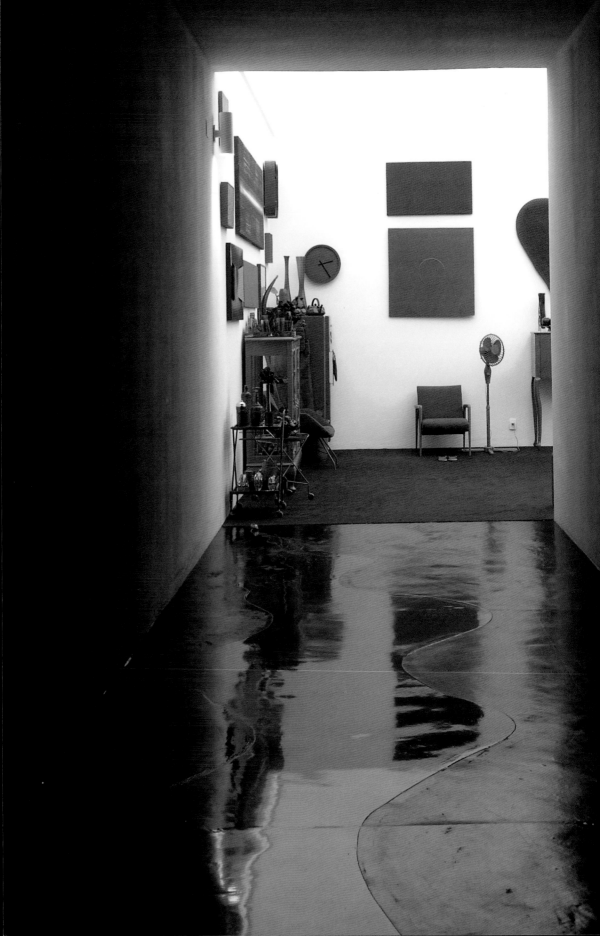

Desvio para o Vermelho:
II. Entorno
Red Shift: II. Spill/Surrounding
1967–84
Darkened room, glass bottle,
red paint
300 × 250 × 500

Desvio para o Vermelho:
III. Desvio
Red Shift: III. Shift (overleaf)
1967–84
Darkened room, white porcelain
washbasin installed at incline,
metal taps, flowing red liquid
300 × 1000 × 500

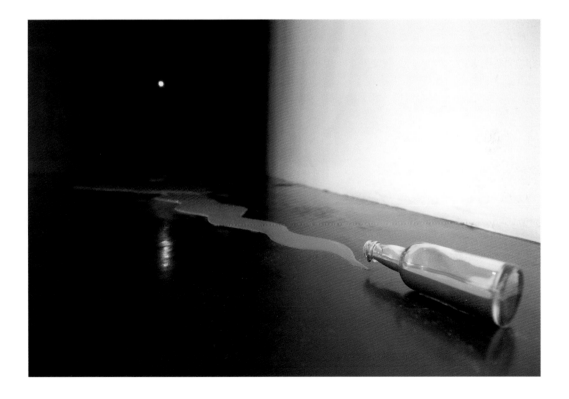

A Shift towards the unnameable

West of Tordesillas, metaphor has no value of its own. It is not that I dislike metaphor. I want every work to be seen some day, not as an object for sterile scholarly ruminations, but as a landmark; as a memory and evocation of real, visible conquests.
Cildo Meireles[1]

SUELY ROLNIK

Having decided to experience Cildo Meireles's *Red Shift*,[2] I take the first available flight to Belo Horizonte. Arriving at Inhotim,[3] I head straight for the work, installed in a building especially constructed for the installation and conceived by the artist himself. A fourth wall has been added to the structure that did not exist in previous versions, which allows a separation from the external space. This is no trifling matter: free from the distracting murmur of exhibitions and with no time limit, I enter the installation, close the door and let myself go.

The first environment: furniture, domestic appliances, carpets, paintings, but also porcelain penguins on a fridge, fish in an aquarium, parakeet in a cage, and all types of knick-knacks and trinkets cluttering the space – signs of the passion for consumption propelled by industrial modernity, mixed with a nostalgia for pre-modern everyday objects. If it were not for a computer, this would be a typical Brazilian middle-class living room of the 1960s and 70s. The ordinary scene of an ordinary life.

Two elements, nevertheless, diverge from this condensed normality: one is colour (everything is red, in different tones; one cannot avoid seeing it), the other is sound (the constant flow of water, soundtrack of a video of the installation itself, which plays in a loop on a television; one cannot avoid hearing it). I let myself be guided by the sound and follow on.

The second environment: in some sort of non-specific in-between space, a thick red liquid, which seems to have been spilt from a small glass bottle that has fallen to the floor, spreads through the rest of the house in an immense stain totally out of proportion to the size of the flask. I let myself be guided by this colour that inundates the floor and go on.

The third environment: the colour is lost in pitch blackness. A single object at the back of the room can be seen under a beam of light. It is a sink, tilted as if falling, whose tap gushes a liquid equally red, which splatters the entire surface. The only scene bearing drama, it seems to suggest that there is a narrative hidden here. Deciphering it would reveal a supposed meaning for the work, but as my intimacy with the installation increases, this expectation dwindles.

In search of the shift

The red in the first environment was not given to the objects by the artist, it arrived with them. Colour constitutes these objects to such a degree that it seems to emanate from them, contaminating my eyes, my ears, my skin, my breath … my subjectivity. It is not by chance that Meireles calls this first space *Impregnation*. Little by little, I begin to lose the references that the objects offered when I first arrived. In the second environment (*Entorno*), the red seems to have detached itself from things, in order to present itself as a density of redness that spills and occupies the entire environment. It was with the double meaning of *entorno* in Portuguese – 'spillage' and 'environment' – that Meireles named this part of the work, where I no longer have any reference with which to situate myself. There is

1 Untitled statement by Cildo Meireles, *Information*, exh. cat., The Museum of Modern Art, New York 1970, p.85.

2 *Desvio para o Vermelho* – the Portuguese retains the more precise meaning: 'shift towards the red'.

3 Inhotim – Centro de arte contemporânea, Brumadinho, Minas Gerais, Brazil.

nothing logical here: between the bottle and the poured liquid there is a total disproportion; it is impossible to find here the recognisable function of a normal residence into which I had supposedly entered. My disorientation is intensified.

In the final environment, *Shift*, colour merges with the sound that has accompanied it from the start, establishing a meaning for the gushing tap at the centre of that precariously held sink: an incessant red flow that nothing can staunch. The relief is short lived; the topsy-turvy logic that would unite these elements does not stand up and dissolves itself under the impact of the deep darkness. A shift, in fact, takes place.

Every time a logic appears to take body, it deconstructs itself with the next step taken, a process that functions as a loop. It is like the video image that we watch in the first room, in which the installation itself eternally returns – as does our own unrest while we remain there. 'The work functions as a circle', argues Meireles himself. With rigorous precision seasoned with subtle humour, the artist plays with elements susceptible to recog nition (be it in terms of meaning or of form in its 'extensive' dimension). These elements promise tranquillity, just as, simultaneously, the artist pulls the carpet under our feet, leaving us ungrounded and thrown into the chaos of the field of forces that are actualised in the work, its 'intensive' dimension. This seems to constitute one of the essential elements of the *thinking poetics* that permeates *Red Shift*.

But it doesn't stop there. During the afternoon I spent in *Red Shift*, after several comings and goings within it, I begin to feel the pulse of a diagram of forces, vaguely familiar, and yet strangely inaccessible. Would it not be precisely here that the shift, which operates in this work, is announced? Yet I still know nothing about it. I must wait until things settle down.

Some days after my visit, my disquiet gains its first words: fainting ... desolation ... despondency ... discouragement ... impediment ... fear ... A never-ending apprehension, absolute impotence, exhaustion. Gradually there takes form the daily sensation of living under the military dictatorship – precisely the period in which the diverse ideas that led Meireles to conceive the installation settled down and came together.[4] This has nothing to do with a metaphor for the regime's truculence in its visible forms, and the representation of them (according to the artist, a hackneyed interpretation). Instead, it relates to the sensation of an invisible atmosphere that impregnates everything – the regime's intensive diagram of forces – implacable for being subtle and inapprehensible. The impression is that under or behind that excessive pathological 'normality' of life under state terrorism, an incessant bloodying of the vital flows of Brazilian society is in process. All is taken over, as the red takes over the whole installation.

It is well known that colours are fields of forces that affect our bodies. Red has the smallest frequency and the longest wavelength of the spectrum. These qualities make it shift less as it moves in space and give it the capacity to attract other colours, imposing itself upon them. Indeed, red in this installation

4 If 1967, when the first ideas for *Red Shift* emerge, is the year prior to the Institutional Act 15 (the moment at which the power of the dictatorship becomes absolute), 1982, when the installation is finally thought through (although it was not exhibited until 1984) is the year of an intense collective process of re-activation of democracy, as well as the poetic force in Brazilian society. In a conversation about this work (by telephone with the writer, April 2008), Meireles refers to the political bias that permeates the work unconsciously.

imposes itself onto the singularity of things and makes them uniform. This physical experience of the work actualises within my body the sensory mark of the omnipotence of military power over subjectivities, which homogenises everything under the impact of terror, restraining the vital movement (understood here as the potential of creation, differentiation, shift). There is no single space that escapes such omnipresence – no home, school, workplace, street, bridge, square, bar, restaurant, shop, hospital, bus, taxi … air itself. An arc of tension that extends itself to the limit: nerves standing on end, a state of permanent alert. A total impossibility of rest, but also of making the 'shift' as we move in space/time.

It is no easy matter to connect with such sensations and overcome their denial; more difficult still is to actualise them, be it visually, or in other languages: verbal, cinematic, musical or even existential. And yet, it is this that is required to re-appropriate and activate the vital flow that has bled away (or in less grave cases, been staunched). If any artistic effort in this direction, as well as that of letting oneself be contaminated by its creations, is effectively worthwhile, the aim is certainly not to remain within the memory of the trauma, nor to substantiate it or historicise it, glorifying in the role of victim. On the contrary, such an effort is valuable because it becomes a way of reactivating and re-inscribing in the present what was there already before the trauma, that which has been drained on account of it – a 'real and visible conquest' that overcomes its toxic effects inscribed in the body's memory. In this installation, Meireles manages to materialise such a shift towards the unnameable, actualised here as 'marks, evocations' of this conquest. If we are able to let ourselves go, this shift can become equally possible in our own subjectivity.

Politics and poetics

The wider context in which Meireles's ideas for this installation originated was the movement of institutional critique that developed internationally during the 1960s and 70s. If the main characteristic of that movement was to problematise the institutional power that the 'art system' brought to bear on works, in the majority of South American countries a political dimension was added. Militaristic state power – explicitly or implicitly present in the institutional territory of art – became a target of this problematisation through art proposals.

Such practices have been grouped together by (official) Art History under the categories of 'ideological' or 'political conceptual art'. However, this does not mean, as 'that' history mistakenly asserts, that the artists have converted themselves into activists. What made them incorporate the political dimension into their poetic investigation was the fact that the dictatorship's oppression was experienced at the core of their creative processes. Far more subtle and harmful than outright censorship of art works is the impalpable presence of the dictatorship as the inhibitor of the actual emergence of creativity – a threat that hovers in the air due to

the inexorable trauma of the experience of terror. A nodal aspect of the tensions that mobilise the need to create, giving them shape in a work of art.

The diffuse and omnipresent experience of oppression that is brought to the present within the artist's work becomes visible and/or audible in an environment where state terrorism's brutality engenders a voluntary blindness, deafness and dumbness, as a matter of survival.[5] In this context, the conditions are given to overcome the schism between micro and macro politics, which in turn is reproduced in the scission between the classical figure of the artist and the political activist. A compound of these two types of acting upon reality seems to have been sketched within the artistic propositions of the period in Latin America, but has been missed by (official) Art History. Before considering the implications of this lapse, it is necessary to ask what exactly differentiates micro and macropolitical actions and why their integration is important.

Both have as their starting point the urgency of confronting the tensions of human life in the places where its dynamic is interrupted or weakened. Both have as their aim the liberation of vital movement from obstructions, making them essential activities for the 'health' of a society (understood here as the affirmation of the inventive potential for change, when life demands it as a condition of its pulse). However, the nature of tensions that each confront are distinct, as are the operations behind their confrontations and the subjective faculties that they involve.

On the side of macropolitics we find ourselves confronted by conflictual tensions in the cartography of visible and speakable reality: conflicts of class, race, religion, gender, etc. It is the plane of stratification that outlines subjects and objects, as well as the relation between them and their respective representations. With micropolitics, we are confronted by the tensions between this plane and what is already announced in the diagram of the sensed reality, invisible and unspeakable (a domain of fluxes, intensities, sensations, and becomings).

The first type of tension is accessed through perception, the second through sensation. The first approaches the world as a map of forms on which we project representations, attributing them meaning; the second as a diagram of forces that affect our senses in their capacity for resonance. The irreducible paradox between these two capacities of the sensible provokes collapses of meaning and forces us to think/create. The classic figure of the artist tends to take the side of micropolitical action while that of the activist tends towards macropolitics. It is this separation that began to dissolve in Latin America during the 1960s and 70s. Acknowledging this, we can begin to answer the question about the damage caused by Art History's lapse with regard to this type of practice.

Ideological conceptualism?

Right from the start, official history failed to do justice to these practices by designating them 'conceptual'. A different name would have

5 Perhaps it is not a mere coincidence that amongst the trinkets in the sitting room of *Shift* are the 'three monkeys of wisdom', each respectively covering their eyes, ears and mouth.

distinguished them from artistic practices designated as conceptual in the United States and Western Europe. Worse still was to describe such a conceptualism as 'ideological' or 'political', as has been attempted in certain accounts. The fact is that we find in these artistic proposals the seeds of the integration between politics and poetics, experienced and actualised in artistic creations, albeit impossible to label. To call them 'ideological' or 'political' denies the state of estrangement that such a radically new experience produces in our subjectivity. The operation is quite simple: if what we experience there is not recognisable in art, then in order to protect ourselves we categorise it as politics and everything is kept in its rightful place. The abyss between micro and macropolitics is maintained. In reality the state of estrangement constitutes a crucial experience because it is the symptom of the forces of alterity reverberating in our own body. These reverberations put into crisis the current cartography and lead us to create. Ignoring it means that the problematising potential that fundamentally characterises artistic action is blocked.

The artistic interventions that preserved their inherent political force were those that emerged from the manner in which the regime's tensions affected the artist's body. It is this quality of relating to the present that such actions can stimulate in their 'perceptors'.[6] The formal rigour of the work,

in its physicality, becomes here indistinguishable from the rigour of its actualisation of tension, such as that lived by the body. The more precise the form, the more pulsating its intensive quality becomes, and the greater its power to insert itself in its surroundings (*entorno*), introducing new politics of subjectivation, new configurations of the unconscious within the social field breaking with the dominant references.

A greater precision of focus is gained, which in contrast becomes troubled when everything related to social life is reduced exclusively to macropolitics, making of the artists who operate in this terrain mere scenographers, graphic designers, and/or publicity agents of activism – which undoubtedly characterised certain forms of practice during those decades.[7] The latter could indeed be described as 'political' and/or 'ideological'. It was in generalising such a qualification to the overall Latin American group of artistic proposals during the 1960s and 70s that the unfortunate misunderstanding of Art History occurred, losing sight of the irreversible shifts that were made.

The work of Meireles is amongst these, and certainly one of the most trenchant examples. Its vigour is not found in the representational content, based upon a reference external to its poetics (ideological or otherwise). This kind of interpretation is based on false clues, placed there by the artist with an anecdotal function: faced with the irredeemably

6 The term 'perceptor' has been suggested by the São Paulo-based artist Rubens Mano to designate the role of the person that approaches these kinds of artistic proposals, whose production depends on its effect upon his/her subjectivity. Notions such as receptor, spectator, participator, participant, user, etc, are inadequate to describe this type of relation with a work of art.

7 Meireles himself insists on this difference, for example when he writes: 'I had problems with political art where the emphasis was on discourse and the work became similar to propaganda.' 'Artist's Writings', in Paulo Herkenhoff, Gerardo Mosquera, Dan Cameron, *Cildo Meireles*. London, Phaidon Press, 1999, p.136. Or when he states (in the telephone conversation referred to above) that asking artists to lend works for the *Impregnation* room, the first time the work was installed, Raymundo Colares brought a badge with the image of Che Guevara. The only white object placed on the mantelpiece, it stuck out from the rest not only because of its colour but also due to its status as a reference to an external representation through its political symbolism, which contrasted with the political status as a dimension of the actual poetics of its surroundings.

implausible, we create an apparently plausible imaginary articulation. Guidelines that misguide.

If the equivocation begins with the very idea that we are placed in the domain of symbols, metaphors and narratives, the work's vigour does not lie either in the physicality of form itself, which is supposedly autonomous and disassociated from life experience. In both these interpretations – these 'sterile scholarly ruminations', as Meireles would no doubt call them – the body of the one who interprets is not there in its vulnerability to the forces of the world and thus of the work, nor is the world there in terms of its potential to affect that body. The work, in short, is not there in terms of its potential to infect its interpreters, nor in its power to intervene in the state of things.

In contrast to these absences, the vigour of Meireles's *Red Shift* will be found in the intensive cluster of world-forces as they reach the artist's body, and indissolubly in the extensive form of their actualisation in the work. It is from this that the status of 'event' emerges. If there is politics and if there is poetics here, they are absolutely inseparable within the precise formation of one single gesture and in the intensive diagram of its inflammatory potential. This is why Meireles's work possesses the power to keep our bodies awake. It depends only on our desire.

Translated from the Portuguese by Michael Asbury

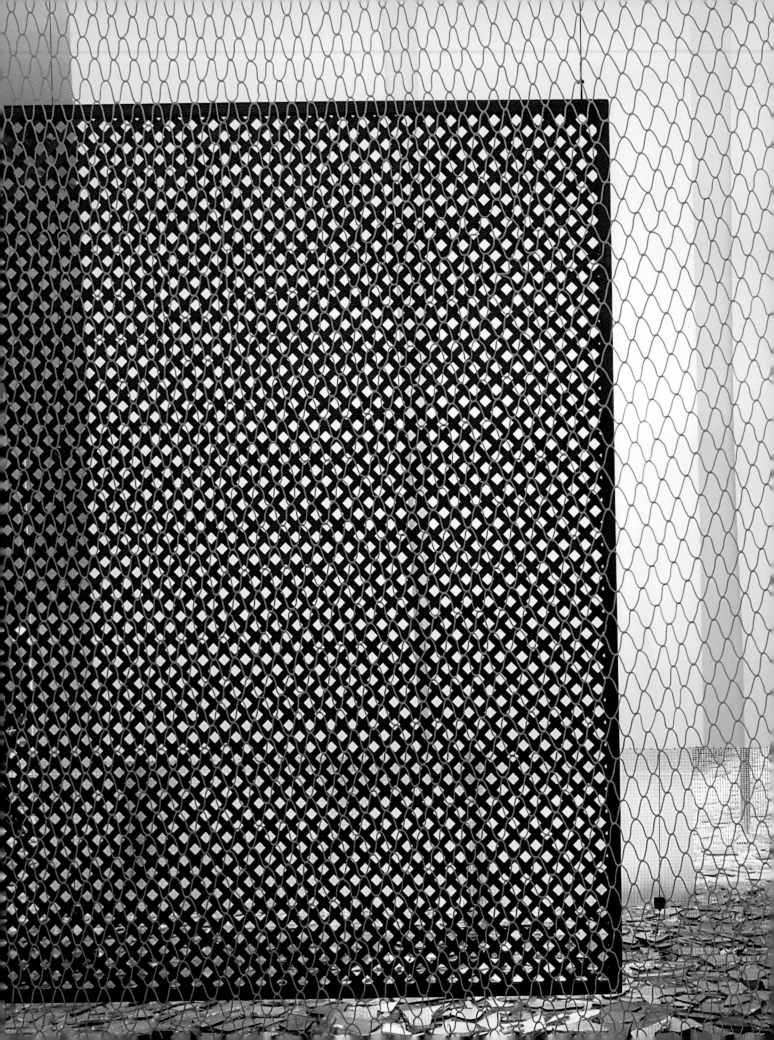

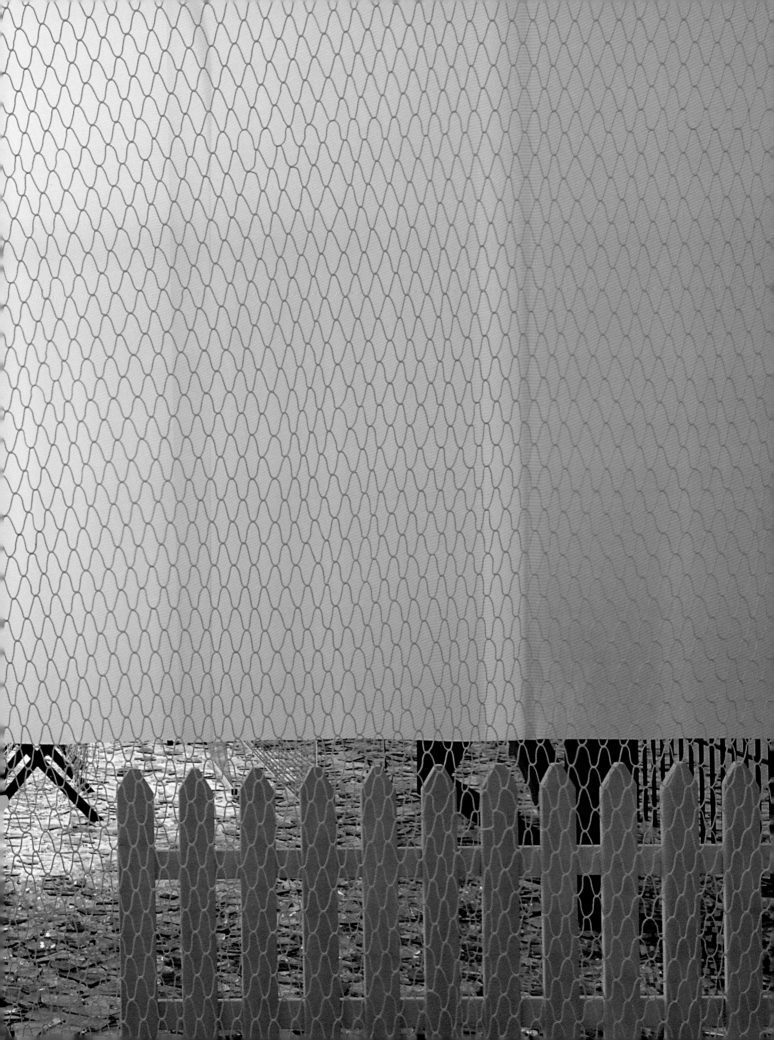

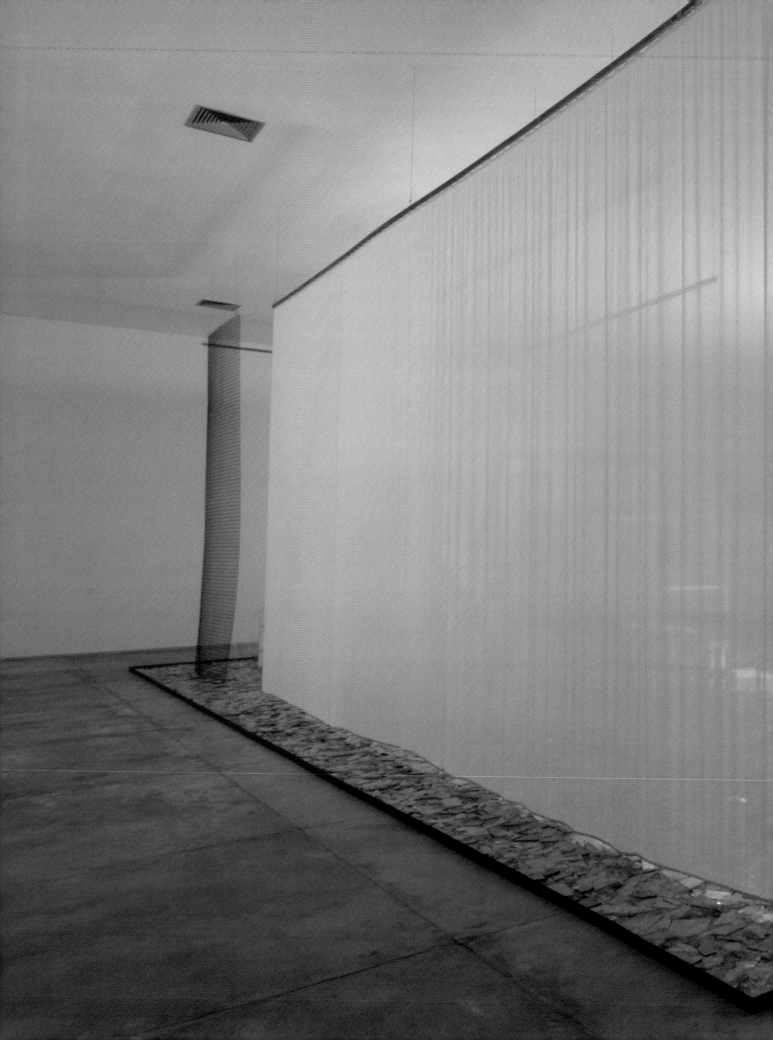

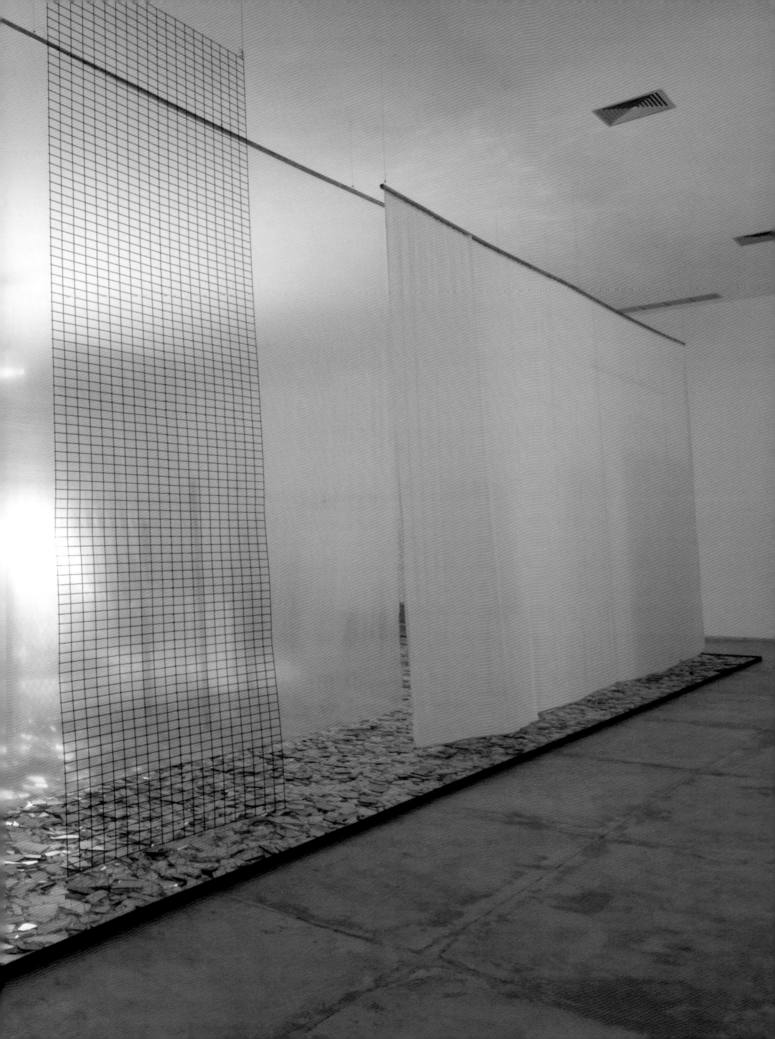

Através
Through
1983–9
Fishing nets, voile, reinforced glass,
livestock nets, architecture paper,
Venetian blinds, garden fencing,
wooded gates, prison bars, wooden
trellis, iron fencing, mosquito nets,

metal city barrier fencing, aquarium,
tennis nets, metal stakes, barbed wire,
chains, chicken wire, museum rope
barriers, cellophane, glass
600 × 1500 × 1500

Através 1983–9
Through

" One day in 1982, I was sitting in my work room in the house we lived in on Rua Fernando Ferrari in Rio's Botafogo quarter, opening a parcel. I crumpled the cellophane wrapper and threw it in the trash. Then I picked up a pencil and returned to what I was doing. Soon, I began to hear a sound. I looked and saw that it was the cellophane moving and making noise. I reflected that, strictly speaking, this was a rigid material, albeit one that could become malleable. I then began to list forms of barrier, restriction or prohibition. But the work grew out of that cellophane ball.

At the outset of the work the problem of visuality was raised. A field consisting of objects with that ambiguity [of the cellophane], which at the same time were objects of prohibition, symbolic or otherwise, but through which sight could pass. Going from a lower limit, which might be a line on the floor in a museum, where it is only a psychological tension that is present, to glass through which only the eyes can pass. ¤

When I thought of the broken glass, on the ground in *Through*, I associated it with the gerund of the verb, that is to say, with the action that would be taking place. Just as had been the case with the cellophane, which was a kind of crumpled glass. Suddenly, I had the possibility of softening something that was based on rigidity – a bit like the soft versions of Oldenburg's sculptures. I was conceptualising soft glass. This is why cellophane is odd: it's a simulacrum of glass that you can crumple. The possibility of having a glass floor, and assuming that people would walk on it – because the piece *was* made for walking – you are exercising a sort of response to that accumulation of prohibitions. In other words, you start breaking: it's as if, in stepping on it, you were freeing yourself. You are metaphorically breaking each piece of debris, each prohibition or obstacle. That was actually the idea behind the glass floor.

Through is a set of 'no's' and a great 'yes', labyrinths of prohibitions, interdictions, that move across this floor and, in a way, it is the breaking glass that creates a sort of continuous metaphor for a piercing through of the gaze. The work allows the gaze to circulate yet restricts body movement. Therefore, there is a synesthesia … I mean, it is exactly when you hear the breaking glass that you begin to see, to understand this piercing through. "

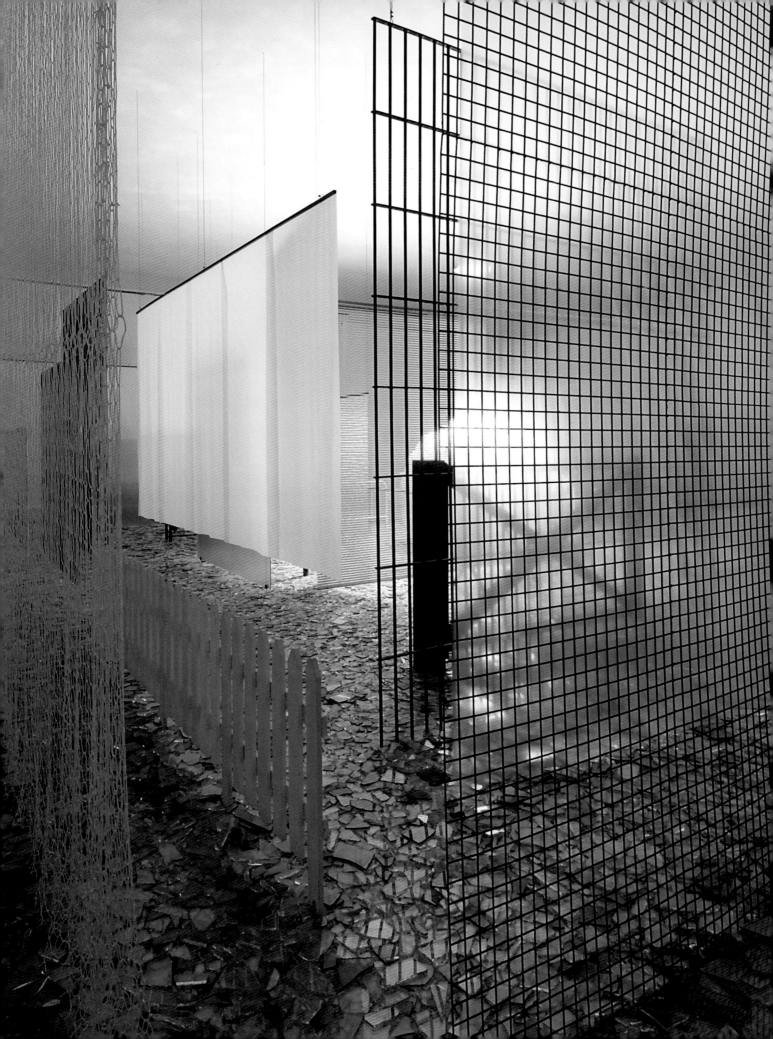

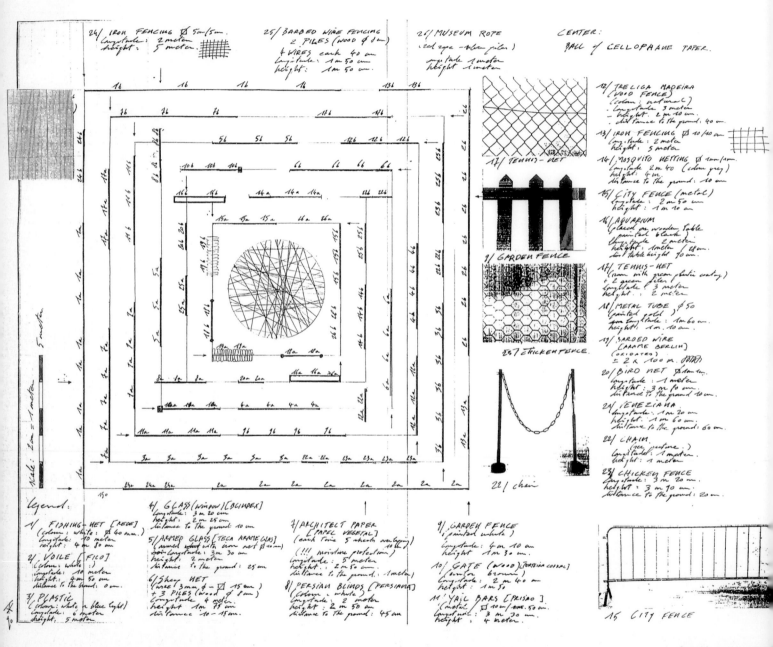

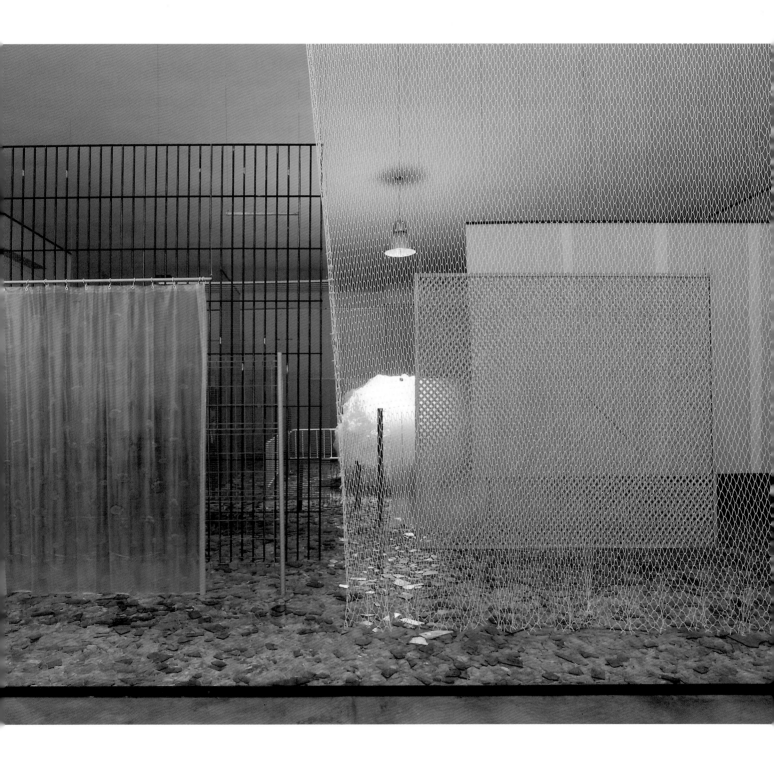

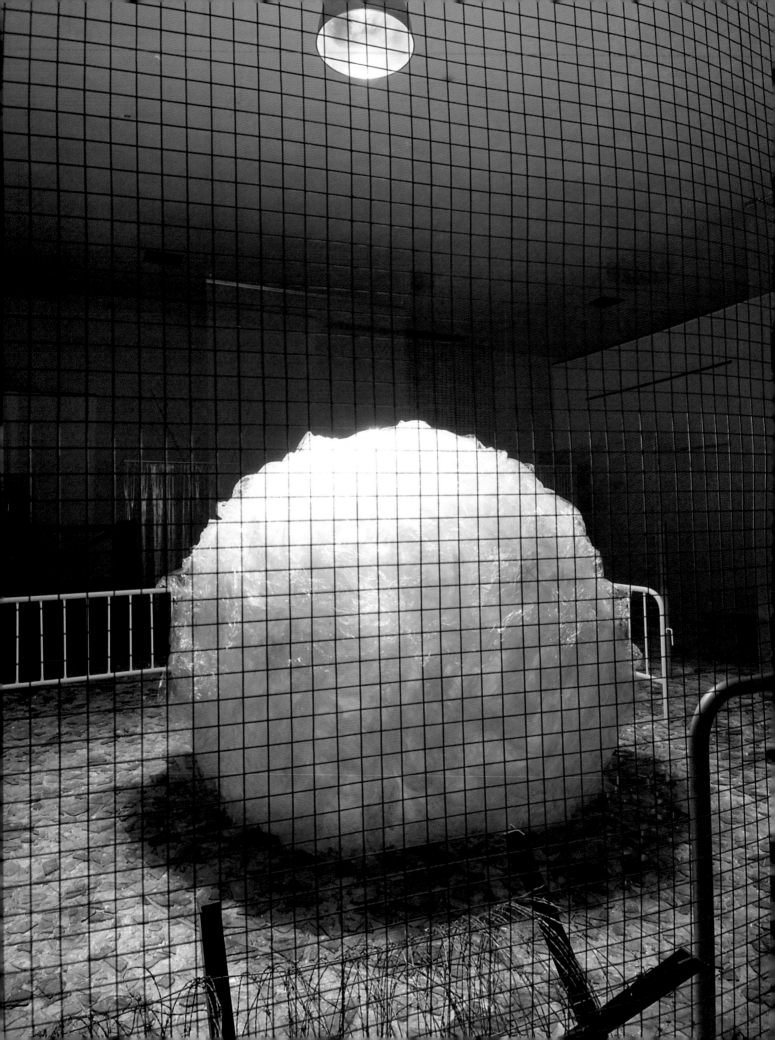

Through

BARTOMEU MARÍ

You have to go in. Even though it may not appear inviting, you have to dare to enter and begin moving around inside; you have to disregard that initial sensation that induces a certain sense of danger and discomfort. Just seeing this work fills you with unease and misgiving as you move around the perimeter trying to understand how the piece functions and what it is composed of. *Through* 1983–9 (pp.138–46), both invites and repels at the same time. It causes us to remain still and alert as if confronted by an active threat, an animal that might bite us. But *Through*, like other threatening works by Meireles, does not act; it responds to our action, engaging us from a distance. The fact is that these works do not exist at a distance. They only exist when we explore them, feel them, experience them. With Meireles's work, we cannot talk about a 'user', or a 'viewer'. The best term is 'subject'.

When I first saw *Through*, it was at a secret moment in its existence, as the artist was installing it at the Kanaal Foundation in Kortrijk in the heart of Flanders. It was not yet finished, yet still it bared its teeth in a pleasantly provocative manner. The work is a maze of generous proportions, a structure composed of various kinds of barriers, grilles and metal or wooden dividers either resting on the floor or suspended from the ceiling. On the ground, fragments of broken glass of different sizes and shapes form a thick layer underfoot that crunches and groans with every step we take as we move around. The very title of the piece propels us towards a set of paradoxes about vision and space, about the eye's capacity to transcend space and the Euclidean dependency our body has on the very space that our eye is able to cross without moving. *Through* is a monument to gravity, impelling us towards the centre of the earth where the broken glass will catch us if we fall, and requiring effort to advance over it.

We know that works of art are not living beings. By their nature, and until otherwise proven, they are inert entities that are activated by their encounter with human minds and bodies, subjects who perceive and who then work with these perceptions. It is this daring consciousness that Meireles's output is about – expressed in works that resemble devices designed to provoke unease.

Other works by Meireles, such as *The Sermon on the Mount: Fiat Lux* 1973–9 (pp.82–5) and *Volatile* 1980–94 (p.181), are close siblings of this piece. In *Fiat Lux*, we encounter a large volume made up of matchboxes, occupying the centre of the room and surrounded by a group of sturdy security agents or bodyguards, exhibiting their function and attributes (dark glasses, postures between the defensive and the threatening, clothing akin to uniform). The entire installation is mounted on a sandpaper floor, making it uncomfortable to walk on. *Fiat Lux* is founded on the plausible but unlikely event that a match could fall, strike itself against the floor, and cause the entire thing to go up in flames. The pantomime of extreme security stages an apparently absurd level of protection for a supposedly precious object that could disappear, be consumed or suddenly altered, as if it were gold or the last fuel on the planet. We are not sure if the threatening guards protect the matches from us, or us from the

matches. Similarly, *Volatile* places us in the very uncomfortable presence of a lit candle on the floor of a room, accompanied by the smell of gas. You are forced to wonder why you haven't been blown sky high.

Both works demonstrate how Meireles goes about creating his installations – these perfectly grafted metaphorical associations in which material and meaning maintain an inversely proportionate relationship between value and volume, between staging and abstraction, between the temptation to use them and the repulsion that suggests we should retreat from them. In these works, Meireles is doubtless echoing the intentions that inspired like-minded artists such as Lygia Clark and Hélio Oiticica as they developed the idea of a work of art as a 'penetrable' (the term was first used by Hélio Oiticica and later by Jesus Rafael Soto) or useable environment. The experience is not limited to the senses, but remains as a mental entity that goes beyond memory and which combines, consciously or unconsciously, with impressions yet to come.

But to return to the work in hand: why don't I fall over on this floor of broken glass and seriously injure myself? The fact is that while the installation allows us to see 'through', we are prevented from moving freely inside it. All the elements that make up the work refer to a hybrid space, larger than a room but smaller than a public space, somewhere between the interior of an enclosed area and the exposure of an 'unidentified' non-place – a patio unenclosed by walls but containing different ways of hindering progress and movement. At first

sight, the work appears abstract, like a large, three-dimensional, uneven, monochrome painting. *Through* is a monument to passive repression, to that unspoken but understood order that inhibits action rather than will itself. Consequently, I would venture to characterise Meireles's work as a counterpoint to the non-explicit and disguised controls which have infiltrated everyday life to such a degree that we no longer react when confronted by a 'state of exception'.[1] We fail to distinguish between exception and normality, the artist seems to tell us.

Meshes of Freedom (pp.91–3) can be considered as a formal and linguistic forerunner of *Through*. Created in 1976, this series of works uses for the first time metal grillework as a material with which to create an image. The title of the work – a perfect oxymoron – expresses a metaphorical representation: barriers to liberty, obstacles to escape, fettered imagination and suffocated breath; nouns and adjectives that cannot coexist. We know that in the Brazil in which Meireles lived at that time, there were factors of external coercion and repression that operated in many aspects of citizens' lives. But looking beyond the context of its creation, the work also refers to internal factors that coexist in any psyche, at any time. These works by Meireles appear to lead to the core of consciousness itself, which determines the criteria of self-regulation. They are located somewhere between seduction and repulsion, between desire and fear, like a crossbow constantly pulled taut. In *Through*, Meireles constructs a visual device that operates as a mechanism of

1 The 'state of exception' is an unusual extension of governmental power in exceptional circumstances. Walter Benjamin made an early study of the subject, in which he wrote: 'The tradition of the oppressed teaches us that the "state of exception" in which we lie is the rule' (1942).

psychological exposure, of questioning the behaviour and action of the individual in an environment that is attractive and hostile at the same time.

The creation of powerful metaphors that transcend the events of a biographical situation are common in Meireles's work. The artist frequently confronts us with tensions and dilemmas between body and mind, which begin in the physical sensations of seeing and hearing and translate to a mental entity that operates in our consciousness. He achieves this with powerful metaphors that cover a huge range. From the massive occupation of a space (*Fontes* 1992, pp.165–7) to the void symbolically created by the most minuscule exhibit (*Southern Cross* 1969–70, pp.58–9); from the abstract, concretist formalism of his early drawings to the association of mundane and ideological meanings (*Mission/ Missions* 1987, pp.99–101), Meireles projects architectonic fantasies that paradoxically both restrict and release, operating both on the immediacy of perception and on the powerful drag and pull of memory.

Translated from the Spanish by Alayne Pullen

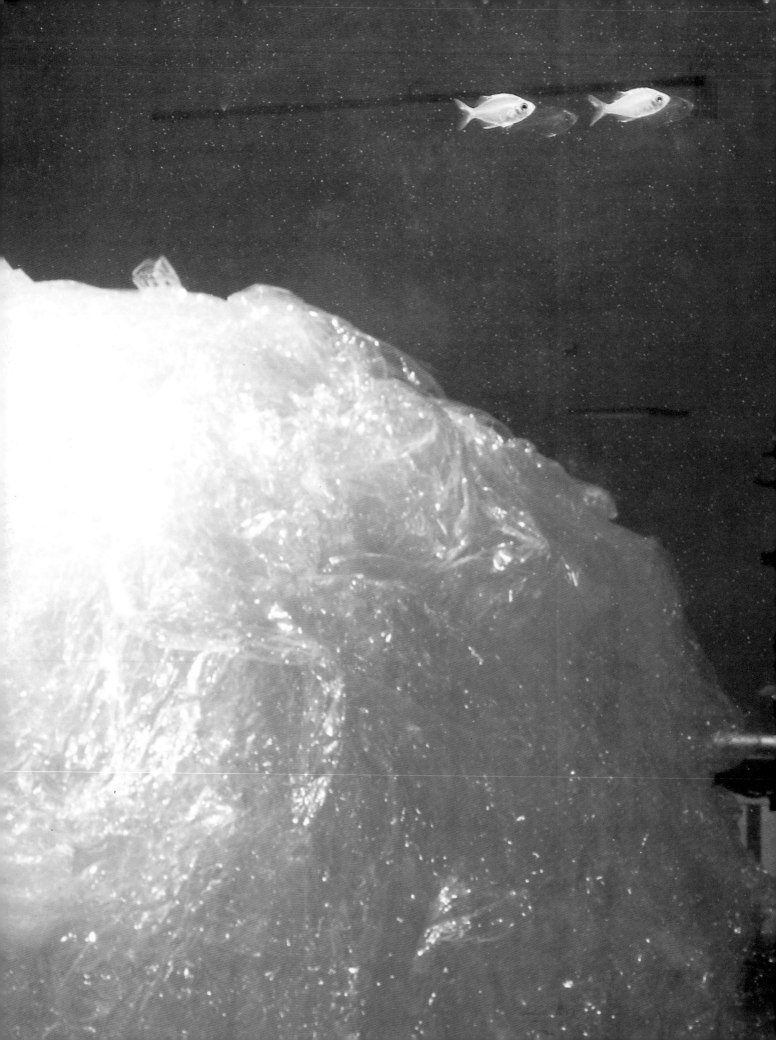

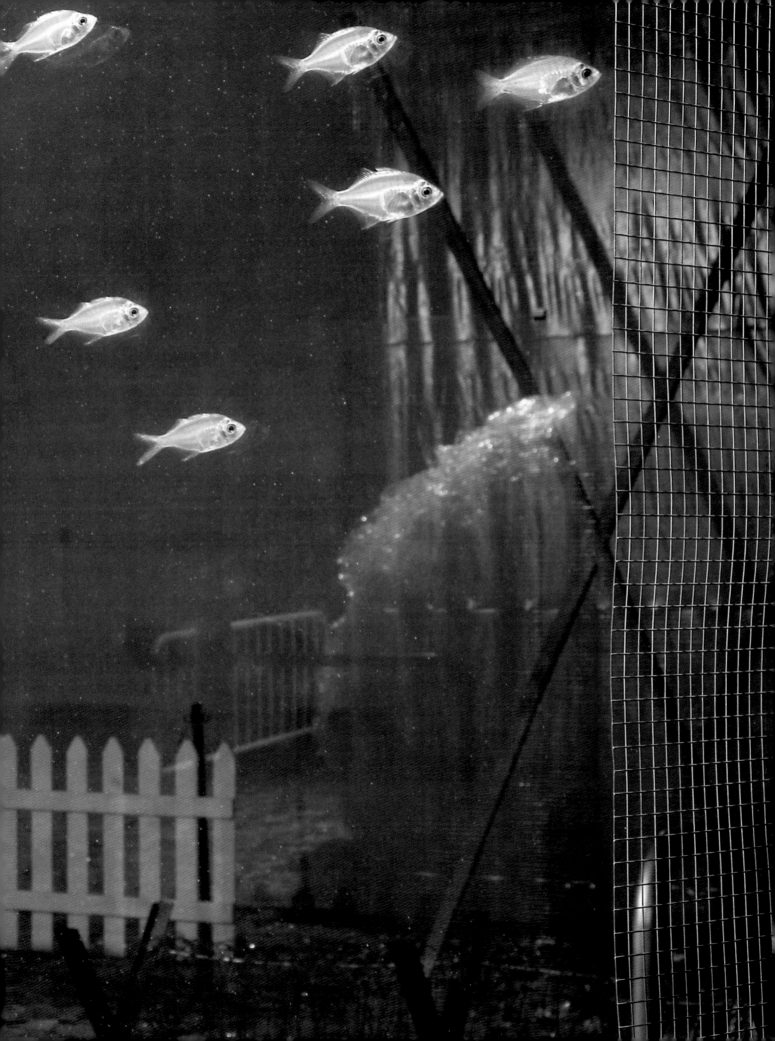

Where

SÔNIA SALZSTEIN

1

Amid countless other equally important works by Meireles, I have chosen – perhaps somewhat arbitrarily – to write about *Eureka/Blindhotland* 1970–5 (pp.111–15) and *Through* 1983–9 (pp.138–46). I do not pretend to situate them as examples of the whole of the artist's production, nor to assign to them some foundational role that might designate the 'development' or 'history' of that output – especially since it is an output that never ceases to problematise historicity itself, to place our experience of time and the genesis of an idea of history at the centre of its concerns.

Furthermore, *Eureka/Blindhotland* and *Through* only secondarily allow themselves to be approached via aspects so often pointed out as central to the artist's trajectory: conceptual affiliation, the political imperative behind the majority of his interventions, the premise that the work constitutes a critical programme of which each of its appearances would be the more or less methodical fulfillment and so forth. Even the association of the two works in this text stems more from intuition than argument, and the pertinence of this procedure – to discover by confronting one with the other whether or not they can formulate problems of relevance to the artist's thought – shall only be verifiable *a posteriori*.

In fact, no internal nexus will be found to connect them in an exclusive manner, and there will be as much to say about what separates them as about what unites them. However, something has led me to approximate them, and I suppose it is the remarkable contrast they signal with regard to the majority of Meireles's works, in which a dynamics of social processes is always in progress.

In different ways, *Eureka/Blindhotland* and *Through* evoke a somewhat refracted memory of social context and in lieu of the kineticism of circulation, these works seem to affirm the drastic cessation of all development; it is as if they resisted historicity itself, as if the dynamics of social processes had been restrained there, contained in a dense time, the flow of which is complex and protracted. We see ourselves in these installations as if projected, transposed to a hypothetical primitive age of social life, in which an order that is only hinted at gropes its way between, on one side, the multiple, multifaceted world of sensations and, on the other, the unified world of objects. Unlike what happens in so many of Meireles's works, these contain no reference to the life cycle as a perpetual circuit of exchanges and the reciprocal substitutive quality of all things, abstract elements that the artist usually exposes to the light of day and which he outlines precisely as mechanisms of social sublimation – the discourse of *intelligibility*, of *transparency* and of *lightness* – in order to ensure, as these works show us, the preservation of social frameworks that are none the less quite concrete.

But let us say that intelligibility, transparency and lightness are, indeed, present – albeit in another way – in both installations. And they are present not because the artist has once again brought to the surface and thus made visible a long since naturalised ideological machinery, but because he has converted them into compositional materials in the work's

formal structure. In *Eureka/Blindhotland* and *Through*, those three qualities would thus manifest themselves in the disorientation of our perceptive faculties, so that what we judge to be light proves to be heavy, what we see as transparent leads us close to blindness and bewilderment, and what we would habitually consider intelligibility confuses and disturbs us.

Both installations ultimately disavow the promise of performance and purpose constantly made to us by the light, transparent and intelligible objects while, conversely, we are submerged by an unfathomable ontology of the objects, of which we soon discover we are a part. All that we had heretofore become accustomed to seeing as the energetic rumour of circulation is inflamed and obstructed; each of the installations is an absolute, unique event, and their social and cultural materials, now unburdened of the principle of rationalisation with which the social processes consume and sublimate them, take on an unexpected corporeality – one of great plasticity, bequeathed to a theatre of nonsense, and bidding us play at their permanent rearticulation.

2

I would say that the selection of *Eureka/Blindhotland* and *Through* resulted less from an act of choosing than from my difficulty in providing a convincing interpretation for these two works, from a feeling that they contain a good dose of the ineffable. In fact, the inability to resist being directed by a handful of adjectives – using expressions such as 'dense time', 'transparency', 'lightness', 'unfathomable ontology of the objects', 'theatre of nonsense', or even rhetorical resources that must take the shortcut of 'as if …' in order to avoid direct contact with the work – certifies that I must support my arguments with false descriptions in order to arrive at the work, and that they obscure it more than they present it. Do these works even solicit interpretation? Does it not seem more realistic merely to follow their operations, and attempt to hear the questions they ask us? Or grasp their 'law of formation',[1] which will actually always be different in each one of them?

Would it not be a matter of recognising the impossibility of exercising the games of perspective, taken for granted in the act of interpretation? Meireles's work is not accessible through this classical system and its logics of a progressive temporality, since it plunges us into a multiplicity of times that crisscross one another continuously, as if we were immersed in an absolute condition of frontality no matter what viewpoint we take. In light of the absolute present in which the installations confine us, a present, so to speak, that has the age of humankind and offers no recesses in which to project a psychology of the subject – not even that of a purely social subject – would it not be a case of admitting that, from the start, we have been inside them or (which might be the same thing) that we are absolutely external to them?

I have probably chosen the two works also because, like monads, they resist approaches that lend themselves to allusion to the artist's production, with its objects and materials strongly impregnated with social and cultural contents, to an 'explanation',

1 The term was coined by Cildo Meireles in an interview with Gerardo Mosquera. See Paulo Herkenhoff, Gerardo Mosquera, Dan Cameron, *Cildo Meireles*, London, Phaidon Press, 1999, p.21.

to a primary sense that, in this case, will invariably be found in the sociological argument. It is not a matter of denying the crucial position of such content in Meireles's work; the problem lies in taking them as a *representation* of the social process, of presupposing that they are at hand for no other reason than to await their exegetes' task of decipherment.

To believe that such contents are available on the surface of the work, and that the surface presents itself according to their methodical disclosure, is tantamount to reducing it to a mechanics of metaphors, to the banal use of the logic of classical representation, given to dramatic oppositions between presence and absence, essence and appearance that serve as corollary to it, a logic before which this work, by repeatedly affirming the literalness of its procedures, the materiality of its praxis, has always revealed itself as a decisive shift.

Here is a complex and sophisticated aspect of Meireles's production: a sort of distanced presentation, of psychological detachment from the narrative of social process to which it alludes. The exasperating literalness with which the artist exhibits social content consists of a complex formal operation of the work, perhaps its most decisive operation, and to seek to find the work in a place set beyond it is to ignore the distance that this work signals in light of a certain tradition of classical rationalism and of moralism that its binary oppositions flatter. Both *Eureka/Blindhotland* and *Through* reject the dualism of the subject/object relationship, presupposing, in its stead, a diffuse notion of the subject, a subject that will never be totalised, that will never separate itself from a sensual, tangible experience of space, and that sees itself permanently placed on the threshold of infinite possibilities of individuation.

3

The two installations seem possessed by a sort of torpor, frozen in a state of suspension, and the marks of the social processes that are usually specified and exhibited in Meireles's work in all their concreteness – the framings, the patterns, the unfailing measurability according to which such processes render us intelligible and communicable to one another – are only suggested, as if they had been erased or mixed up. In lieu of presenting terms that make up a system and its way of functioning, in both cases, the artist has operated more precisely by subtraction, exposing us to the negative of the objects, as it were, and the disarrangement that ensues from systems when we undermine the connections that produce them as a universality and force them down from heights in which concepts hover.

Spaces devoid of a highly defined social and cultural determinacy yet of impressive physical power are left over from this operation, for objects previously subsumed in the transparency of a flow of social signifiers now recede to an archaic stage, like sediments of signs that find themselves converted into the raw material of the works themselves. Everything in these spaces reveals itself to be immobilised in a sort of culmination, a stasis; our

perception of the force of gravity and our experience of the mass of all things – including that of our own body – are exacerbated to such a degree that we find ourselves submerged in dense spaces even when the artist resorts to light, hollow, transparent materials like air, as is the case in *Through*.

One's sensation before these open spaces – spaces that one may, at least, circumnavigate – is paradoxical, for the installations avoid access more than they permit it, even though they unfold close to us, like extensions of the ground upon which we tread. The ground – and the pressure that the objects may exert upon it – is actually the outstanding element in both cases. It is the element that would enable the exuberance of exchange and circulation, while it guarantees the sedentary quality indispensable to these actions; that is, a single, continuous surface that would totalise everything. But – as we can see – the ground cannot be subsumed to the horizon line in *Eureka/Blindhotland* or in *Through*; it is pure discontinuity and confusion of sensations and perceptions in both works – weight and pressure, a surface with unpredictable development that conjoins with our body and resists being abstracted as a plane.

One could do everything or nothing here, advancing beyond the nets, screens and other devices (or protocols) of *passage* that border the works, because we find ourselves compelled to a type of *participation*, the rule for which we do not know, and which, in any case, is not necessarily motor, does not involve a mechanical movement. In fact, if these works call for participation, we shall have to admit that participation must be *negative*, so to speak. Assuredly, Meireles's work would not contain – and this aspect is decisive in both installations – anything that might evoke even the remotest morality of *use* or of *function*; participation – if it might still be called this – would instead be an integral act of production.

First and foremost, then, we are urged to decide *where* we are: whether already inside or outside these works. And we soon realise that, whatever the answer, we are already completely involved in them, inasmuch as they continue to force us to make decisions, compelling us at every instant to dimension our relative position in time and in space.

4

If they do not allow themselves to be fully apprehended by the cultural criticism that has bequeathed a considerable and relevant literature on Meireles's trajectory, the chosen works are no less marked by another crucial issue, which has always been present in the artist's thought and which interests me most directly in this text: a very individual symbology of sensations, based on the idea of the de-hierarchisation of the values of all things, sometimes revealing the unequivocal, concrete dimension of the bodies, at other times showing them to be volatile and inapprehensible so that, according to the drastic reversals and permutations set in motion by the work, it would be necessary, after de-conditioning the faculty of perception, to do nothing more nor less than reinvent it.

Indeed, *Eureka/Blindhotland* and *Through* are among what we could call the metaphysical works in Meireles's corpus, a corpus in which, it is known, the dry objectivity of procedures stands out: the brutal mimicry with which the elements subsume certain social procedures, an exhibition of discourses so naked that they are ultimately reduced to the raw material of each work. At the very least, it might be said that the physical dimension into which both installations draw the spectator is not seated in the factual evidence of the empirical objects through which they manifest themselves, nor still in structures of the material life to which these works allude directly.

Ultimately, this physical dimension bears no relation to the datum of the objects' positive existence; diversely, it has do with the dense atmosphere that Meireles obtains in so many of his installations, and which is able to reveal objects whose presence we would never notice, a dense atmosphere in which they take on a disconcerting residual body and mass that language has not entirely succeeded in abstracting and generalising, residuals that constitute the very material to be interrogated and turned upside down in a labour that is particularly attentive to the inherent ambiguity of language.

In *Eureka/Blindhotland* it is the conventions of perception and the hierarchies of values that such conventions imply – so internalised that we never perceive them as 'values' – that gain density and a weight of 'things' in the work, so that, in this way, we become susceptible to the permanent game of deconstruction and rearticulation that the latter

predicts. The habits of perception that guarantee one another reciprocally and reproduce themselves in an endless cycle are, thus, exposed there in all their strangeness, now dissociated from the instrumentality in which they justify and internalise themselves as predicates of the space itself; it is – as may well be imagined – a matter of those habits that inculcate in us the idea that the reality of things is given by their measurability and that, being measurable, all these things will also be permanently and reciprocally replaceable.

The predicative, functional world of objects is exposed in *Through*: a device made up of passages that nevertheless do not lead us anywhere, do not progress, rendering the trajectory diffuse and indeterminate. It is precisely because they are passages that lead to nothing that one will never be able to abstract them – they are, after all, the condition for the appearance of space, its 'law of formation'. *Through* foils an entire symbology of moral and affective values normally associated with the idea of freedom. It dissects the idea of freedom as the formation of private individuality; that idea of freedom according to which, in the culmination of a momentous private adventure, we succeed in clearing complex obstacles previously interposed in our journey. The paths in *Through* – it is an arduous task to walk them- – are not hierarchised, and thus cannot promise a succession or progression in the crossing of so many passageways.

In short, in this installation, there is no way to reward the work expended in so many comings and goings, to restore the nationality, country and origin

of an individual submitted to the test of so much splintering, so many deflections – as would be the case in classical narratives associated with the themes of crossing and passage, in which, precisely and ultimately the unifying and heroic figure of individuality would appear. This installation can evoke psycho-motor sensations of passage, flux, clearance, development and overcoming; one can also find oneself confronted by a complex order of circulation, articulated by a plethora of industrial objects that serve the regulation and hierarchisation of space.

Because in both works the events are all foregrounded – and neither dramatise nor represent anything beyond the evidence of their own operation – they belong to the order of demonstration. The lighting is either uniform, as in 'Through' or, variously, local, addressing itself diffusely to the singularities of *Eureka/Blindhotland*, so that in both cases there will be no point of culmination or the suggestion of a temporal progression. As we have seen, areas contiguous to the space in which the observer is positioned are extensions of the ground he treads and through which he would naturally move should he advance but a few steps more – were it not for the semi-transparent screens and materials that serve *Eureka/Blindhotland* and *Through* as boundaries.

Thus, there appears to be an 'inside' and an 'outside' in these installations, yet they are equivalent and commute to one another. It will be up to whosoever perceives himself to be 'outside' to decide whether it is walls or a persistent fog that surround *Eureka/Blindhotland* and *Through*; whether they need to be surpassed in order for that which is 'inside' to break or whether one is always 'inside' what appeared to be 'outside', being, instead, that which is frighteningly near. It might be more precise to say that the works posit neither an 'inside' nor an 'outside' and that a spectator is not even presupposed by the works, whether we are there from the beginning or admit that the works consist of the experience of being impenetrable.

Translated from the Portuguese by Stephen Berg

La Bruja, 1979–81
The Witch

" The work originates in 1978. I thought of the possibility of exhibiting it as a one-person show at the Luisa Strina Gallery in São Paulo. She had a space on the first floor. I thought I could lay the strings on the sidewalk, trailing around the block and then climbing the stairs, so someone could follow them and come eventually to the broom.

I actually showed the work for the first time at the São Paulo Biennale in 1981, using 2,500 kilometres of string running over three floors of the building. It's about … you take a kind of chaos and suddenly give it order, give sense to it, a kind of explanation. The broom is ambiguous, you can see it as the beginning, the origin of a huge expansion, or as the final point of contraction, of compression. And there is another paradox in that, instead of cleaning up, the broom produces this kind of chaotic mess. In São Paulo the Biennale maintenance people were very frustrated because they couldn't clean the area! I liked very much the way it was installed at the Kunstverein in Hamburg. You could start with the massive tangle, totally dark, and be led to the broom, or you start with the broom and enter this dark, black chaos. You had to look at both possibilities. "

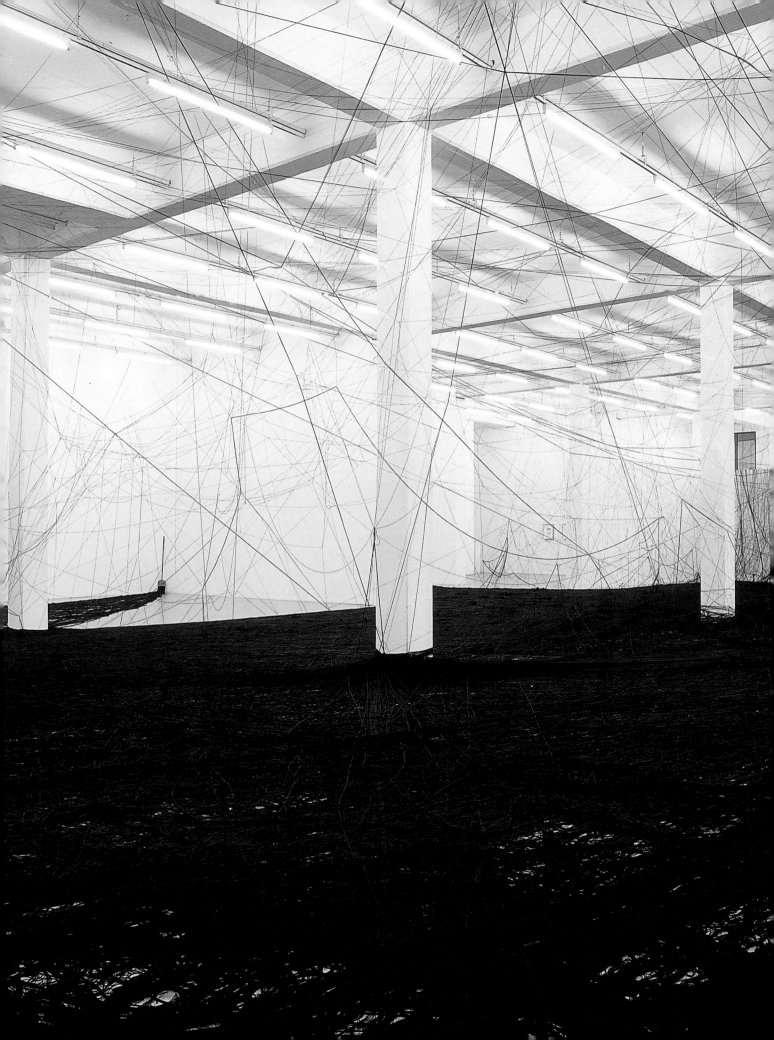

Glovetrotter
1991
Steel mesh, balls of various sizes,
materials and colours
520 × 420

Glovetrotter, 1991

" In the early 1990s, I began collecting balls, spheres and putting them in boxes. At the time, my son Pedro Ariel was little and had many balls: every so often, I would inherit, find or buy one. I still didn't know what to do with them; perhaps something to do with a return to this elementary form or those boxes of balls that the children dive into. But later I began to collect heavy balls, steel balls.

Orson Joaquim, my youngest son, was born in 1991 and when he was small, he went through a phase of testing everything with his foot by treading on it: he would jump on an aluminium surface and leap on another surface. I had already made a work for Pedro, so I decided to make one for Orson. I began to think about those spheres and imagined something that would refer to the idea of conquering

worlds, using that collection of elementary forms and something that would somehow contain them and would also be reminiscent of the great voyages, in the modern age, of Portugal and Spain and the conquest of the New World. I then thought of this stainless-steel mesh, which has an amazing modular capacity: it possesses a weight, it retains, it generates a field all by itself.

I also thought about the gesture of casting a net, of capturing. Therefore, a work came out of this that is dedicated to Orson Joaquim. The work possesses a ludic content, also, because this mesh material is used in making safety gloves for butchers and packing plants. Hence the pun on worlds and gloves.

Glovetrotter is made from two materials: one is the elementary form, the other is a medieval defence accessory. But when they work together, they create a sort of high-tech resolution. It's a situation in which the materials relate through imposition. The mesh imposes itself.

A dialogue could well happen in this piece. I thought of people entering it and changing the configuration. Whenever I showed the work, I imposed no restrictions, but the spectators walked around the work so respectfully! In early exhibitions at which I mounted this work, it had a room all to itself. So I thought: I'll spare them! Even if they wore socks, several spheres would not escape destruction, because the balls are made of wood, metal and even pearl. Some are fragile, made of rubber, plastic, etc. There are more than 200 spheres in this work.

The surface underneath the balls suggests tactility, because what happens is that the larger ones attract the smaller ones. With some of the smaller balls one can perceive only a slight alteration in the surface of the mesh. But what happens – and this is the biggest problem – is that, as you spread the spheres, some of the smaller ones are attracted to the 'gravitational' field of the larger ones; they go under the larger ones. They are hidden by the larger ones. "

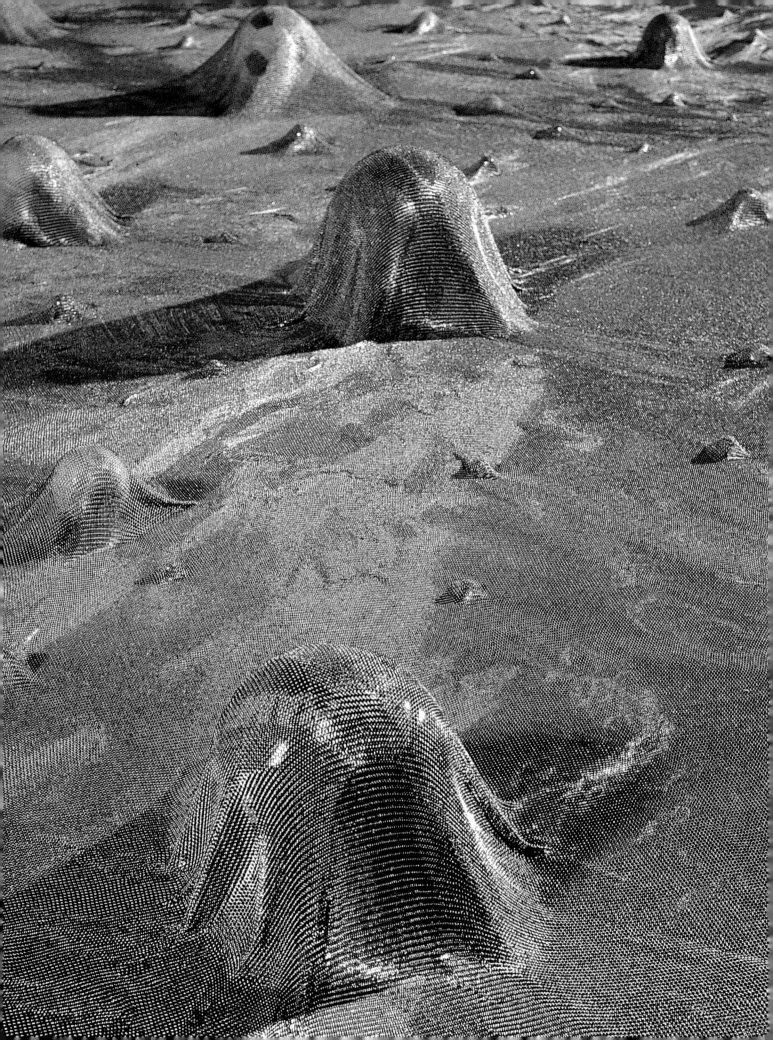

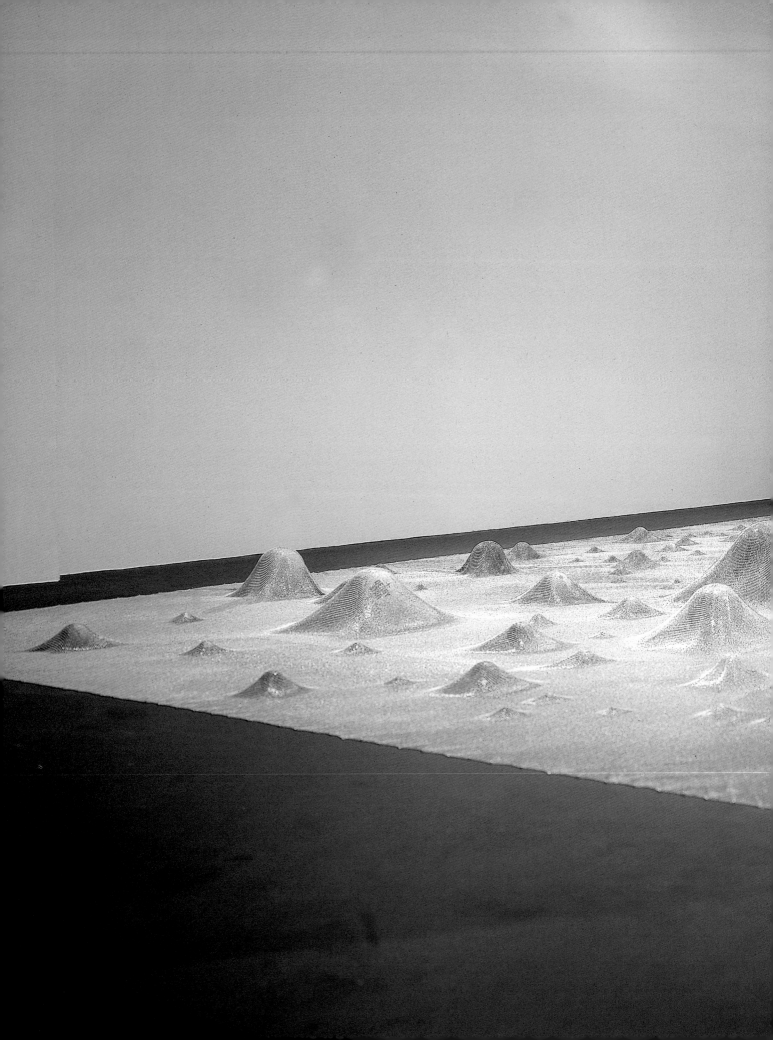

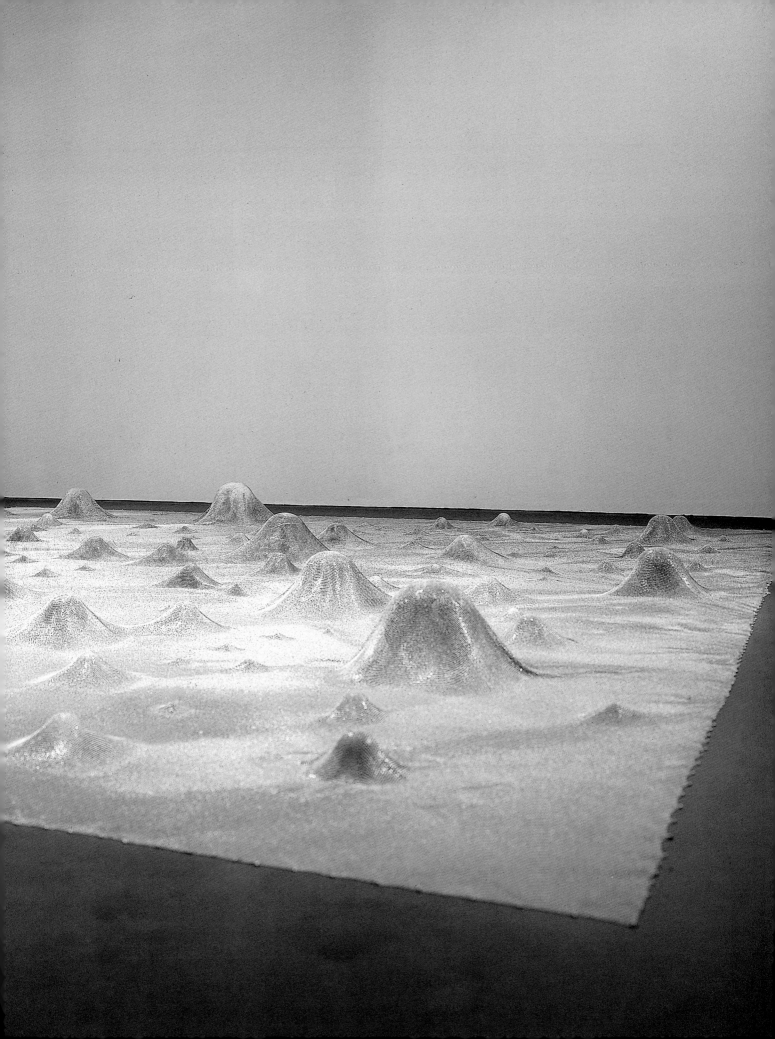

Fontes
1992
Approx 6,000 carpenter's rulers,
1,000 clocks, 500,000 vinyl numbers,
soundtrack
300 × 600 × 600

Fontes, 1992/2008
Dedicated to Alfredo Fontes

“ For me, this work has its roots in Marcel Duchamp's *3 stoppages étalon* [*3 Standard Stoppages* 1913–14]. The rulers of chance.

I began to think about the project and naturally moved straight on to the instance of space and time. Clocks as paradigmatic instruments for measuring time, just as the rulers are to space. I began to think about something that might unite these two units. The interesting thing was that if I used something with rulers, and this idea of measurement and the clock, I would have two structures and a base with which to mount something: a sonic and visual piece. It would unite music and visual arts. Early in 1991 I went to Ghent to meet Jan Hoet, the curator of Documenta IX (1992). He functioned in chaos and was totally agitated. He began to talk and to explain on the blackboard the idea of his Documenta. The concept of Documenta IX was displacement. And the only thing I was taking to Hoet was the idea for this work: a kit containing four fragments of each of the rulers – which my friend Alfredo Fontes made – and the clocks – at the time I wanted a

floor of clocks – and a sort of visual maquette of the work, in cardboard, which suggested the hanging rulers. Jan Hoet listened to my idea, was enthusiastic and financed the project. The idea of covering the floor with clocks was impractical, so I decided to put the numbers on the floor and raise the clocks … Such is the story of the piece. The sad note is that when I was making the drawings of the rulers that would be used in the piece, my great friend Alfredo Fontes died. That is one of the reasons that the piece is dedicated to him. Hence the title *Fontes*.

Making a soundtrack for the work was fundamental, because in addition to emphasising the system you had in the clocks and rulers, you were also creating a sort of curtain of isolation; creating a counterpoint with the sensation of isolation you would have in the centre of the piece, the place where most rulers were, which therefore became impregnable. You knew there was someone very close to you, but you had no idea who it was; there was no way of knowing. I think the fact that one lost oneself, that one became highly 'individuated', alone, isolated in the space of the piece is very interesting. ”

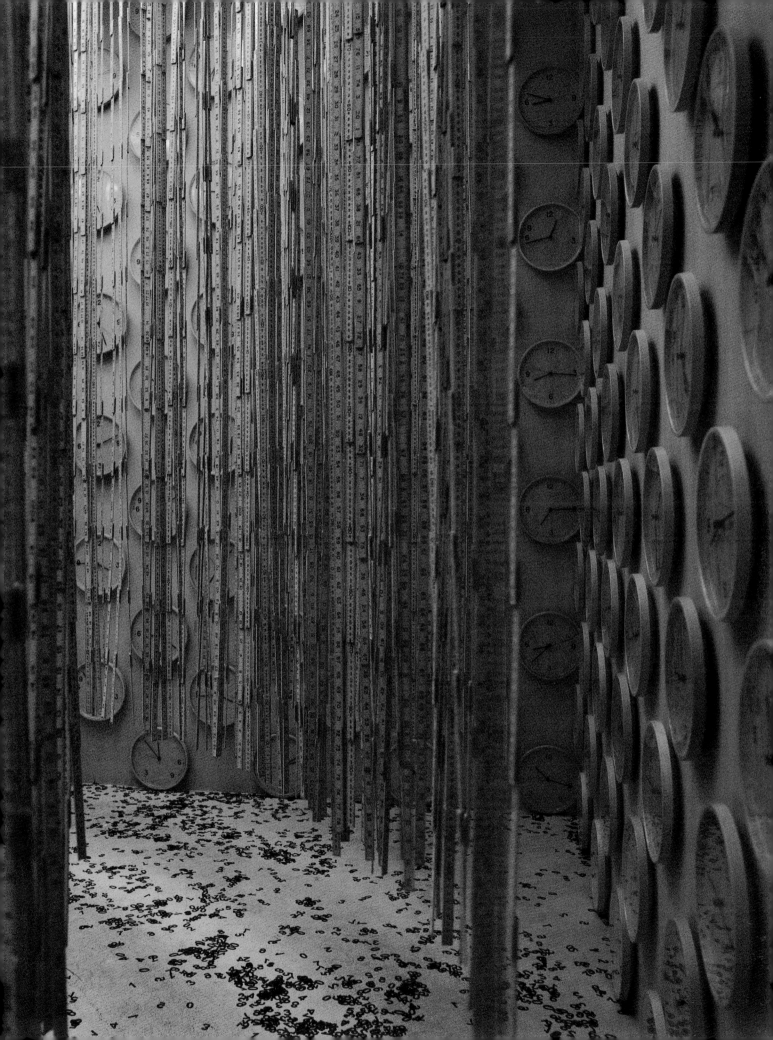

“ If *Fontes* didn't have a wall and you could look at it from above, you would see a double spiral, a structure that moves towards a centre and becomes increasingly dense. Seen from the side it was also a projection of the Milky Way. I used the Milky Way as a model. So it actually is a decomposition of the Milky Way.

Like most of the works I've made since 1979–80, I planned three versions of this work. I call the first one (the Documenta piece) *Van Gogh*: the rulers are black on yellow. Black on yellow is a paradigmatic combination for rulers and signalling.

In the second version of the piece, which I am making for London, the rulers and the clocks are made in black on white; the choice of colours is purely aesthetic. The ruler would be white and the numbering would be black. I call this version *Bauhaus*. In the third version, which I'm still working on, there will be phosphorescent numbers on a blue background.

The sound that is part of the work is much more subtle or discreet than 'clockwork' because it is battery-driven, but even so you have this sound of the clock because it is a mechanical object. ”

Babel, 2001

Babel
2001
Radios, metal
Diameter 500 × 300

" *Babel* began in 1990, on Canal Street, in New York. There were eleven years of notes before I finally realised the work in 2001, in Helsinki, at the Kiasma Museum of Contemporary Art. Upon observing the quantity and diversity of radios and all the different types of sound objects that were sold around Canal Street, I thought of making a work with radios. Radios are interesting because they are physically similar and at the same time each radio is unique.

My original idea had always been to build a tower and a bridge as well. From the start, the reference was Babel, in the sense that, by accumulation, it would become a tower of incomprehension, more than comprehension (incomprehensibility vs. comprehensibility), because each radio was tuned into a different station, broadcasting different sounds.

During this initial stage, I thought of doing something geometric, clean, almost aseptic. The idea was to mount each module of the tower with the same model of radio, which would have produced layers of different models, actually functioning as much as possible like bricks. The first time

I mounted it, in Helsinki, I decided to use second-hand radios; in so doing, I discovered that I had added a sort of mapping or archaeology of the object 'radio'.

The biggest radios were necessarily closest to the ground. The heavier and bigger the radio, the closer to the ground it was. The old radios at the base of the installation were like pieces of furniture, and the last radios we added were cutting-edge transistors. Therefore, the tower would grow in a decreasing order that would end up in a sort of conical section, which was cool because it emphasised the work's perspective.

I mounted this work for the first time at the *Ars 01* exhibition. It was interesting because it was a way to collect all those radios that were there on the second-hand market. In Finland, I think they ran out of second-hand radios because the tower was made up of 1,000 radios and, in a way, it was a landmark in the history of radio in Finland: it was the possibility of maintaining and preserving a collection that would surely be lost.

The noise could be deafening, but the radios leave the studio with an adjustment, because you can't solder the knob, since each city is tuned into a different place on the dial. The idea is that each radio be adjusted to a volume at which it is minimally audible; this is the criterion. The work was mounted in Vila Velha in the state of Espírito Santo, in 2006, during the World Cup and the elections took place soon afterwards. Whether you wanted it or not, in addition to [being a sort of archeo-logical cross-section of] the radio as object, you are also taking an archeological sample of events. Because it was the World Cup, so there was a lot of soccer stuff on. Or it might be done during election times, when one would hear an abundance of political speeches. The sociological fact 'captured' by the piece is quite fascinating: I am astonished at the amount of evangelical stations that come over the airwaves whenever we mount the work in Brazil. By the time one has left the work, if one isn't careful, one will be evangelised. "

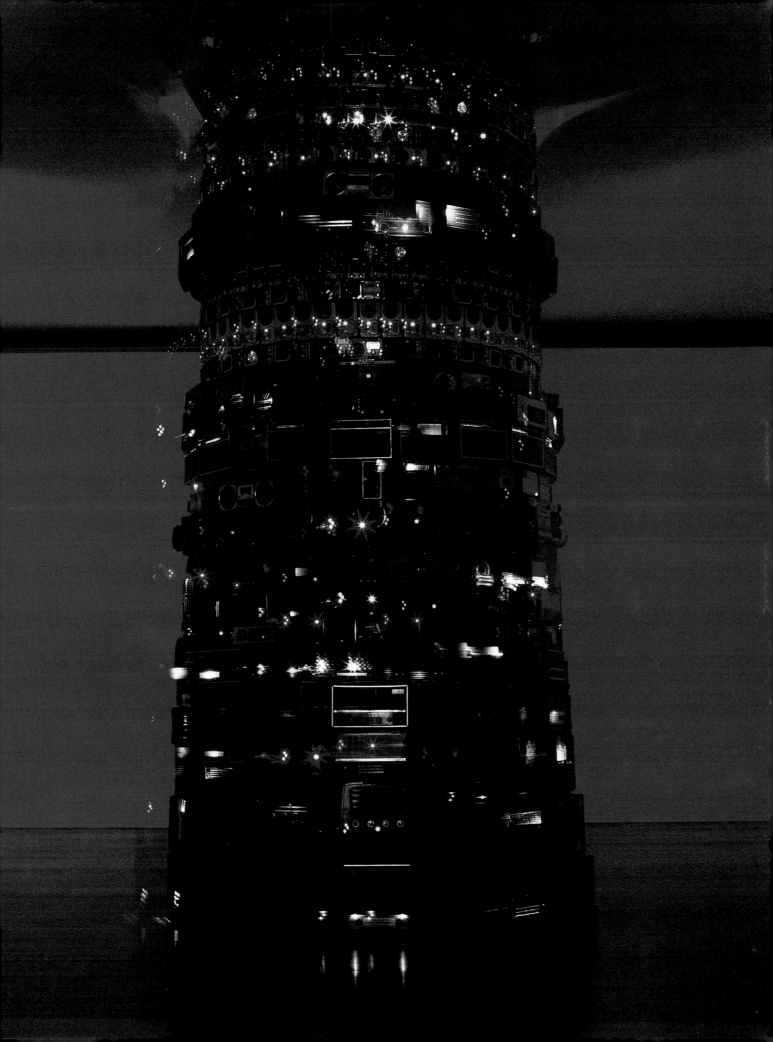

Where all places are

MOACIR DOS ANJOS

In one of his best-known stories, Jorge Luis Borges describes a moment in which – seated on the floor in a cellar and looking at a fixed spot some metres above – the tale's narrator sees an 'Aleph', a 'place where all places are – seen from every angle, each standing clear, without any confusion or blending'.[1] Several other such passages in the Argentinean author's work reveal a desire to invent devices for confronting rigid codes of perceiving the world that are unable to grasp the fluidity with which the body traverses and experiences it. Almost from the beginning of his trajectory, Cildo Meireles, too, has devoted himself to critically discussing the idea of space in which human life unfolds – whether in its physical, everyday dimension or from a political perspective of broad temporality – dismissing reductive or circumscribed ways of mapping out territories.[2] To this end, he makes use of a method of investigating the world that, instead of restricting itself to the field of retinal perception, is based on the 'synthesis between sensorial and mental relationships', so that senses and reason stimulate one another and together produce knowledge regarding complex spaces.[3] An installation originally constructed in 2001, *Babel* (p.169) bears eloquent witness to the artist's interest in an expanded notion of space and his belief in the cognitive power of synesthetic relationships.[4]

Upon entering the environment occupied by *Babel*, the visitor soon identifies (albeit imprecisely) a low, continuous noise and the contours of a tall, conical structure in which he is able to make out multiple small light sources. Attracted by this volume disposed in the centre of the room and enveloped in near-darkness, he circulates around it and finally realises that it is a tower – over two metres in diameter and five metres tall – made from the accumulation and superimposition of hundreds of radios. All of these are switched on, and it becomes clear that their LEDs and dials are the source of the luminous dots that had been seen from a distance. There are many different sizes of radios from many different periods. The larger, valve-driven sets serve as a base for others that are lighter and more portable thanks to their electronic components. Gradually, the indistinct hiss becomes distinguishable as individual songs, newscasts and radio programmes that, broadcast from various countries on sound waves of variable range, combine randomly. The fact that sounds of various origins are gathered in a single place would appear to allude to the existence of a space for symbolic, economic and political negotiation concerning what each territory deems appropriate for itself; a space for the establishment and continuous re-elaboration, through processes of human expression, of distinctions between peoples.[5] Even before the work can be discerned visually, perception of its sound elements confirms, therefore, Meireles's interest in investigating the nature and characteristics of

1 Jorge Luis Borges, 'The Aleph', in Jorge Luis Borges (trans. Norman Thomas di Giovanni), *The Aleph and Other Stories 1933–1969*, New York, Bantam, 1971.

2 'Many of my works deal with an idea of "territory" which is in an undefined, suspended state at this very moment. Personally, I have always found the notion of "country" – as an extension of the body or the place of a localized happiness – to be as vague and imprecise a code of classification as any other.

I once thought of a country which would be so narrow that it could only be run from abroad. It would be a tiny place – just a borderline – that would contain a single person, perhaps not even that.' Cildo Meireles, in *Cildo Meireles: Geografia do Brasil*, Rio de Janeiro, Artviva Produção Cultural, 2001.

3 Ferreira Gullar, 'Teoria do Não-Objeto', *Jornal do Brasil*, 21 November – 20 December 1960. The centrality of synesthetic relationships in the work

of Meireles is analysed in Kaira M. Cabañas, 'Cildo Meireles: "La Conscience dans l'Anesthésie"', *Parachute*, 110, 2003.

4 Because of these features, *Babel*'s resemblance to *Salt without Meat* 1975 (p.97) and *Marulho (Murmur of the Sea)* 1992–7 should be mentioned here.

5 For a critical approach to the idea of belonging, see Arjun Appadurai, *Modernity at Large*, Minneapolis, University of Minnesota Press, 1996.

space by making use of more than one sense, which requires visitors to explore *Babel* with their own bodies and in their own time.[6]

The title and formalisation of this work are obviously references to the biblical story of the Tower of Babel (Genesis, XI, 1–9), which takes place during a time in which all humanity spoke only one language and, led by the descendants of the children of Noah (Shem, Ham and Japhet), decides to settle on a large plain in Mesopotamia. Here, the community resolves to erect a tower tall enough to reach the heavens – simultaneously a monument to itself and a strategy to avoid the dispersion of its members to other parts. However, God understands the construction as an affront to His authority or an attempt to rival His powers, and decides to interfere. At a sign from Him, the workers begin to speak in different languages. From that moment on, the inhabitants of the world cease to understand one another, divided amongst themselves and scattering to the corners of the planet. According to the myth, this absence of linguistic communication was the first cause of all mankind's conflicts. The recurrent difficulty in communication even between those who speak the same language, however, makes of that disagreement a particular case of the divergence of interests which divides or produces discord in nations or communities.[7]

At first, the use of radios as constructive elements of the tower appears to contradict the idea of a necessarily contentious coexistence between peoples who do not share the same codes and beliefs, as implied in the biblical story. After all, ever since the 1920s, radio has been a fundamental instrument of instant communication – between the most varied and far-flung places – of that which excessive distance hides from sight, separating sounds from their immediate, visible sources. Just as much as television, the availability of radio in the everyday lives of most communities worldwide led in the early 1960s to the formulation of the idea that the world had become a 'global village', thus promising the healing of the fracture in the sense of community that an acute social division of labour had long since provoked.[8] The fact that the radios gathered together in this installation are tuned in to many different stations underscores, moreover, the notion that, even within a context of growing interrelationship between peoples, it might be possible to generate and assert difference. In opposition to the social entropy proclaimed in the narrative of Genesis, the demise of a universal language – and the subsequent end of a presumed transparency of meaning in the spoken language of all the inhabitants of the world – might in fact be associated with the interruption of a colonial rule that imposed the language and culture of a single nation upon everyone, and therefore constrained the emergence of alterity.[9] Connected yet different, members of that network cannot thus be associated

6 The fact that *Babel*'s topology is initially indicated by sounds and only later confirmed by the gaze likens this installation to Meireles's *I. Study for Space* 1969, which, by means of written instructions, asked the reader to stand still in a place listening to the nearest and furthest sounds that could be made out, thus demarcating an imagined area. This work was presented as part of a group of three 'studies' (the others are *II. Study for Time* and *III. Study for Space-Time*), at the Salão da Bússola (Rio de Janeiro, Museu de Arte Moderna, 1969). Cildo Meireles, 'Places for Digresssions', interview with Nuria Enguita, in *Cildo Meireles*, exh. cat., IVAM Centre del Carme, Valencia, 1992.

7 George Steiner, *Depois de Babel. Questões de Linguagem e Tradução*, Curitiba, Editora UFPR, 2005.

8 Marshall McLuhan, *Understanding Media: The Extensions of Man*, New York: McGraw Hill 1964. The authority and importance of radio in modern life may be measured by the extent of the panic that filmmaker Orson Welles unleashed upon more than a million listeners in his 30 October 1938 broadcast of successive special reports in which aliens were said to be attacking the Earth. The fake news broadcasts were, in fact, an adaptation for radio of *The War of the Worlds* by H.G. Wells.

9 Jacques Derrida, *Torres de Babel*, Belo Horizonte, Editora UFMG, 2002.

with exclusive interests nor reduced to a uniform amalgamate, being better understood as individual parts of a 'multitude' which produces and shares that which it imagines it holds in common.[10]

However, the other elements that make up *Babel* problematise this communal utopia, indicating that the expression of various opinions is an insufficient condition for the most equitable division of power between distinct human groups. From the first glimpse of the work, it is obvious to the visitor that the radios piled up by the artist to form the tower are bearers of the most varied technologies – from the obsolescent to the excess of resources. This diversity may be understood as an index of the unequal access of nations (and also of the many social strata within each one of them) to the power of communicating with that which is distant and, by this token, of asserting that which they deem to be important. In fact, the 'right to narrate' that all nations and communities constantly claim – the right to be heard, recognised and represented[11] – is always conditioned by the hierarchical (albeit disseminated and dispersed) control of technological media and political instruments through which it is exercised, thus rendering such media and instruments integral parts of the 'ideological circuits' that anesthetise difference and block change in stratified societies.[12] Even though they occupy the same space in the exhibition room, using the same means of transmission, these many different radios allude to the simultaneous presence, among different peoples or even within a single nation,

of distinct social times. Thus they symbolise the asymmetrical distribution of power that allows for the assertion of sovereignties and the decentralised yet effective command of the mechanisms that structure exchanges between distant places.

The drone produced jointly by all of the sets also suggests that the immeasurable quantity of information transmitted by radio in the contemporary world – as well as by television and even more so by the internet – eventually obscures the content of intended communications, emptying them of clearly discernible meanings. Within any given transmission frequency, the number of stations is great enough for their broadcasts occasionally to overlay each other, mix or even cancel one another out. Thus, the listener is alienated from the speech of others less through scarcity than through excess of information, provoking a 'negative ecstasy of radio'.[13] It is an ecstasy that reduces differences not by rendering that which is communicated more transparent but, on the contrary, by rendering indistinct each discourse that desires to affirm itself as unique. Paradoxically, this erasure of alterity becomes all the greater as the means of communication needed for its expression become more widely disseminated.[14]

The enunciation of diverse points of view and the control or dilution of that which is unique are, therefore, phenomena that coexist in *Babel*. They may be taken as metaphors for the intricate interaction between distinct nations and communities, in

10 Michael Hardt and Antonio Negri, *Multidão*, Rio de Janeiro, Record, 2005.
11 Homi Bhabha, 'The Right to Narrate', available at www.uchicago.edu/docs/millenium/bhabha/bhabha_a.html.
12 Cildo Meireles, 'Insertions in Ideological Circuits 1970–75', in Paulo Herkenhoff, Gerardo Mosquera, Dan Cameron, *Cildo Meireles*, London, Phaidon Press, 1999.
13 Jean Baudrillard, 'The Ecstasy of Communication', in Hal Foster (ed.), *The Anti-Aesthetic: Essays on Postmodern Culture*, Seattle, Bay Press, 1983.
14 The idea that the densification or accumulation of a thing might contradict its function is exemplified in the work *Geometry Kit (neutralisation by opposition and/or addition)* 1977–9, in which Meireles brings together identical, potentially harmful objects (razor blades, nails, cleavers) in such a way as to neutralise their danger.

which differences are produced by each one of them amid the inequality of power to establish their singularity before the others. However, the work does not point to resolutions to the tensions it presents. Without implying an appeasement of the conflicts that mark the state of the contemporary world, Meireles seems to advocate a need to adopt explanatory paradigms that are relational and focused, for this very reason, on recognising the existence of a territory with uncertain boundaries, one that accommodates multiple oppositions and produces the mutual contamination of cultural expressions previously separated by geographical and historical injunctions. *Babel* not only evokes this territory, but offers it up to the visitor as something to be experienced in real time through the dense web of sound that the radio transmissions weave in unison.

Translated from the Portuguese by Stephen Berg

Liverbeatlespool
2004
Twenty-seven songs by the Beatles
that reached no.1 in the UK or
US charts
CD, headphones
Duration 14 minutes, 8 seconds
Dimensions variable

Liverbeatlespool, 2004

" I was invited to the Liverpool Biennial in 2004 and I went to visit the city. For me, though, Liverpool will be the Beatles forever. No matter how much information you have about the city's history and the importance of the port, the fact that it has been economically very active and England's main port, to me the strongest, most immediate fact is the Beatles.

The idea behind this work was to gather all the songs ever recorded by the Beatles and overlay them so as to create a solid from this superimposition. It would therefore be a sound work. And that's what I ended up doing. I wanted to use the process that Puerto Ricans used on the lower East side in New York in the early 70s, which consists of putting loudspeakers on window ledges facing the street. So when you walked you would be covered with a 'rain of music'.

It was Pedro Ariel, my son, who helped me. With the aid of the computer, we established the axis, the exact middle of each song, the temporal middle. At that point, we timed the longest one (*Hey Jude*) and it was about seven minutes long. So we used that song as a base and then, after a while, *Help* (another long song) comes in, until we finally arrived at the shortest song. We also used software called *Backwards*, which allowed us to play two songs simultaneously but in opposite directions. We could also programme it so that the songs remained linear and alternate. So I actually have two sound variants.

The first obstacle was that the copyrights to most of the songs belonged to Michael Jackson, who purchased the rights to the music at auction in the 1990s. He was charging a lot of money for them and that made it impossible to use all the songs ever recorded for this project. But we negotiated the rights to use all the songs on *1*, a disc with the twenty-seven Beatles songs that made it to the top of the charts. As for the installation of the work proper,

it proved impossible to have the radios arranged on window sills and ledges. In the end, I remembered something I had seen some two years previously, in Pernambuco, where I went to do the *Geografia do Brasil* exhibition – bicycles with loudspeakers. So I decided the way to do it would be to have a headphone with a CD player at Tate Liverpool (which was one of the Biennial's venues) and ask them to make a bicycle with loudspeakers and a chip that distributed the two tracks of sound. I hired a young artist, a graduate student who was working at the Biennial, to bicycle around Liverpool with this loudspeaker. Therefore, the work consisted of a headphone installed at Tate Liverpool and a student who bicycled around the city for the entire duration of the Biennial, an average of six hours a day. "

The Ballad of John and Yoko

Ocasião
Occasion
1974/2004
Two rooms, enamel basin,
metal support, money, mirrors
Each room 400 × 600

Ocasião, 1974/2004
Occasion

" I first thought about it around 1974,
the year of the *Zero Cuzeiro*. In fact
I considered at one time showing the
Money Tree alone in this kind of space,
with the mirrors. You would encounter
a sort of interface which makes you feel
like a voyeur. You find that this voyeurism
has much to do with time: when you pass
into the second room you look back and
see someone else in the situation you
were in a minute or two before. The
work is an occasion to check out your
own attitudes.

The money is in a basin, which rather
reminded me of Pontius Pilate: to
'wash one's hands' of moral responsibility.
People get a little bit nervous in the room,
I don't think they feel comfortable at all. "

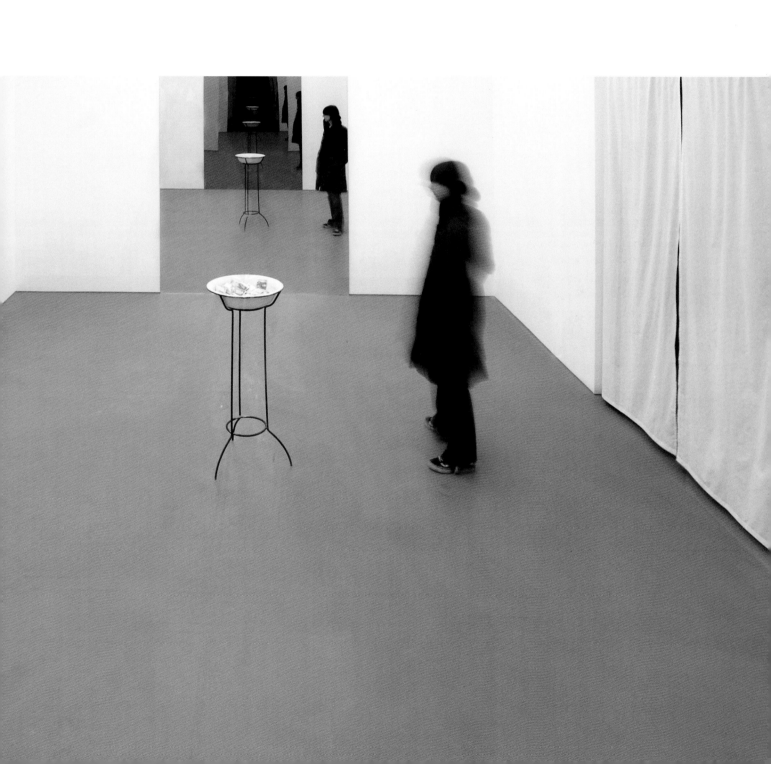

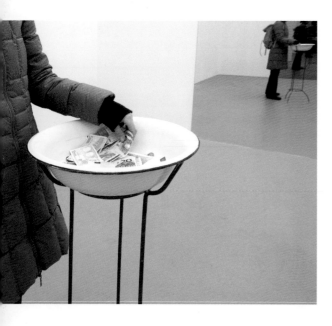

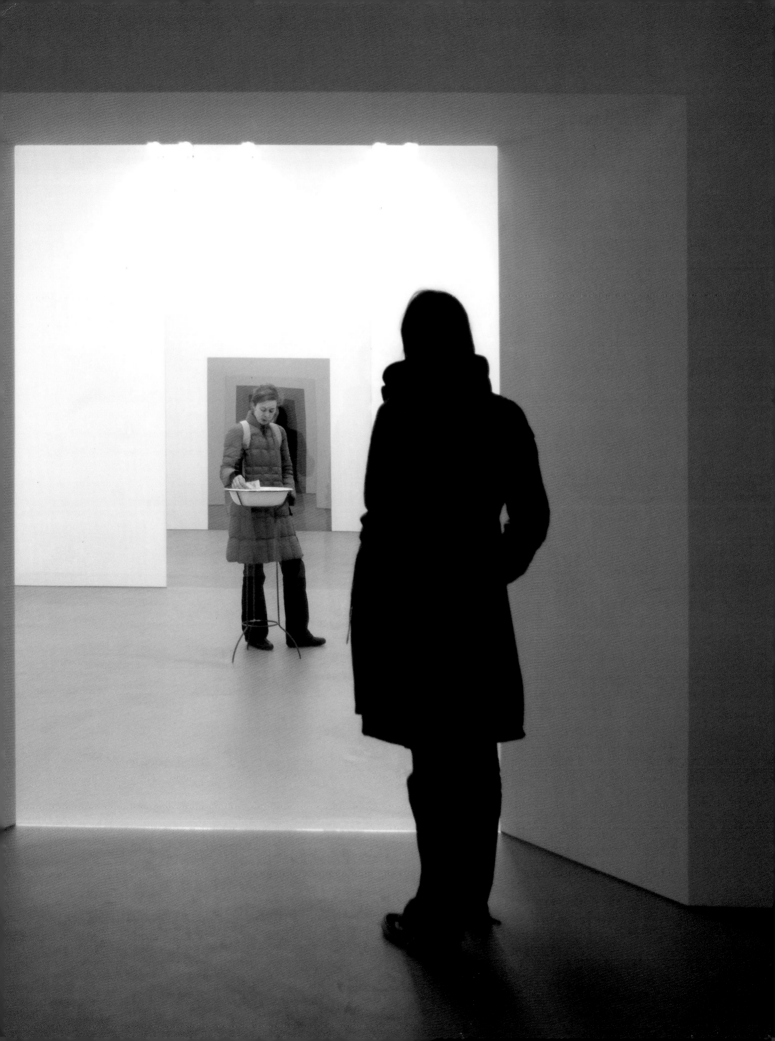

Volátil, 1980–94
Volatile

" The biography of the work begins with the first phase, in which there is a candle in a bell jar, and the space is filled with gas. That was how the work was initially planned. It was to have been a large, sealed dome fed by oxygen, a candle lit in an environment filled with real gas, meaning natural gas plus T-butyl-mercaptan. To me, it also works like the childhood game of dangling one's legs over the mouth of a well – just sitting there and looking at the bottom. I was interested in discussing the central problem of metaphysics: to be or not to be. That is to say: there you are, there's the candle, the room's impregnated with gas, it's as if I had hung the hammer of reason and you, the spectator, made your decision.

But *Volatile* eventually moved to another version, which became the final one, in which I impregnate the environment with the scent of gas (T-butyl-mercaptan), which is used in conjunction with natural gas in our kitchens so that we will know when there is a gas leak. It is as if we were ignorant of speed and only considered space and time.

The work moved toward this version, in which you remove the true degree of danger involved. At the same time, you gain another element, because you really are moving into the realm of allegory. Ever since I first showed it, people have considered the work to be – at the least – in solidarity with the martyrdom of the Jews, referring to the concentration camp, to the gas chamber of the concentration camp. And there are cases of the opposite, of people who do not see it in tragic terms. For myself the first time I walked barefoot in the powder, it was a pleasurable feeling, like walking in the clouds.

I believe *Volatile* is an attempt to associate sensation and emotion, producing an almost instantaneous link. It also navigates through this region of fear. I have always been interested in identifying tiny things, in terms of formatting and expanding them. This is beauty, which also points at this insignificance of being. "

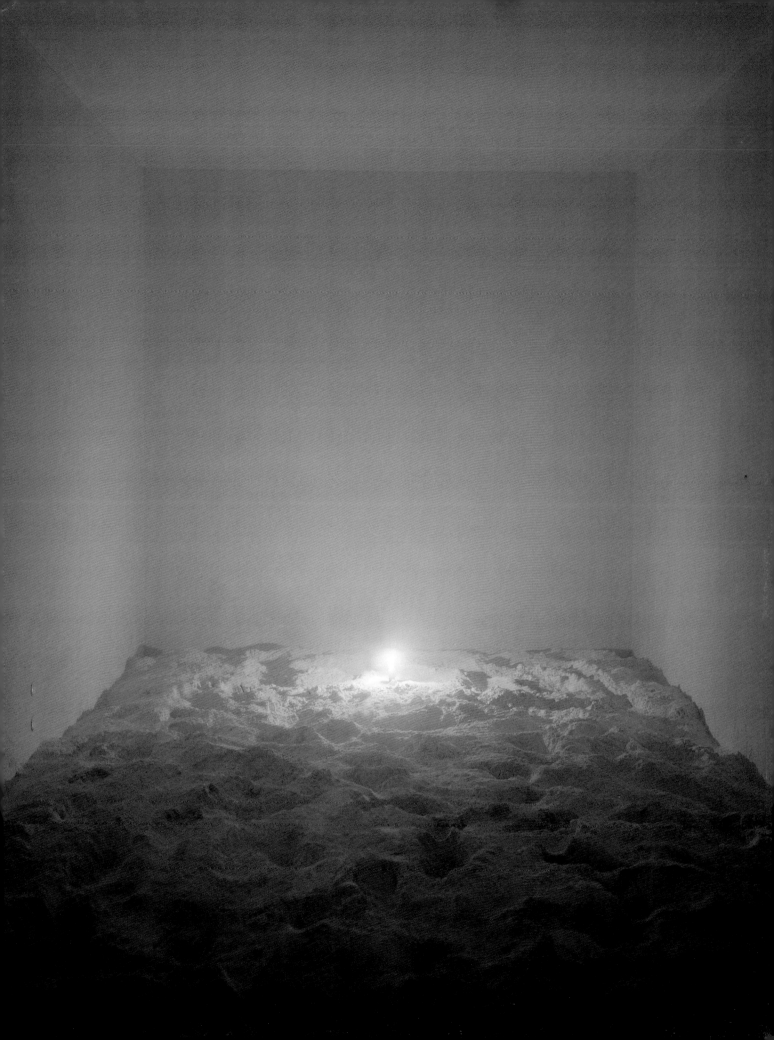

List of Exhibited Works

Works illustrated in this publication but not shown in the exhibition are excluded from this list. Not all works in this list will be show at every venue.

Measurements are given in centimetres, height before width and depth.

Desvio para o Vermelho: I. Impregnação 1967–84
Red Shift: I. Impregnation
White room, red objects including carpet, furniture, electric appliances, ornaments, books, plants, food, liquids, paintings; DVD
300 × 1000 × 500
Collection Inhotim Centro de Arte Contemporânea, Minas Gerais, Brazil
Illustrated on pp.123–7

Desvio para o Vermelho: II. Entorno 1967–84
Red Shift: II. Spill/Surrounding
Darkened room, glass bottle, red paint
300 × 250 × 500
Collection Inhotim Centro de Arte Contemporânea, Minas Gerais, Brazil
Illustrated on pp.128–9

Desvio para o Vermelho: III. Desvio 1967–84
Red Shift: III. Shift
Darkened room, white porcelain washbasin installed at incline, metal taps, flowing red liquid
300 × 1000 × 500
Collection Inhotim Centro de Arte Contemporânea, Minas Gerais, Brazil
Illustrated on p.131

Canto IV 1967–8/74
Corner IV
Wood, canvas, paint, woodblock flooring
305 × 100 × 100
Collection Museu de Arte Moderna do Rio de Janeiro
Illustrated on p.23

Canto II 1967–8/81
Corner II
Wood, canvas, paint, woodblock flooring
305 × 100 × 100
Collection Luisa Malzoni Strina
Illustrated on p.21

Canto VII 1967–8/2008
Corner VII
Wood, canvas, paint, woodblock flooring
305 × 100 × 100
Courtesy of the artist

Canto VIII 1967–8/2008
Corner VIII
Wood, canvas, paint, woodblock flooring
305 × 100 × 100
Courtesy of the artist

Espaços Virtuais: Cantos 1968
Virtual Spaces: Corners
Ink and graphite on millimetre graph paper
32 × 23
Series of thirteen drawings
Courtesy of the artist
Selection illustrated on p.22

Volumes Virtuais 1968–9
Virtual Volumes
Graphite on millimetre graph paper
28.8 × 39.3
Series of seventeen drawings
Courtesy of the artist
Selection illustrated on pp.25–7

Ocupações 1968–9
Occupations
Chinese ink and graphite on millimetre graph paper
32 × 47.7
Series of eleven drawings
Courtesy of the artist
Selection illustrated on pp.29–34

Arte Física 1969
Physical Art
Ink, graphite and collage on millimetre graph paper
32 × 45
Series of twelve drawings
Courtesy of the artist
Selection illustrated on pp.41–5

Arte Física: Cordões/ 30km de Linha Estendidos 1969
Physical Art: Cords/ 30km Extended Line
Industrial cord, map, wooden box
Closed 60 × 40 × 8
Courtesy of the artist
Illustrated on p.48

Arte Física: Caixas de Brasília/Clareira 1969
Physical Art: Brasília Boxes/Clearing
Sequence of photographs and maps; three boxes of earth
Photographs 60 × 90
Map 60 × 80
Each box 30 × 30 × 30
Courtesy of the artist
Illustrated on p.49

Mutações Geográficas: Fronteira Rio–São Paulo 1969
Geographical Mutations: Border Rio–Sao Paulo
Leather case and earth
60 × 60 × 60
Collection Fundação de Serralves, Museu de Arte Contemporânea, Porto
Illustrated on pp.46–7

Árvore do Dinheiro 1969
Money Tree
100 folded one-cruzeiro banknotes
Notes 2.5 × 7 × 6
Courtesy of the artist
Illustrated on p.77

Cruzeiro do Sul 1969–70
Southern Cross
Wooden cube, one section pine, one section oak
0.9 × 0.9 × 0.9
Courtesy of the artist
Illustrated on pp.58–9

Condensado I – Deserto 1970
Condensation I – Desert
Yellow gold, white sapphire, one grain of sand
2 × 2 × 2
Instituto Carlos Scliar – Collection Francisco Medeiros Scliar
Illustrated on p.50

Condensado II – Mutações Geográficas: Fronteira Rio/São Paulo 1970
Condensation II – Geographical Mutations: Border Rio/São Paulo
Soil, white gold, onyx, amethyst, sapphire
2.2 × 2 × 2
Instituto Carlos Scliar – Collection Francisco Medeiros Scliar
Illustrated on pp.50–1

Inserções em Jornais 1969–70
Insertions in Newspapers
Advertisement placed in *Jornal do Brasil*, 13 January 1970
57.8 × 37.5
Private Collection, London
Illustrated on p.61

Inserções em Circuitos Ideológicos – Projeto Coca-Cola 1970
Insertions into Ideological Circuits – Coca-Cola Project
Transfer text on glass
Each 25 × 6 × 6
Tate. Presented by the artist 2006
Illustrated on pp.62–5

**Inserções em Circuitos Ideológicos –
Projeto Cédula** 1970
**Insertions into Ideological Circuits –
Banknote Project**
Ink on banknotes
Each 7 × 15 cm
Tate. Presented by the artist 2006
Illustrated on pp.66–7

Para ser Curvada com os Olhos 1970/75
To be Curved with the Eyes
Wooden box, iron bars, graph paper,
bronze plaque, enamel plaque
12 × 50 × 25
Collection Luiz Buarque de Hollanda,
São Paulo
Illustrated on p.105

Espelho Cego 1970
Blind Mirror
Wood, mastic, metal
49 × 36 × 18
Collection Marcantonio Vilaça, Brasília
Illustrated on p.107

Mebs/Caraxia 1970–1
Vinyl record recorded with
frequency oscillator
Diameter 17.6
Two-track recording
Courtesy of the artist
Illustrated on p.95

Eureka/Blindhotland 1970–5
Rubber, fishing net, metal, cork,
wood and audio
400 × 700 × 700
Tate. Presented by the American Fund
for the Tate Gallery 2007
Illustrated on pp.111–15

Inserções em Circuitos Anthropológicos
1971
Insertions into Anthropological Circuits
Metal token for dispensing machines,
telephones or transport,
empty matchboxes, clay
Dimensions variable
Courtesy of the artist
Illustrated on p.75

Zero Cruzeiro 1974–8
Offset print on paper
Unlimited editions
6.5 × 15.5
Courtesy of the artist
Illustrated on p.79

Zero Centavo 1974–8
Metal
Unlimited editions
Diameter 1.3
Courtesy of the artist
Illustrated on p.78

Sal Sem Carne 1975
Salt without Meat
Vinyl record, eight-track recording
Diameter 30.2
Courtesy of the artist
Illustrated on p.97

**A Diferença entre o Círculo e
a Esfera é o Peso** 1976
**The Difference between the Circle
and the Sphere is the Weight**
Texts and drawings on paper
Various dimensions
Courtesy of the artist
Illustrated on p.109

Malhas da Liberdade I 1976
Meshes of Freedom I
Cotton rope
120 × 120
Courtesy of the artist
Illustrated on p.91

Malhas da Liberdade III 1977
Meshes of Freedom III
Iron, glass sheet
120 × 120
Courtesy of the artist
Illustrated on p.93

Zero Dollar 1978–84
Offset print on paper
Unlimited editions
6.8 × 15.7
Courtesy of the artist
Illustrated on p.81

Zero Cent 1978–84
Metal
Unlimited editions
Diameter 1.5
Courtesy of the artist
Illustrated on p.80

Volátil 1980–94/2008
Volatile
Talcum powder, candle, gas scent
350 × 700 × 900
Collection of Contemporary Art
Fundación 'la Caixa'
An identical version of this work
is also in the Collection of
Diane and Bruce Halle, Arizona
Illustrated on p.181

Obscura Luz 1982
Dark Light
Wood-based industrial sheeting,
electric light, lightbulb
66 × 66 × 22
Susana and Ricardo Steinbruch
Collection
Illustrated on p.103

Através 1983–9/2007
Through
Fishing nets, voile, reinforced glass,
livestock nets, architecture paper,
Venetian blinds, garden fencing,
wooden gates, prison bars, wooden
trellis, iron fencing, mosquito nets,
metal city barrier fencing, aquarium,
tennis nets, metal stakes, barbed wire,
chains, chicken wire, museum rope
barriers, cellophane, glass
600 × 1500 × 1500
Courtesy of the artist
Illustrated on pp.138–46; 150–1

**Missão/Missões
(Como Construir Catedrais)** 1987
**Mission/Missions
(How to Build Cathedrals)**
Approx 600,000 coins, 800 communion
wafers, 2,000 bones, 80 paving stones
and black fabric
235 × 600 × 600
Daros-Latinamerica Collection, Zurich
Illustrated on pp.99–101

Glovetrotter 1991
Steel mesh, balls of various sizes,
materials and colours
520 × 420
Courtesy of the artist
Illustrated on pp.161–3

Fontes 1992/2008
Approx 6,000 carpenter's rulers,
1,000 clocks, 5,00,000 vinyl numbers,
soundtrack
300 × 600 × 600
Courtesy of the artist
Illustrated on pp.165–7

Condensado III – Bombanel 1996
Condensation III – Ringbomb
White gold, magnifying glass,
glass and gunpowder
3 × 2
Courtesy of the artist
Illustrated on p.53

Babel 2001
Radios, metal
Diameter 500 × 300
Courtesy of the artist
Illustrated on pp.6, 169

Liverbeatlespool 2004
27 songs by the Beatles, which
reached no.1 in the UK or US charts
CD, headphones
Duration 14 minutes 8 seconds
Courtesy of the artist
Illustrated on p.175

List of Lenders

Collection Luiz Buarque de Hollanda, São Paulo

Collection of Contemporary Art Fundación 'la Caixa'

Daros-Latinamerica Collection, Zurich

Collection Fundação de Serralves, Museu de Arte
Contemporânea, Porto

Instituto Carlos Scliar – Collection Francisco Medeiros Scliar

Collection Inhotim Centro de Arte Contemporânea,
Minas Gerais, Brazil

Cildo Meireles

Collection Museu de Arte Moderna do Rio de Janeiro

Susana and Ricardo Steinbruch Collection

Collection Luisa Malzoni Strina

Tate, London

Collection Marcantonio Vilaça, Brasília

and other private lenders who wish to remain anonymous

Acknowledgements

My sincere and profound thanks to not only Vicente Todolí, for once again inviting me to put on a great exhibition, but also to Guy Brett, who agreed to participate in this project from the beginning; to Trudo Engels, always brilliant and fraternal; to Catherine Bompuis, for her precious and constant help; to Amy Dickson, tireless and perfect; to Bernardo Paz, always generous; to Mary Sabbatino and Luisa Strina, for their diligent helpfulness and attention; to all and to each of the authors of the texts; to Mary Richards and Philip Lewis, for the catalogue; to the teams at Tate Modern and at Tate Publishing. And to all, who, directly or indirectly, contributed to the materialisation of this exhibition, its catalogue and related projects, as well as to:

Rubens Teixeira dos Santos
Max Jorge C. Meireles
Carmen Maia
Valdir Tavares Sobral
Bernardo Damasceno
Gerônimo Mauricio da Silva
Luiz Carlos Ferreira
Antonio Julio de Souza
Felipe Scovino
Janaína Melo
Jochen Volz
Rodrigo Moura
Renato Patalano Henriques
Katia Maria Braga Risse Dias – Zipa Expres
Darcy de Souza Dias – Plastitek, Rio
Patricia Perla

Meditec (Jan Henry Stefenson, Fernando Pereira Lopes, Vera Lucia dos Santos Mendes, Olgarina Coelho Neves, Maria Aparecida Nunes Oliveira, Jussara Leal Ribeiro, Celso Chaves Maia, Rosimar Pimentel da Cruz, Angela de Fátima Peres, Edna Solange C. da Costa, Robson Passos da Silva, Adílio Pereira Maia, José Carlos Alves Peçanha, Maria das Graças Pereira Miranda, Ranolfo Francisco de Moura, Iza Regina de Souza Nogueira dos Santos, Ana Lucia Sena da Silva Conceição, Sônia Maria Lopes de Macedo, Conceição da Silva Ventura, Tania Regina Guedes).

Muito Obrigado!

CILDO MEIRELES

Exhibition History

Cildo Meireles

Born in Rio de Janeiro in 1948
Lives and works in Rio de Janeiro

SOLO EXHIBITIONS

1967
Cildo Meireles: Desenho, Museu de Arte Moderna, Salvador, Brazil

1975
Eureka/Blindhotland, Museu de Arte Moderna, Rio de Janeiro

Blindhotland/Gueto; Espaços Virtuais: Cantos, Galeria Luiz Buarque de Hollanda & Paulo Bittencourt, Rio de Janeiro

1977
Casos de Sacos, Pinacoteca do Estado de São Paulo; Museu de Arte e Cultura Popular, Cuiabá

1978
Cildo Meireles: Desenhos, Pinacoteca do Estado de São Paulo

1979
O Sermão da Montanha: Fiat Lux, Centro Cultural Cândido Mendes, Rio de Janeiro

Artigos Definidos, Galeria Saramenha, Rio de Janeiro

1981
Artigos Definidos & Espaços Virtuais: Cantos, Galeria Luisa Strina, São Paulo

Cildo Meireles, Funarte, Rio de Janeiro

1983
Obscura Luz, Galeria Luisa Strina, São Paulo; Galeria Saramenha, Rio de Janeiro

Eureka/Blindhotland, Rio Arte Humaitá, Rio de Janeiro

1984
Desvio para o Vermelho, Museu de Arte Moderna, Rio de Janeiro

Duas Coleções: Desenhos (Coleção Luiz Buarque de Holanda e Coleção Antônio Maluf), Sala Oswaldo Goeldi, Brasília

1986
Desvio para o Vermelho, Museu de Arte Contemporânea da Universidade de São Paulo

Cinza, Galeria Luisa Strina, São Paulo; Petite Galerie, Rio de Janeiro

1989
Campos de Jogos, Galeria Luisa Strina, São Paulo

1990
Cildo Meireles: Missão/Missões (How to Build Cathedrals) & Cinza, Institute of Contemporary Arts, London

Projects 21: Cildo Meireles, The Museum of Modern Art, New York

1992
Metros I, Galeria Luisa Strina, São Paulo

1994
Entrevendo & Volátil, Capp Street Project, San Francisco

1995
Ouro e Paus, Joel Edelstein Arte Contemporânea, Rio de Janeiro

Cildo Meireles: Retrospectiva, IVAM Centre del Carme, Valencia; touring to Museu Serralves, Porto (1996); Institute of Contemporary Art, Boston (1997)

Two Trees, Laumeier Sculpture Park, Saint Louis, Missouri

Volátil, Gallery Lelong, New York

1996
To L.C., Dados & Condensados: Bombanel, Espaço Cultural Sérgio Porto, Rio de Janeiro

Cildo Meireles, The Fabric Workshop Museum, Philadelphia

1997
Chove, Chuva, Le Creux de l'Enfer Centre d'Art Contemporain, Thiers

Eureka/Blindhotland & Fio, Gallery Lelong, New York

Cildo Meireles: Atelier FINEP, Paço Imperial, Rio de Janeiro

1998
Camelô, Galeria Luisa Strina, São Paulo

1999
Cildo Meireles: Ku Kka Ka Kka & Fio, Kiasma Museum of Contemporary Art, Helsinki

Cildo Meireles: Retrospectiva, The New Museum of Contemporary Art, New York; touring to Museu de Arte Moderna de São Paulo (2000); Museu de Arte Moderna, Rio de Janeiro (2000)

2000
Ku Kka Ka Kka & Camelô, Galerie Lelong, New York

2001
La Bruja, Marulho & Strictu, Arte Futura e Companhia, Brasília

Cildo Meireles: Geografia do Brasil, Museu de Arte Moderna Aloísio Magalhães, Recife; touring to Museu de Arte Moderna da Bahia, Salvador (2002); Espaço Cultural Venâncio/ ECCO, Brasília (2002)

2003
Cildo Meireles, Musée d'Art Moderne et Contemporain, Strasbourg

Descalas, Galeria Luisa Strina, São Paulo

Cildo Meireles, Miami Art Museum

From left to right: Cildo Meireles, Luiz Fonseca, Artur Barrio, Vicente Pereira and Luiz Alphonsus, Rio de Janeiro, 1974

2004

Cildo Meireles: Occasion, Portikus, Frankfurt

Cildo Meireles, Kunstverein in Hamburg

Cildo Meireles: Descalas & Strictu, Lelong Gallery, New York

Cildo Meireles, Wüttembergischer Kunsteverein Stuttgart

2005

Cildo Meireles: Algum Desenho 1963–2005, Centro Cultural Banco do Brasil, Rio de Janeiro

Casos de Sacos, SESC Rio – Unidade Petrópolis, Brazil

2006

Babel, Museu Vale de Rio Doce, Vila Velha, and Pinacoteca de Estado, São Paulo

2007

Cildo Meireles: Camelô, Galeria de Artes Visuales H10, Valparaiso

2008

Cildo Meireles: Algum Desenho 1963–2008, Museu Oscar Niemeyer, Curitíba

Cildo Meireles, Tate Modern, London; touring to Museu d'Art Contemporani de Barcelona (2009); The Museum of Fine Arts, Houston (2009); Los Angeles County Museum of Art (2009); and Art Gallery of Ontario (2010)

SELECTED GROUP EXHIBITIONS

1965

II Salão de Arte Moderna do Distrito Federal, Teatro Nacional de Brasília

1969

Salão da Bússola, Museu de Arte Moderna, Rio de Janeiro

Pre Paris Biennial [closed before opening], Museu de Arte Moderna, Rio de Janeiro

1970

Do Corpo à Terra, Palácio das Artes, Belo Horizonte

Agnus Dei: Thereza Simões, Guilherme Magalhes Vaz & Cildo Meireles, Petite Galerie, Rio de Janeiro

Information, The Museum of Modern Art, New York

1974

Desenho Brasileiro/IX Salão de Arte Contemporânea de Campinas, Museu de Arte Contemporânea de Campinas, Brazil

1975

Novas Tendências: Audiovisual, Paço das Artes, São Paulo

1976

37th Venice Biennale

Arte Brasileira: Os Anos 60/70: Colecção Gilberto Chateaubriand, Museu de Arte Moderna da Bahia, Salvador

1977

9th Paris Biennial

1979

Exala Áquila, Núcleo de Arte Contemporânea, João Pessoa

Figuração Referencial: IX Salão Nacional de Arte, Museu de Arte, Belo Horizonte

1980

Clementina de Jesus: a Benção Quelé, Funarte, Rio de Janeiro

1981

1 Colóquio de Arte No-objetual de Medellín, Museo de Arte Moderno, Medellín, Colombia

16th São Paulo Biennial

Quase Cinema: 'Cildo Meireles': Direction Wilson Coutinho, Fundação Cultural do Distrito Federal, Brasília

Primeira Exposição de Arte Latina, Prefeitura Municipal, Recife

1984

Private Symbol: Social Metaphor, 5th Sydney Biennal, Art Gallery of New South Wales, Sydney; Ivan Dougherty Gallery, Paddington, Australia

Tradição e Ruptura: Síntese de Arte e Cultura Brasileiras, Fundação Bienal de São Paulo

Intervenções no Espaço Urbano, Galerias Sérgio Millict e Espaço Alternativo, Funarte, Rio de Janeiro

1986

Depoimento de uma Geração: 1969/1970, Galeria Banerj, Rio de Janeiro

Galeria Luisa Strina: 12 anos Trabalhando Juntos, Galeria Luisa Strina, São Paulo

Uma Geração 18 Anos Depois, Investiarte Galeria, Rio de Janeiro

1987

Modernidade: Art Brésilien du XXe siècle, Musée d'Art Moderne de la Ville de Paris; Museu de Arte Moderna, São Paulo

Palavra Imágica, Museu de Arte Contemporânea da Universidade de São Paulo

1988

Missões: 300 anos – Visão do Artista, Teatro Nacional, Brasília; Escola de Artes Visuais do Parque Laje, Rio de Janeiro; Museu de Arte Moderna, São Paulo; Reitoria da Universidade Federal do Rio Grande do Sul, Porto Alegre

The Latin American Spirit, Bronx Museum of the Arts, New York

Eureka/Blindhotland, Brazil Projects, P.S.1, The Institute for Art and Urban Resources, Long Island City, New York

The Debt, Exit Art, New York

Broken Musik, Daadgalerie, Berlin; Gemeentemuseum, The Hague; Le Magasin, Grenoble

1989

20th São Paulo Biennial

Through/Lezards, with Tunga, Kanaal Art Foundation, Kortrijk

Magiciens de la Terre, Musée National d'Art Moderne, Centre Georges Pompidou; Grande Halle, La Villete, Paris

1990

The Rhetorical Image, The New Museum of Contemporary Art, New York

Transcontinental: Nine Latin American Artists, Ikon Gallery, Birmingham; Cornerhouse, Manchester

Cinza, Institute of Contemporary Arts, London

Casino Fantasma, Casino Municipale, Venice; Institute of Contemporary Art, New York

1991

Dénonciation, École d'Architecture de Normandie, Rouen

1992

Latin American Artists of the XX Century, Estación Plaza das Armas, Seville; touring to The Museum of Modern Art, New York (1993); Museum Ludwig at Josef-Haubrich-Kunsthalle, Cologne (1993)

Encounters/Displacements: Cildo Meireles, Alfredo Jaar & Luiz Camnitzer, Archer M. Huntington Art Gallery, The University of Texas at Austin

Documenta IX, Kassel

Sydney Biennial

Amerika: The Bride of the Sun, Koninklijk Museum voor Shone Kunsten, Antwerp

Pour la suite du Monde, Musée d'Art Contemporain de Montréal, Canada

Emblemas do Corpo, Centro Cultural do Brasil, Rio de Janeiro

1993

Time and Tide: The Second Tyne International Exhibition of Contemporary Art, CWS Warehouse, Newcastle-upon-Tyne

L'ordre du Temps, Centre d'Art – Domaine de Kerguehennec, France

L'autre à Montevideo/ homenaje a Isidore Ducasse, Museo Nacional de Artes Visuales, Montevidéu, Uruguay

A Presença do Ready-made, 80 Anos, Museu de Arte Contemporânea da Universidade de São Paulo

Representação: Presença Decisiva, Museu de Arte Contemporânea da Universidade de São Paulo

O Desenho Moderno no Brasil: Coleção Gilberto Chateaubriand, Museu de Arte Moderna, Rio de Janeiro; Galeria de arte Sesi, Rio de Janeiro

1994

Bienal Brasil Século XX, Fundação Bienal de São Paulo

Trincheiras: Arte e Política no Brasil, Museu de Arte Moderna, Rio de Janeiro

1995

Art from Brazil in New York: Cildo Meireles and Waltercio Caldas, Galerie Lelong, New York

Colisiones, Centro Artístico Arteleku, San Sebastian, Spain

Dinheiro, Diversão e Arte, Centro Cultural Banco do Brasil, Rio de Janeiro

Continuum: Brazilian Art, 1960s–1990s, University of Essex, Colchester, UK

1996

Zona Archives, Escola Nacional de Belas Artes, Florence

Sin Fronteras: Arte Latinoamericana Atual, Complejo Cultural La Rinconada, Museo Alejandro Otero, Caracas

1997

You Are Here: Re-Siting Installations, Royal College of Art, London

Re-Aligning Vision: Alternative Currents in South American Drawings, Archer M. Huntington Art Gallery, The University of Texas at Austin; touring to El Museo del Barrio, New York; Arkansas Art Center, Little Rock; Museo de Bellas Artes, Caracas; Museo de Arte Contemporáneo, Monterrey, Mexico; Miami Art Museum

1st Mercosul Biennial, Porto Alegre, Brazil

Face à l'Histoire, Musée National d'Art Moderne, Centre Georges Pompidou

Trade Routes: History and Geography, 2nd Johannesburg Biennial

Arte Pará: Fronteiras, Museu do Estado, Palácio Lauro Sodré, Belém

Arte/Cidade: A Cidade e suas Histórias, São Paulo

1998

Insertions: Notes Towards the Dematerialization of the Art Exhibition, Nordiska Museet, Stockholm: Tekniska Museet, Stockholm

Hélio Oiticica e a Cena Americana, Centro de Arte Hélio Oiticica, Rio de Janeiro

Núcleo Histórico: Antropofagia e Histórias de Canibalismo, 24th São Paulo Biennial

Horizonte Reflexivo, Centro Cultural Light, Rio de Janeiro

The Garden of Forking Paths: Contemporary Art from Latin America, Kunstforeningen, Copenhagen, touring to Edsvik Konst & Kultur, Stockholm; Helsinki City Art Museum; Nordjyllands Kunstmuseum, Aalborg

1999

Por que Marcel Duchamp?, Paço das Artes, São Paulo; Paço Imperial, Rio de Janeiro

Global Conceptualism: Points of Origin 1950–1980, Queens Museum of Art, New York, touring to Walker Art Center, Minneapolis; Miami Art Museum; MIT List Visual Arts Center, Cambridge, Mass.

Circa 1968, Museu Serralves, Porto

Horizontes Cambiantes, University of Essex, Casa da América, Colchester, UK

2000

Zona Instável: Cildo Meireles, Luiz Alphonsus e Alfredo Fontes, Escola de Artes Visuais do Parque Lage, Rio de Janeiro

Worthless (Invaluable): The Concept of Value in Contemporary Art, Museum of Modern Art, Ljubliana

Man + Space, Kwangiu Biennale 2000

Cildo Meireles + Lawrence Weiner, Kunstverein Heilbron, Kölnischer, Cologne

Versiones Del Sur: Fricciones, Museo Nacional Centro de Arte Reina Sofia, Madrid

Versiones Del Sur: Heterotropias, Museo Nacional Centro de Arte Reina Sofia, Madrid

Versiones Del Sur: No És Solo lo que Vés: Pervertiendo el Minimalismo, Museo Nacional Centro de Arte Reina Sofia, Madrid

Others Modernities, The London Institute

Vivências / Lebenserfahrung / Life Experience, Generali Foundation, Vienna

Técnica Mista Sobre Papel, Galeria Thomas Cohn, São Paulo

2001

Versiones Del Sur: Eztetyka del Sueño, Palácio de Cristal, Museo Nacional, Centro de Arte Reina Sofia, Madrid

Beyond Preconceptions: The Sixties Experiment, Veletrzni Palac National Gallery, Prague; Centro Recoleta, Buenos Aires; Fundação Armando Álvares Penteado, São Paulo; Paço Imperial, Rio de Janeiro

Breeze of Air / Hortus Conclusus, Witte de With, Rotterdam

Ars 01: Unfolding Perspectives, Kiasma Museum of Contemporary Art, Helsinki

Do Corpo à Terra: Um Marco Radical na Arte Brasileira, Itaú Cultural, Belo Horizonte

Da Adversidade Vivemos: Artistes d'Amerique Latine, Musée d'Art Moderne de la Ville de Paris

Paralelos: Arte Brasileira da Segunda Metade do Século XX em Contexto, Museu de Arte Moderna, São Paulo; Museu de Arte Moderna, Rio de Janeiro

2002

Beyond Preconceptions: The Sixties Experiment, University of California, Berkeley Art Museum, Berkeley; Freedman Gallery, Albright College Center for the Arts, Reading

Documenta XI, Kassel

Tempo, The Museum of Modern Art, New York

Der Globale Komplex, OK Center for Contemporay Art, Linz

Vivências: Dialogues Between the Works of Brazilian Artists from 1960–2002, New Art Gallery, Walsall; Sainsbury Centre for Visual Art, Norwich

Fluxus und die Folgen: 40 Jahre, Strojectbüro Stadtmuseum, Wiesbaden, Germany

Arte all'Arte/ Arte Achitectura Paisaggio 7, Palazzo delle Papesse, Centro Arte Contemporânea, Sienna

Les Années 70 : l'Art en Cause, Musée d'Art Contemporain, Bordeaux

El Final del Eclipse, Museo Extremeño e Iberoamericano de Arte Contemporâneo, Badajoz, Spain

2003

8th Istanbul Biennial

Dreams and Conflicts: The Dictatorship of the Viewer, 50th Venice Biennale

Uneasy Space: Interactions with 12 Artists, Site Santa Fe Museum, Mexico

Arte e Sociedade: Uma Relação Polêmica, Itaú Cultural, São Paulo

Contemporaneidade: Homenagem a Mário Pedrosa, Galeria Evandro Carneiro, Rio de Janeiro

Geometrias: Abstração Geométrica Latinoamericana en la Colleción Cisneros, Museo de Arte Latinoamericana de Buenos Aires

Apropriações: Curto-circuito de Experiências Participativas, Museu de Arte Contemporânea, Niterói, Brazil

O Sal da Terra, Museu Vale do Rio Doce, Vila Velha, Brazil

Um Difícíl Momento de Equilíbrio, Museu de Arte Moderna, São Paulo

A Subversão dos Meios, Instituto Itaú, São Paulo

2004

Inverted Utopias, The Museum of Fine Arts, Houston

A Angles Vifs, Musée d'Art Contemporain de Bordeaux (CAPC)

Beyond Geometry, Los Angeles County Museum of Art; Miami Art Museum

4th Liverpool Biennial

Imagem Sitiada, Espaço SESC, Rio de Janeiro

Paralela 2004, Vila Olímpia, São Paulo

2005

Nuevas Adquisiiones: Colección Fundació 'La Caixa' 20 Anys amb l'Art Contemporani, Fundació 'La Caixa', Caixa Fórum, Barcelona

Person of the Crowd, Contemporary Museum, Baltimore

Transeuntes: América Latina, Museu de Arte Contemporânea da Universidade de São Paulo

Always a Little Further, 51st Venice Biennale

Open Systems: Rethinking Art c.1970, Tate Modern, London

Populism, Stedelijk Museum Amsterdam; touring to Contemporary Art Center, Vilnius; National Museum of Art, Architecture and Design, Oslo; Frankfurter Kunstverein

2006

Seduções: Valeska Soares, Cildo Meireles, Ernesto Neto, Daros Foundation, Zurich

Figura e Vestígio, Collection Marcantonio Vilaça, Rio de Janeiro

To See the World, To Feel with your Eyes, Lofoten International Art Festival

Cruz de Miradas: Visiones de America Latina, Collection Patricia Phelps de Cisneros, Museo del Palacio de Bellas Artes, Ciudad de Mexico

2007

Anos Setenta: Arte Como Questão, Instituto Tomie Ohtake, São Paulo

Arte para Crianças, Museu de Arte Moderna, Rio de Janeiro

6th Mercosul Biennial, Porto Alegre, Brazil

Futuro do Presente, Itaú Cultural, São Paulo

New Perspectives in Latin American Art 1930–2006: Selections from a Decade of Acquisitions, The Museum of Modern Art, New York

Medellín Biennial, Colombia

Contributors

Moacir dos Anjos is Senior Researcher at Fundação Joaquim Nabuco and an independent curator based in Recife, Brazil. He was Director of the Museu de Arte Moderna Aloísio Magalhães – MAMAM, in Recife, between 2001–6. He is the author of *Local/global: arte em trânsito* (Rio de Janeiro, Jorge Zahar Editor, 2005) and *Contraditório: Panorama da Arte Brasileira* (São Paulo, Museu de Arte Moderna, 2007).

Guy Brett lives and works in London. He has written extensively for the art press since the 1960s and has organised a number of international exhibitions. His book *Carnival of Perception* was published in 2004 and he is currently working on a study of the art of Rose English.

Okwui Enwezor is Dean of Academic Affairs at San Francisco Art Institute and Adjunct Curator at International Center of Photography. He was Artistic Director of Documenta 11, 2nd Johannesburg Biennial, 2nd Seville Biennial. His most recent exhibitions include, *Snap Judgments: New Positions in Contemporary African Photography* and *Archive Fever: Uses of the Document in Contemporary Art*, both at ICP. He is currently the Artistic Director of 7th Gwangju Biennale. He lives in New York and San Francisco.

Maaretta Jaukkuri is the artistic director of Kunstnernes Hus in Oslo, Norway. She has previously worked as Chief Curator of the Museum of Contemporary Art Kiasma in Helsinki. She is also Professor at the Faculty of Art and Architecture of the Norwegian University of Science and Technology (NTNU) in Trondheim.

Bartomeu Marí is, since April 2008, Director of the Museu d'Art Contemporani de Barcelona (MACBA), where he occupied the position of Chief Curator since 2004. He was Curator of Exhibitions at Fondation pour l'Architecture in Brussels (Belgium), Curator at IVAM – Centre Julio González in Valencia (Spain) and Director of Witte de With in Rotterdam (the Netherlands). He has curated numerous exhibitions and published extensively on contemporary art.

Lu Menezes is a Brazilian poet and researcher, PHD in Comparative Literature mainly interested in the use of colour in poetry and the crossbreeding of verbal and visual language.

Suely Rolnik is a psychoanalyst, researcher and curator. She is Full Professor at the Universidade Católica de São Paulo (Master and Doctoral Program on Subjectivity) and also teaches at the Museu d'Art Contemporani de Barcelona Independent Studies Program (PEI-MacBa). She is co-author with Félix Guattari, of *Micropolítica. Cartografias do desejo* (1986; 8th ed., 2007), published in English with the title *Molecular Revolution in Brazil* (Semiotext/MIT, USA, 2007).

Sônia Salzstein is Professor of Modern and Contemporary Art History at the Universidade de São Paulo. She has written extensively on Brazilian modern and contemporary art, including essays on such artists as Antonio Dias, Iole de Freitas, Mira Schendel and Waltercio Caldas, as well as on cultural issues connected with modernisation in peripheral contexts.

Lynn Zelevansky is the Terri and Michael Smooke Curator and Department Head, Contemporary Art, Los Angeles County Museum of Art. She recently published the first history of contemporary art at the museum in BCAM/LACMA, the book that accompanied the opening of LACMA's new building for contemporary art (2008). Among the exhibitions she has organised for LACMA are *Beyond Geometry: Experiments in Form, 1940s–70s* (2004–5) and *Love Forever: Yayoi Kusama, 1958–68* (1998–9). As a member of the Department of Painting and Sculpture, the Museum of Modern Art, New York (1987–95) she organised *Sense and Sensibility: Women Artists and Minimalism in the Nineties* (1994) and Projects shows by Cildo Meireles (1990), Guillermo Kuitca (1991), Gabriel Orozco (1993), and others.

Index

The titles of illustrated works are given in English.
For Portuguese titles please see the list of works on pp.182–3.

Page numbers in **bold** type refer to main entries.

Photographic credits